SUPERIOR: The Haunted Shore

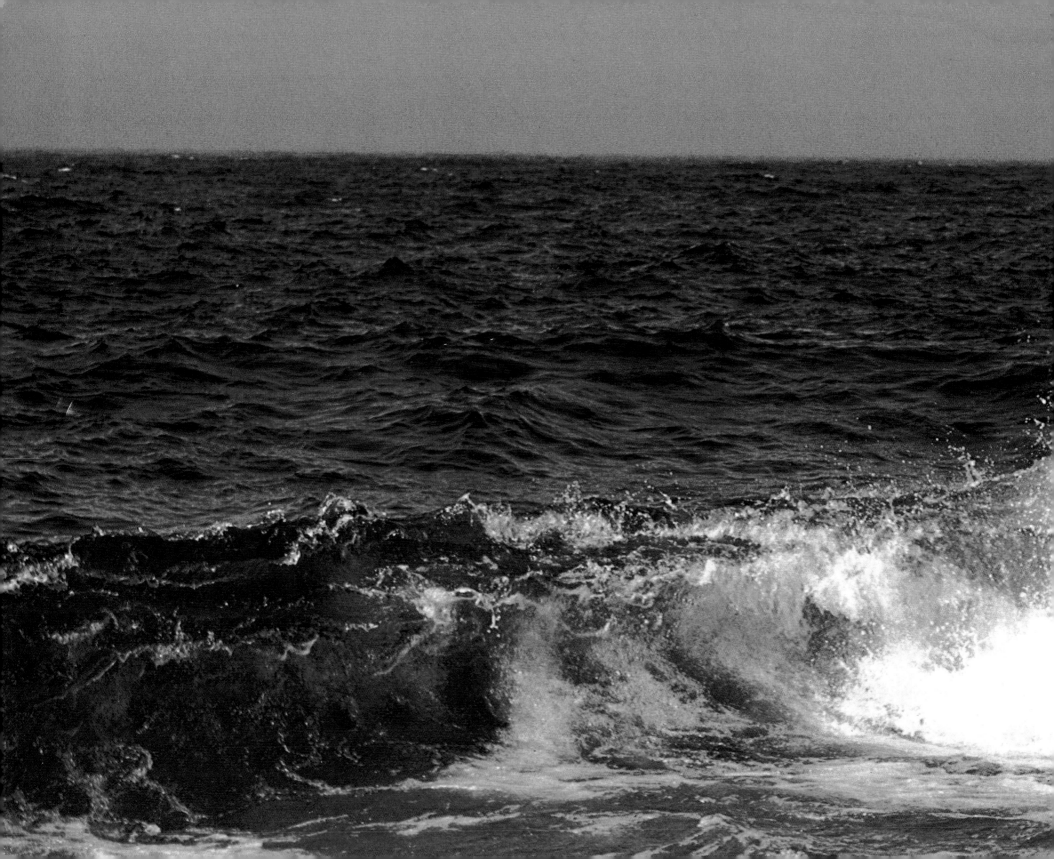

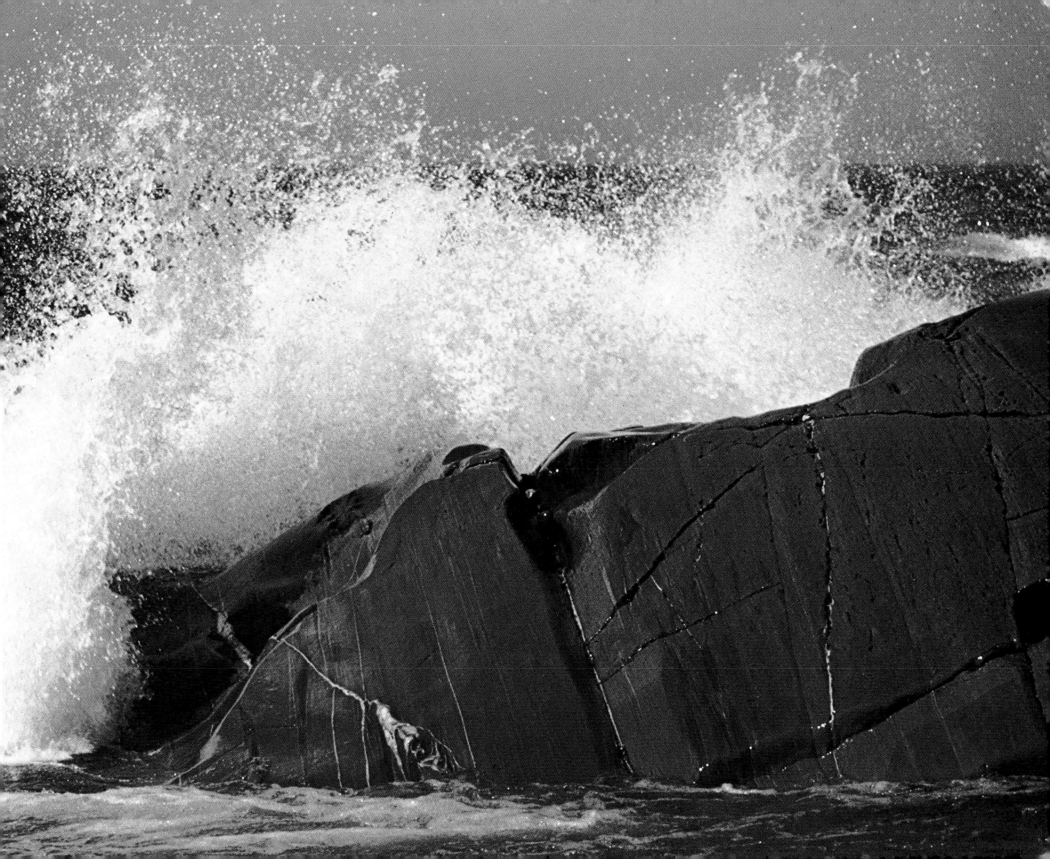

To our parents who taught us early to respect the wilderness

Photographs by BRUCE LITTELJOHN / *Text by* WAYLAND DREW

A FIREFLY BOOK

Cataloguing in Publication Data

Litteljohn, Bruce M., 1935–
 Superior : the haunted shore

Rev ed.
isbn 1-895565-58-8

1. Superior, Lake - Description and Travel 2. Superior, Lake - Region - History. 1. Drew, Wayland 1932–II Title

FC3095.S86L58 1994 971.3'12 C95-930078-3
F1059.S9L58 1994

Book design by Vernon Mould & Dorothy Mould
Layout revision by V. John Lee
Type layout by Fortunato Aglialoro
Typography in Cartier and Deepdene by Mono Lino Typesetting Co. Ltd.
Printed by Friesen Printers Ltd.

This new and revised paperback edition published by

Firefly Books Ltd.
250 Sparks Avenue
Willowdale, Ontario
Canada M2H 2S4

Printed in Canada

About the Authors

BRUCE LITTELJOHN is an active environmentalist with a particular interest in wilderness preservation. His historical and conservation writing has been published widely, and he is co-editor of several books on the Canadian wilderness. His photographs are frequently exhibited and appear in many publications. He lives in Toronto, where he teaches at Upper Canada College.

WAYLAND DREW is a freelance writer and teacher living in Bracebridge, Ontario. He is the author of several novels and is at work on a science fiction trilogy. He has also written many scripts for CBC radio and has contributed articles to various periodicals.

Preface To The New Edition

The origins of Lake Superior's shores go back over a billion years to the time when a plume of hot mantle rock broke open what is now central North America. Thousands of cubic kilometres of lava flooded the landscape. Emptied of its contents – like a boiled-over-pot – the uprising subsided leaving a basin rimmed by their hardened flows which form much of today's shoreline. A billion years of the rock record was erased after that by the ever-patient, ever-mighty forces of erosion, including the grinding continental glaciers. When they melted a few thousand years ago, the rushing rivers filled Lake Superior.

Twenty years in more than a billion is equal to the blink of the eye in a human life; nonetheless, much has changed along the north shore since this book was first published in 1975.

Happily, the water is purer now, thanks largely to major cleanups of pulp-and-paper-mill effluent and to better sewage-treatment plants in most communities. Except close to towns, one can still scoop up a cup of Lake Superior and safely drink some of Earth's sweetest water. What wouldn't most of the world give for that treat?

Good stretches of shore are now protected from cottage development. Pukaskwa National Park, Slate Island Provincial Park, and Michipicoten Island Provincial Park, as well as a few small nature reserves, have all been created in the past 20 years. Along with the older Neys, Lake Superior, and Sleeping Giant Provincial Parks, they protect some of the most scenic and remote shore. But more ought to be set aside, notably the string of islands stretching almost continuously from Copper Island near Rossport westward to Victoria Island near the Canada–U.S. border, and including the Black Bay Peninsula. Whatever is not protected within parks soon will be developed, thus cutting off most people's access to the lake and further degrading the Lake Superior ecosystem.

Twenty years ago, only a few sailors, powerboaters, and adventurers in canoes travelled on Superior for fun. Today, summer armadas cruise from harbours around the lake. Many boats are as well appointed as a modern house; their owners make no attempt to meet the lake on its own terms, but bring with them the very civilization they are trying to escape. Afraid of rocks they travel kilometres offshore during the day and congregate at night in the relatively few harbours, some of which are badly abused. Nor are the growing numbers of canoeists and kayakers without impact. They travel close to shore as much to appreciate the beauty depicted in this book as to avoid Superior's dangers. Their minimalist travel style means that they leave little garbage, but they tend to camp on the most fragile vegetation and beautiful sites along the shore. Each party leaves the spot of crushed vegetation just a little larger. Yes, there are monsters loose on the lake, and they are not Windigo or Mishipishew.

In a sense, this book is becoming a lament for what was; like the lava, a moment frozen in time. But it does not have to be so. If each traveller appreciates the north shore's wildness just a little bit more, it will be less threatened. And if each person uses it just a little more considerately, the beauty reflected in this book will survive. A shoreline much like today's and a Superior from which anyone can scoop a cup of good water in the year 3000 – what a legacy that would be!

Bill Addison
Kakabeka Falls
1995

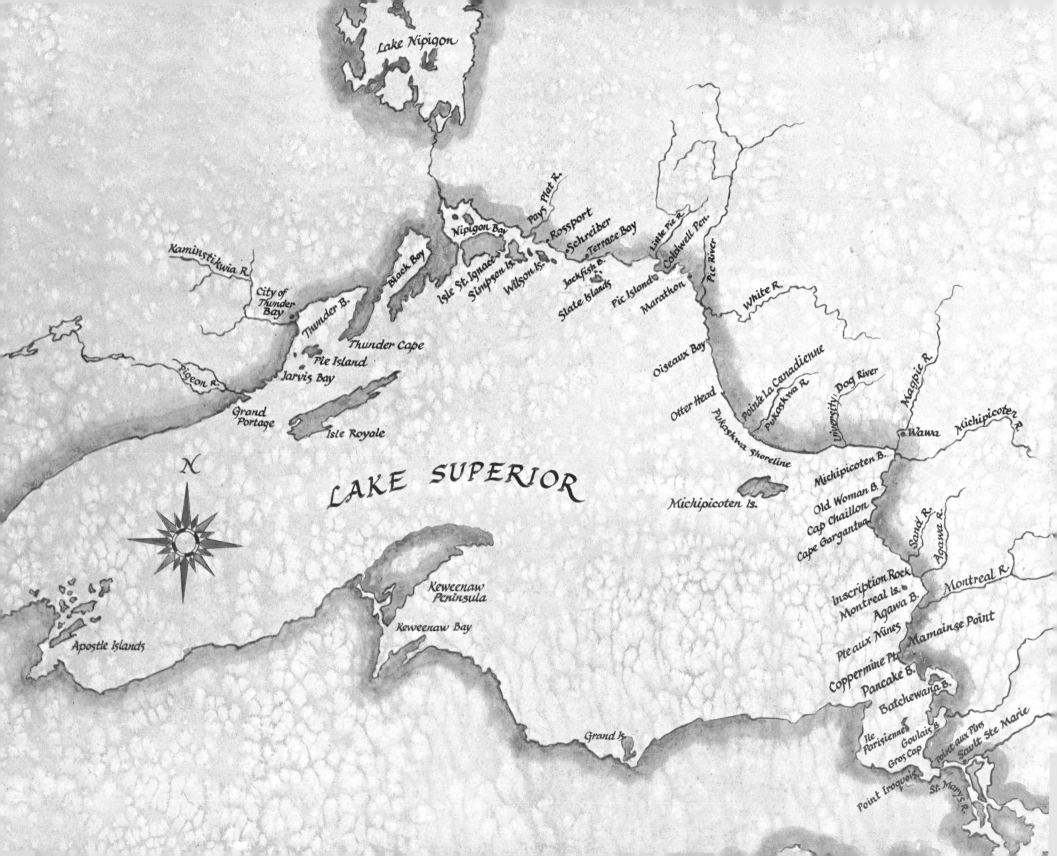

Introduction

Many North Americans know at first hand the region that is the subject of this book. Every summer thousands of travellers journey northward from Sault Ste. Marie, following the old route of the fur trade canoes past Batchawana, Agawa, and Michipicoten westward to the Pic River, west again past Nipigon and Thunder bays, then south and across the border to Grand Portage. Those who have travelled these 450 miles of Superior's north shore are already acquainted with the splendour of the region, and with its dramatic contrasts.

We have found two of these contrasts especially haunting, and they recur as themes throughout our book. The first is the co-existence of power and fragility—of the immensity of landscape on the one hand, and the astonishing resiliency of delicate plant and animal life on the other. The second is the humbling insignificance of the human record as the rocks of Lake Superior reveal it—ten restless millennia against three billion somber years of endurance.

We have travelled far together in preparing this book. As often as possible, our journeys have been by canoe along the north shore of Superior itself. Our respect for the region and its people, high when we began, grew as we proceeded. From the outset we knew that a plea for the integrity of the wilderness would be inherent in our work, for we consider the wild places to be the birthright of those who will travel after us.

United in essentials, we therefore chose to work individually during the writing and the final selection of photographs, rather than striving for an integration which could easily become contrived and artificial. That is why the photographs present the natural beauty of the shore, while the theme of the text is human transience. We believe that if any synthesis is required it will occur in the imagination of the reader, and we are content to leave the difference as it stands, feeling that it is appropriate to the generative tension of the wilderness out of which it grew.

Bruce Litteljohn
Wayland Drew
1975

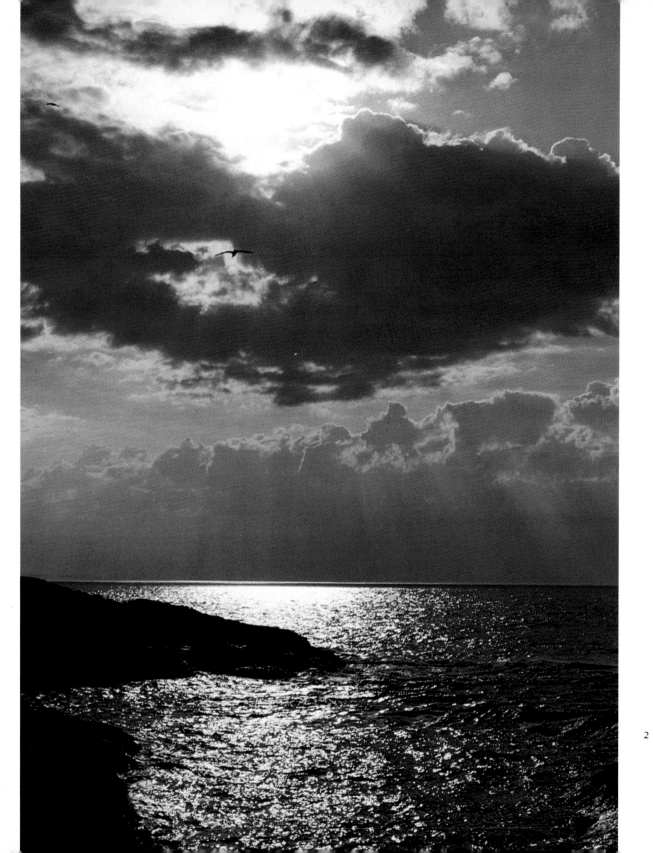

2

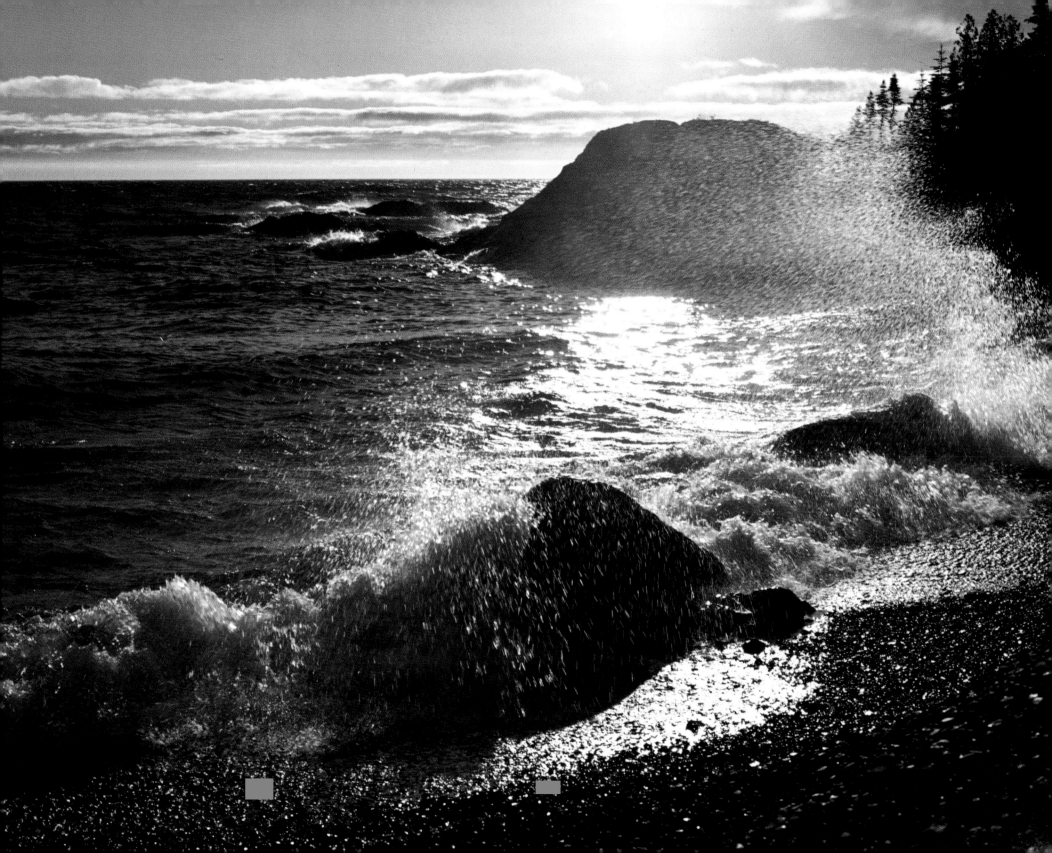

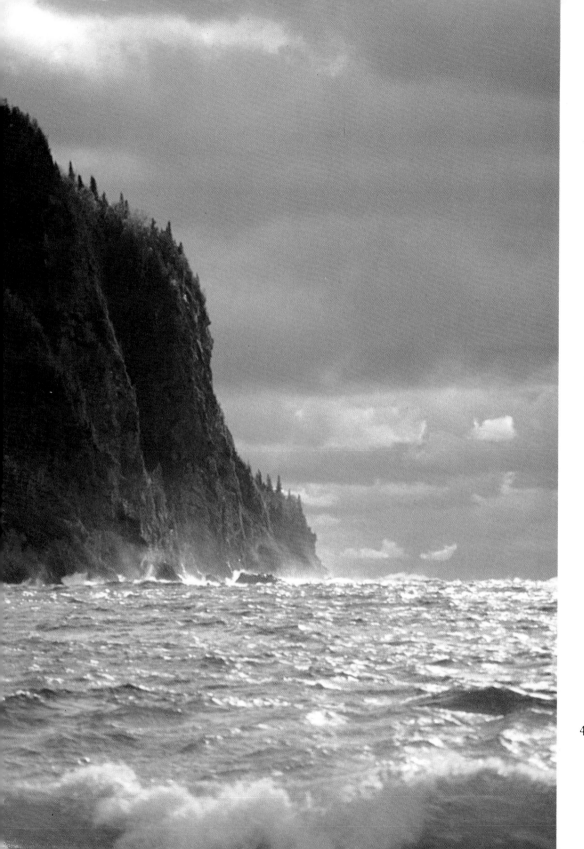

4

5

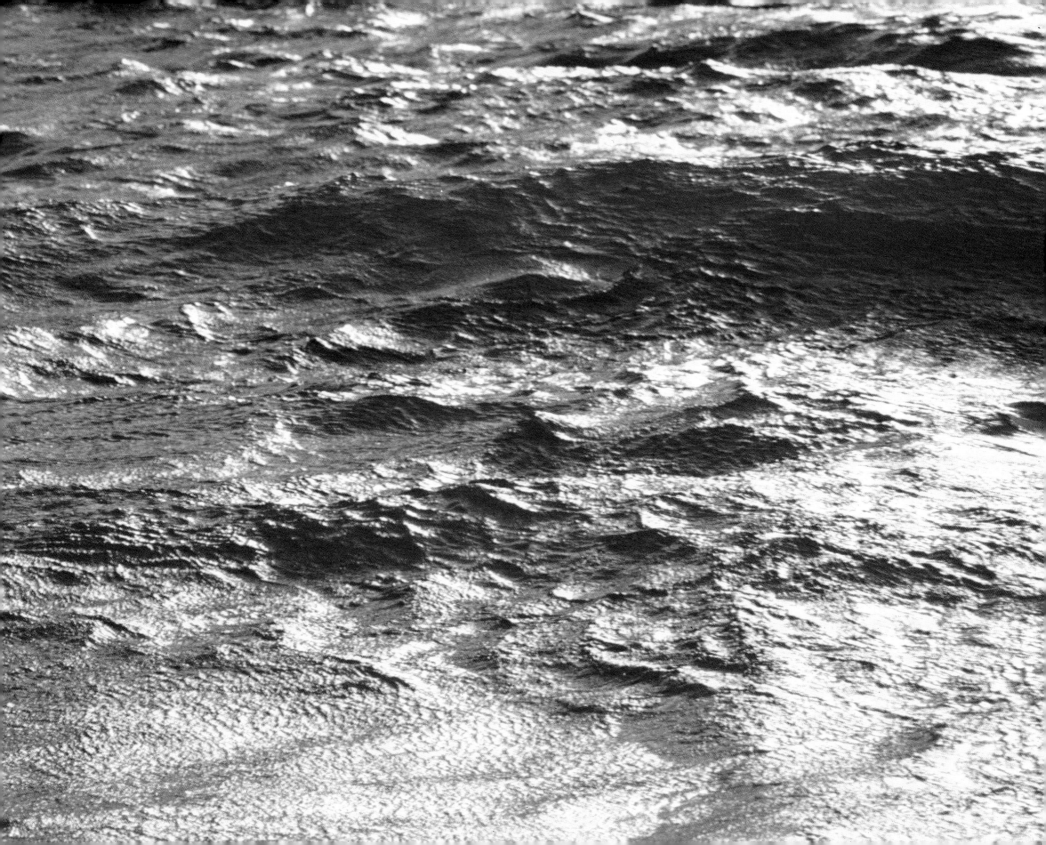

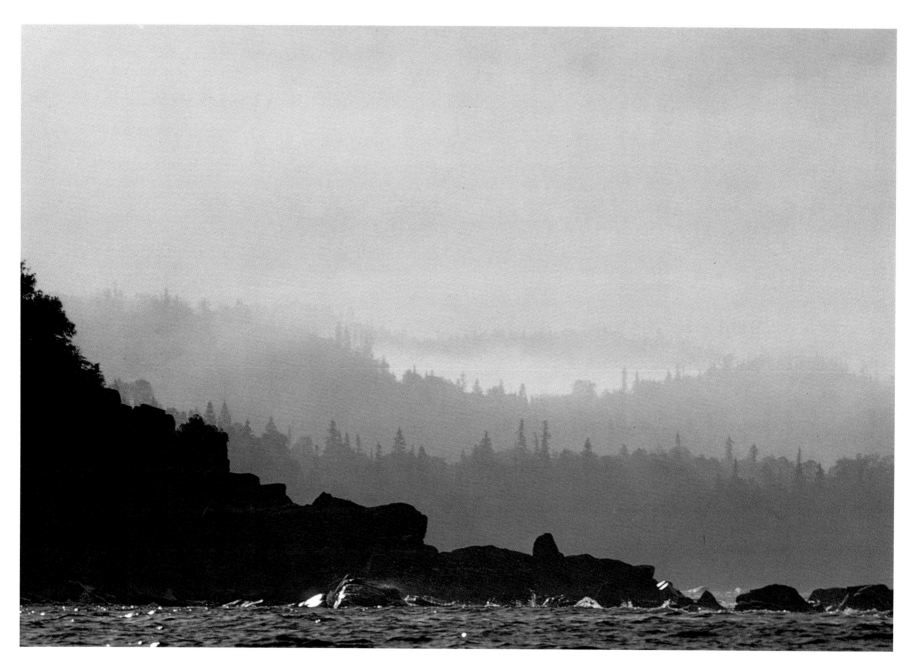

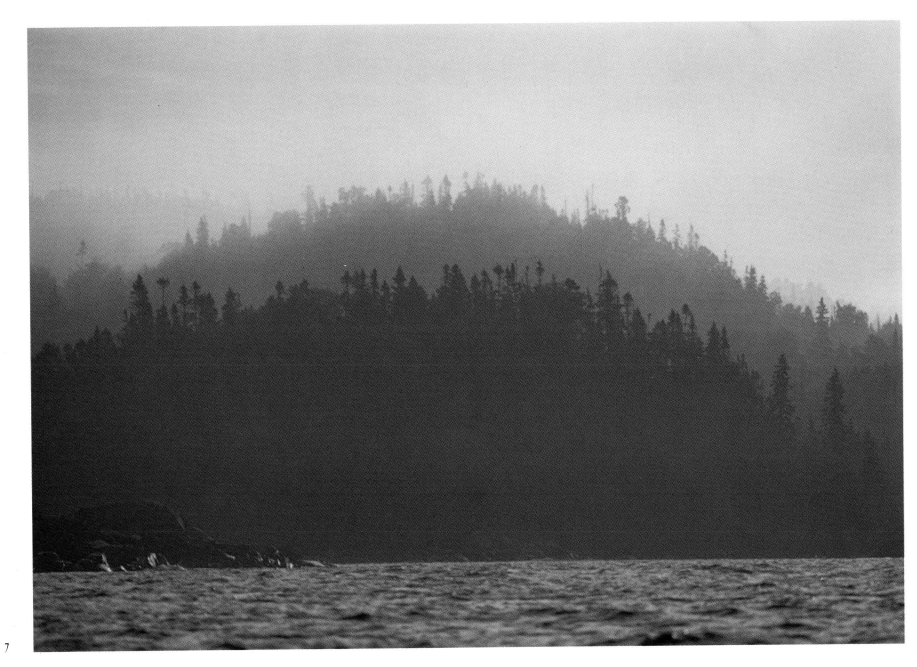

7

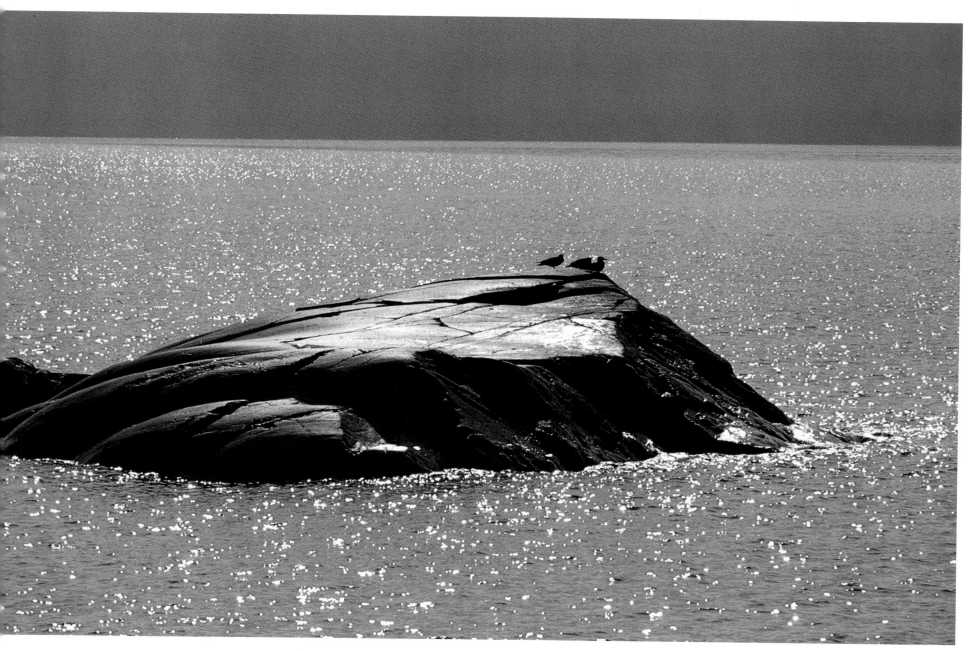

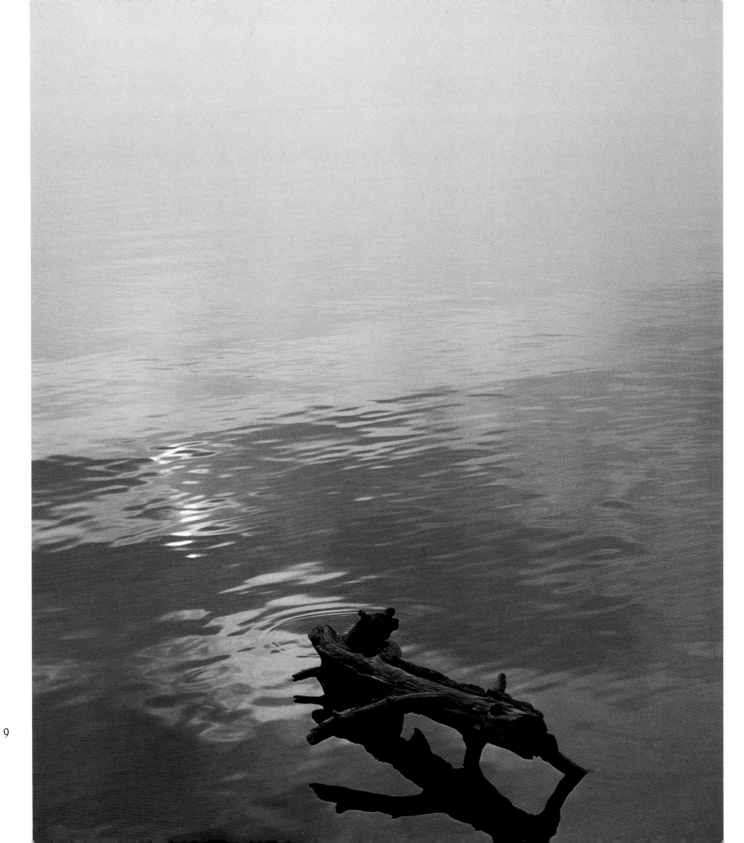

9

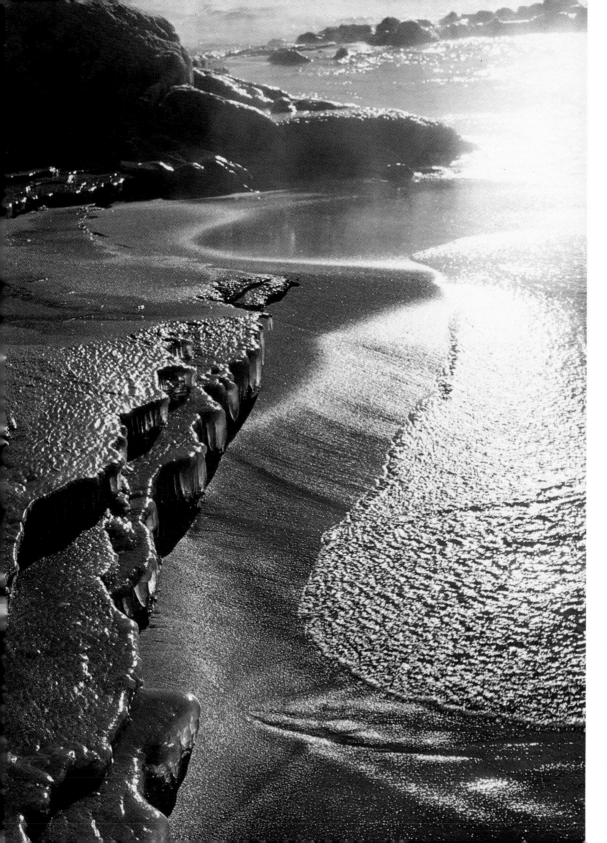

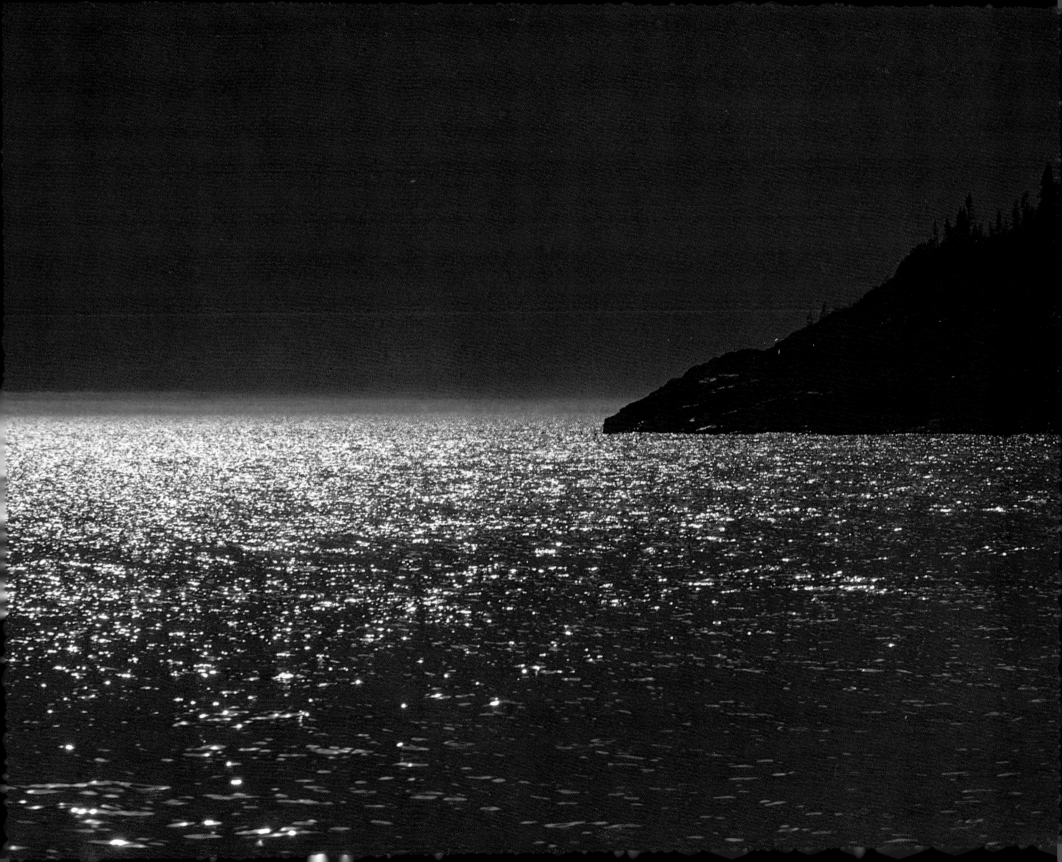

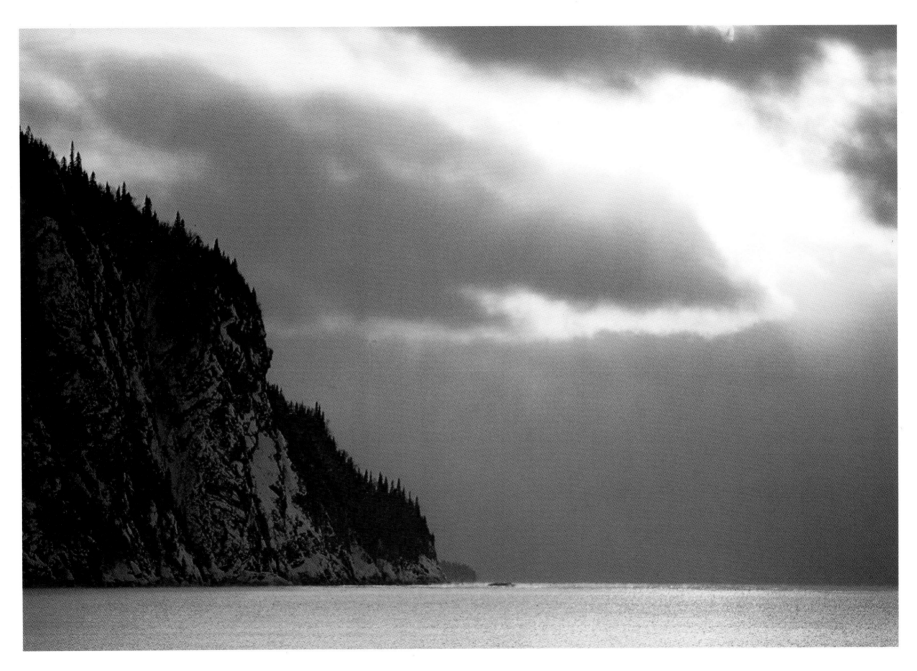

12

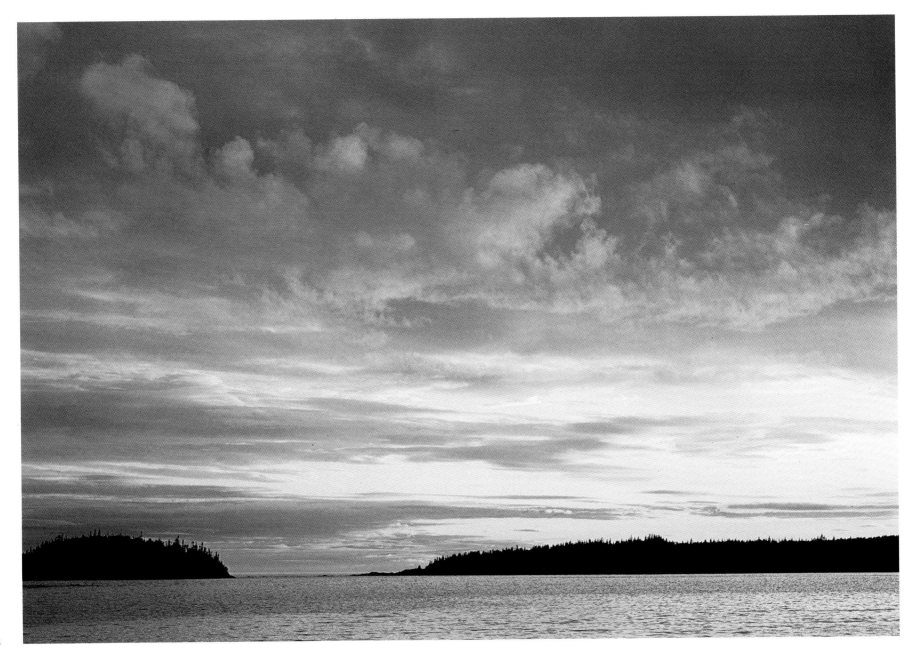

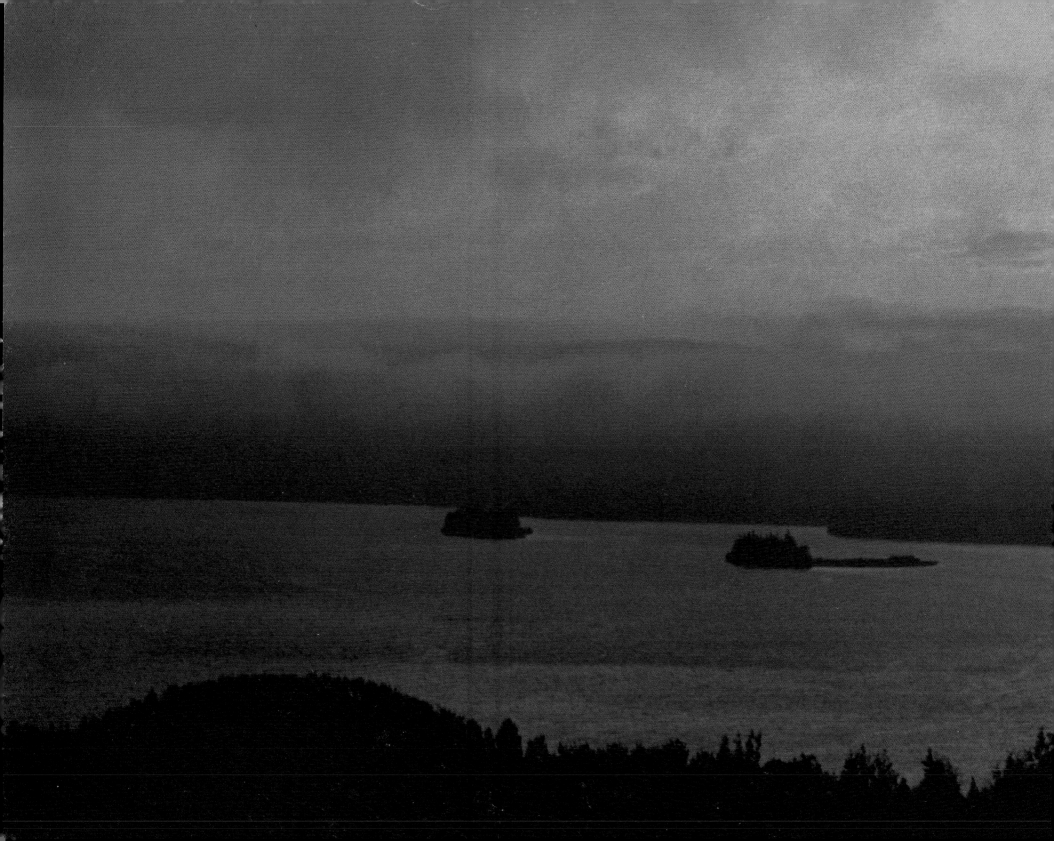

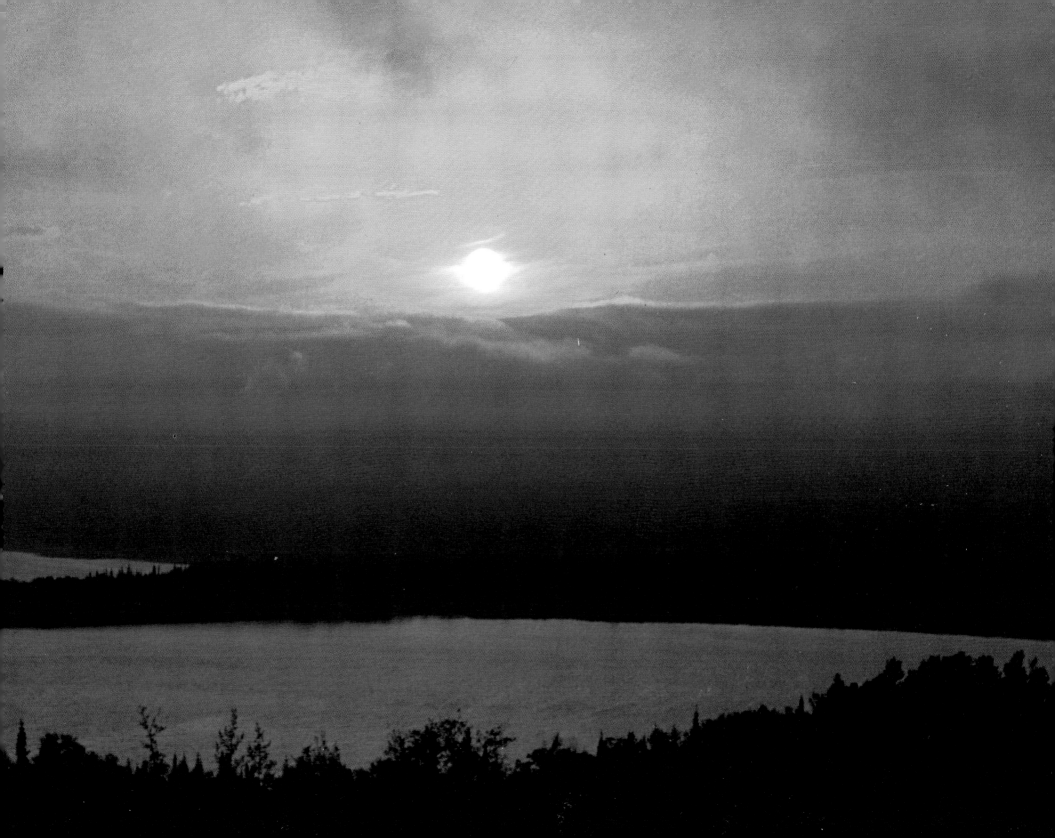

Some may say that I gossip a little.
This possibly may be so. It has
happened to the wisest of men when
beguiled by an agreeable theme.

Dr. John J. Bigsby, *The Shoe and Canoe*, 1850

Thirteen thousand years ago, the bowl in which Lake Superior now lies was covered by the last of the great glaciers, the Wisconsin, a translucent mass of ice so immense that its slightest movement powdered the granite beneath it. Slowly as it melted, changing the shape of the land and the drainage patterns, it formed lakes of various depths and extents, some of which carved the beaches which may be seen high above the present shore. This process of rearrangement took many thousands of years and is, in fact, still continuing; for the north shore of the lake, freed of the tremendous weight of ice which once compressed it, is rising at the rate of eighteen inches every century.

About ten thousand years ago man first came to the shore, hunting the game that browsed on new growth behind the receding glacier. For eight thousand years more there would be no history, no written record, although there would be a record of a different kind, a record that so far remains scanty, mute, and enigmatic. It begins with the earliest artifacts yet discovered—leaf-shaped flint and taconite blades from Pass Lake on the Sibley Peninsula, crafted when mastodons roamed the area and when immense elk bellowed in the mists of the lake. It continues with polished axes and chisels, with harpoons, gaffs, ornaments and implements of native copper, and with objects of less certain use—smooth "birdstones", and "bannerstones" which might have weighted spear-throwers. Centuries after Indian women had begun to shape and fire their pottery, each cording it and inscribing it in her personal manner, history had still not come to the shores of the lake, and many generations would live and die before the first white travellers arrived, carrying a new view of time and a new insistence on continuity.

Like their ancestors, those people who welcomed the French had not suffered from the lack of history. They were neither ignorant, nor improvident, nor slothful. There was no impediment in their memory, and nothing haphazard in their uses of myth. They remembered well; and when personal recollection faltered, legend endured, legend that was cherished and refurbished from one generation to the next. Theirs was a rich racial memory woven into the land by a sense of timelessness, of season, and of cycle.

Long before it arrived, in 1622, these people would

have heard rumours of what was coming, gathering at Hochelaga for the leap across Lakes Simcoe and Huron to the rapids at Bawating. They would have known by the swift telegraphy of the north that strange men would appear, men with sallow skins, and beards, and hard, rude gazes. Along the Huron trade routes, through the Ottawa, through the Ojibway, west to the Dakota, and north to the Cree, news of these strangers, so like the legendary white giants of the north, would have spread swiftly and accurately in the soft inflections of the tribes.

At first, except for some irregularity in the trade for Huron grains, there was probably no disruption in life west of the rapids and the Ojibway village of Bawating. The old cycles would have continued as before. In the calm of autumn the women would harvest wild rice, overshadowed by hillsides already changing colour. Around Batchawana on the east and Pine Bay on the west, they would see the orange, red, and yellow umbrellas of maple and elm begin to blossom out of the surrounding green. Farther north the only colour amidst the fir would be the boreal striations of yellow poplar, angling like *cuestas* until they vanished in the mist. All along the shore the ducks would be flying, and the lazy serrated arrowheads of geese would be probing south. As usual in autumn, at Michipicoten and Pigeon Bay, the tree limbs would bow under masses of pigeons, and the hunters, slipping through the cover behind the beach, would have easy shooting.

But this bounty would not last. Soon would come the frosts of late September and mornings when one would turn back the lodge door on a still, cold clearing. It would be time then to part with friends, and to leave many—the very old and the sick—for the last time.

The bands would separate. Families would venture out on the lake bearing with them all that was valuable, all the fruits of their hunting, winnowing, and preserving, and all the products of their craftsmanship. In the low warmth of Indian summer they would follow the shore northwest to their chosen river, and either camp at its mouth or continue inland over the portages to the place where, with good fortune, the hunting might prove sufficient.

In November, winter would close in. One morning the frost would not melt away, but before evening would be thickened by snow and then by more snow. Squalls would become storms that lasted for many days, furious storms that whipped the lake as if to cleanse it of all human flotsam. Sometimes waves seventy feet high would surge over islands and shatter upon the beaches in thousands of tons of ice and water.

Snowshoe moon, spirit moon, long moon—month by month Peboan, the winter, would fasten himself deeper into the crevices of the shore with massive talons. On some nights ice and rocks would crack repeatedly, echoing down the shore like the thudding of erratic drums. In the depth of winter the lake itself would be frozen so far out that a man would have to strain his eyes, peering through bark goggles against the sun to discern the lift and breaking of even the largest wave, or to catch that delicate tracery which was the movement of caribou among the islands. Children would whirl their bull-roarers then, and make snowmen and snowhares to draw Keewaydin, the hunting wind. There would be times of marvelous good fortune when the frozen meat would be dragged home on toboggans, and other times when the spectre of Wendigo, the cannibal, embodiment of dread and famine, circled close.

Yet, even then there would be room for laughter in the lodges, and for grandmother, Nokomis, to gather the children close, narrow her eyes against the smoke, and tell the old stories of Nanabozho, endlessly embellished. Winter was the time for stories, when the animal *manitos* slept and would not hear themselves spoken of, and when there was no danger—Nokomis would say—of monster snakes and frogs emerging from their swamps and pursuing her, the daring storyteller. On nights when the wind howled outside the wigwam, infants lay on the cradleboards watching

charms sway in the firelight, and older children played with sweetgrass dolls whose bodies were redolent of life and promise, and heard again how godlike Nanabozho stole fire for man from the summit of Animikie-wakchu, and how, human and ridiculous, he had scorched his bottom with that same fire.

This was not history, but life: layers of remembered life like wafers of shale, sinking limpidly into myth as if into the lake itself. Grandmothers were its repositories, having grown large enough and deep enough to contain it in all its horror and beauty, its joy, its agony and triumph. Theirs was the duty to show how to recollect, and how to comprehend what had been recalled so that it might be regenerated for as long as people lived on the borders of the lake.

By mid-April, the snow would begin to melt off the southern exposures, dripping down into icicles that first fattened night by night, then thinned into palisades of glassy needles. Swelling up over the ice dams, the rivers would begin to boil once more into the lake—the Agawa, the Michipicoten, the Pukaskwa, the Aguasabon, and the Kaministikwia—two hundred altogether, and with them countless unnamed streams and rivulets. Gulls would circle above the fan-shaped openings at the rivers' mouths, and behind them would come the ducks—grebes, mallards, scoters, and mergansers. Then geese would begin settling in the marshes of the great bays, and the cycle of plenty would start again.

One by one the winter camps would be abandoned with whatever had been worn out or broken. New burial pallets would be left in the trees. The canoes would be freshly gummed and stitched with *wattap*, loaded with the belongings of those who now composed the family, and pointed south toward Batchawana. All down the shore the phratries would be gathering—the Awausee, the Businausee, the Ahahwe, the Noka, and the Mousonee—all those affiliations which made up the Ojibway nation.

A new year began. For the French at Hochelaga it was the spring of 1622; but for those who sat in the waists of the canoes among the furs and the packs of bark and rawhide, the year had not yet earned a name. It was simply the renewal of life and the reknitting of society, and it would require time, like a boy growing to manhood, before it could take its character.

The first of the year's festivals was the harvest of maple syrup. In late April the sap would be running behind the great bays north of Bawating—Goulais, Batchawana, Agawa, Old Woman, and Michipicoten—and families would journey to their traditional locations. Each kept a storehouse for utensils, left in place year after year, and each would tap several hundred trees. Boiled down in a factory-residence constructed for the purpose, the precious sugar would be poured for storage into birchbark cones, sometimes elaborately ornamented in keeping with the festive spirit. For the first time in months food was easily obtainable—calorie-rich and delicious food—and the combination of mellow weather, rejuvenating energies, and renewed friendships marked the beginning of the long and careless summer.

That spring, however, the first Huron traders to pass northward would bring disquieting news. Gossiping beside the fires and the bulging hide reservoirs of sap, they would tell of the white men who were even then approaching, asking strange questions, driven by some vision of a shoreless sea. Perhaps, laughing in the smoke and the steam, the Hurons would suggest to their friends that they would be wise always to say what the white men longed to hear; or to say, keeping safe: "Yes. . . . Perhaps. . . . No one knows for certain." Then the Hurons would be gone northward, their canoes passing swiftly into the fog; and the Ojibway would be left to murmur among themselves and to glance south along a coast less secure than it had been before.

When the sap flow ceased, the families converged on Bawating for the summer-long harvesting of whitefish. They swelled the tiny village there into a twin-lobed camp that sprawled along both sides of the mile of white water. At the

foot of the rapids the *attikumaig* milled in such numbers that at any time the canoes could be poled among them and the wattap nets could dip them out for smoking. All summer the fires would smoke under racks heavy with fish, and the preserved carcasses would be stored with berries, caribou meat, and tubers from the nearby lowlands. All summer there would be an abundance of food at Bawating, as there had always been.

It was a loosely organized community, far different from the palisaded gardens of Huronia, or from the Mohawk longhouses, arranged like lozenges on their green fields. Without undue formality, the essential work of government and social continuity would get done at Bawating during the summer. New partnerships would be formed, new agreements sealed, new liaisons accomplished, new wives acquired, and new leaders tested by hunt and battle. There would be time for display, for feasting, many games, and much sport. The women would laugh and gossip at their work and the listening girls would be filled like reservoirs with the soft Ojibway ways of womanhood. Among the older boys, a favourite sport would be to jog up to the head of the rapid carrying one's canoe, and then to launch out into the current and sweep down, competing, learning, showing off. For the men, the annual gatherings provided a vital forum for keeping aware of the resources of the land, and an intricate set of social mechanisms for regulating population.

After the summer of 1622, when the white man's time entered the lake and began to germinate, these social relationships changed in small but significant ways. The ebb and flow of commerce on the lake would be more restless and less predictable than ever before, and the people of the lake would be harassed by new and insidious possibilities. In this new time the old checks and balances would be swiftly destroyed, and a delicate culture would succumb to a virulence against which it had no defences.

The first European to arrive was Étienne Brûlé,
Champlain's prime scout, dispatched westward to test Lescarbot's theory from Herodotus: that "the great river of Canada", like the Nile, flowed in two directions from its source, and led across the continent into the southern sea. After the battle near Sorel in 1610 Brûlé had been sent home with the Huron allies. He was about seventeen. One can imagine him returning a conqueror to the walled towns, becoming agreeably licentious in the Huron manner, but yearning still to find that oriental route which the Indians assured him was there, across their great lake and beyond the rapids. He was a tough man, a loner, a renegade even then. Perhaps he was chosen for some cold flame that the shrewd Champlain detected in him. Unfortunately, we have no picture of his eyes; by 1622, after the skirmishes and the wilderness winters, after the journey to the Susquehanna and the Iroquois ravaging of his fingers and face, they would have been cynical indeed, these thirty-year-old eyes; cynical and cold, the eyes of a man at the limits of life, caring less for fame or fortune, for God or king, country or woman, than for the moment when the canoe's prow tipped toward the rapid, or the Mohawk brave rose up from his ambush—the moment when life, never more imperilled, was never more intense.

Within a decade he would be dead in a Huron brawl—killed and eaten, according to reports—and the Récollet priest du Creux would write his epitaph: "Long a transgressor of the laws of God and man ..." Before his death, turned traitorous, he would receive Champlain's curse as he had once received his blessing: "... whatever happens, you will always have a worm gnawing at your conscience...."

One morning early in that summer of 1622, Brûlé would rise out of his sleeping-robe somewhere on the north shore of Lake Huron, in the area of which a cartographer would write thirty-three years later, "Toute cette coste n'est pas connue." Perhaps it would be at Thessalon, or at Pallideau Island, or at Campement d'Ours. He would be

clothed in deerskins dark with sweat and smoke. He might wash perfunctorily before placing his hat over his eyes to shut out the hot gleam of morning. He would grunt his thanks for the strip of dried meat handed to him. His party would eat in silence, backs to the sun; and when they had finished there might be time enough for a pipe and a bit of the talk that occurs among friends who have travelled considerable distances in the wilderness and who were together still, despite rapids and storms and Iroquois. Perhaps the Huron leader would lift his chin to the west and say that in the afternoon they would reach *Skia-e*, Bawating, and Brûlé would gaze west to the horizon beyond which he might still find the lanterned cities.

Then they would paddle—three or four craft in a shifting line close to shore, perhaps a dozen men whose kit and foodpacks were so light that they scarcely ballasted the canoes, scarcely kept the bark hulls from trembling in the current that rippled under them. Close to shore: through the screen of islands southeast of Maskinonge, up the Neebish gut, past the Bar River and Squirrel Island. One can imagine other canoes approaching, appraising looks, courses warily converging, calls across the water. One can imagine the pace slowing as the river narrowed and the current increased, the paddlers silent and bending hard to their work. And, in the vagaries of the breeze moving across the promontories, one can imagine how the sound of the rapids first came to them, unclearly, so that Brûlé would have turned his head to listen. Half a mile closer there could be no mistaking the sound, like a strong and steady wind, and rounding Point Nolan they would have caught the first glimpses of white water. One can imagine the little flotilla moving then into rough line abreast, the pace slowing almost to an idle so as not to seem presumptuous to those people whose lodges could now be seen along the banks and on the island in the centre of the river.

So they would have come, strange and startling despite their precautions, their rounded prows so like those of the Iroquois. One imagines a clamour among the dogs and a silence among the people, the women straightening slowly at the cookfires, the men moving out to see and to be seen, the young canoeists in the rapids veering for shore. For a moment there would have been no sound except for the dogs and the waters from Lake Superior, dropping in white stages across their terraces. Brûlé, his musket beneath the gunwale and his paddle across his knees, would have assessed the movement of the Ojibway braves; or wondered whether he had enough needles and star beads to impress the wives of the chief men. Then the Huron leader would rise and speak, meeting all standards of protocol. The canoes would be invited in, the dogs placated, and Étienne Brûlé would step ashore.

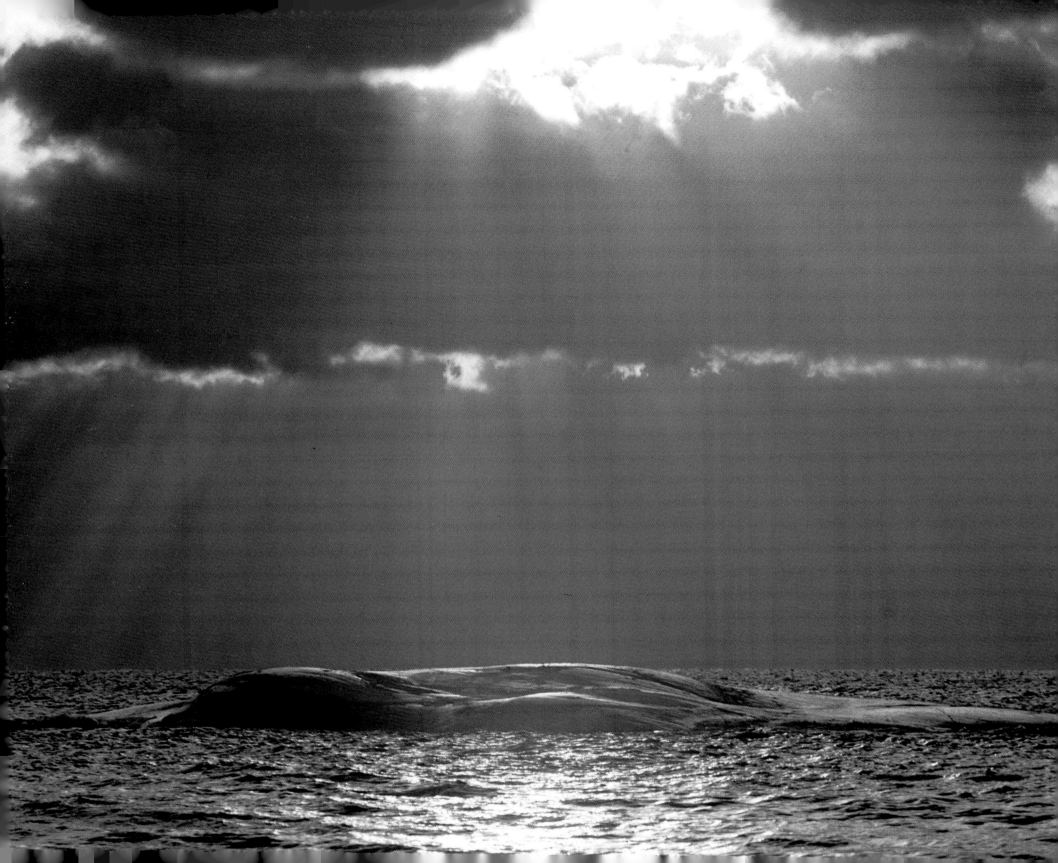

The savages say that it was (Nanabozho)
who taught their ancestors to fish, that he
invented nets, and that he took the notion
of them from the spider's web. These
people, as you see . . . do not give
greater honour to their God than he
deserves, since they are not afraid of
sending him to school to a vile insect.

Pierre de Charlevoix, *Journal*, 1761

The Ojibway have many legends about Bawating—how the shores of the lake were held together there by the magical singing and dancing of the Great Fisher, or how the rapids were made by beavers breaking down a boulder dam. Some say that the spirits of women who have died at that place inhabit the whitefish, and that it is their singing one hears in the rapids.

As one of the twenty-seven stops made by the Anishinabeg, "the old people", on their migration from the east, Bawating was sacred in Ojibway mythology. To this place the Anishinabeg followed the *migis*, the white sea-shell, and united here for the last time they received the blessings of the manitos before dispersing around the borders of the lake. Besides serving political and economic functions, therefore, the annual gatherings at Bawating had strong religious undertones.

Priests of several sects practised among the villagers. The most orthodox were members of the Midewiwin, a secret and intricate society of several degrees emphasizing ritual and tradition. Older and less codified was the craft of the Mashkikike, the herbalists. Usually these were women, for the generative correspondences between women and the earth were recognized and respected by the Ojibway. From the Mashkikike it was possible to purchase curatives of all descriptions; a few specialized in poisons and love potions, although their motivation was generally benevolent. The most ambivalent shamans were the Wabenos, elusive figures who appear in the journals of early travellers, presiding at night-long feasts and coating themselves with unguents in order to perform dangerous tricks with fire. Many reports of the Wabenos emphasize their pernicious and baleful influence. The Jessakkids, on the other hand, were much more dependable. They were doctors capable of isolating evil spirits and sucking them from the body through long straws. They were also seers whose spiritual ancestors had been granted unique power by the thunderbirds. Through them the fundamental spirit of the earth, symbolized by the Great Turtle on whose back all land rested, made his wishes known. This sense of identification with the spirit on which natural processes depended caused the Jessakkids to resist missionary advances more stubbornly than any other group of shamans.

Christianity was not long in coming to the lake. After his stay at Bawating, Brûlé travelled farther west, perhaps to Michipicoten Island, perhaps to Keweenaw or to Isle Royale, perhaps as far as Grand Portage. In any case, when he and his friend Grenoble met Father Sagard later that year, Brûlé showed the priest a lump of native copper taken from a lode somewhere beyond the rapids. Sagard duly recorded the event.

Entering the lake for the first time, several years later, Father Claude Allouez also commented on the burnished lumps of copper to be discovered there:

I have several times seen such pieces in the Savages' hands; and since they are superstitious, they keep them as so many divinities, or as presents which the gods dwelling beneath the water have given them, and on which their welfare is to depend. For this reason they preserve these pieces of copper, wrapped up, among their most precious possessions. Some have kept them for more than fifty years; others have had them in their families from time immemorial, and cherish them as household gods.

The Ojibway word for a talisman is *nigouimes*, and amulets of special significance were often worn around the neck in a *pinjigosan*, or medicine bag. Perhaps Brûlé carried his piece of copper in this manner, dangling on his chest with his Agnus Dei.

Father Allouez represented the consolidation of the Jesuit empire in the region. Before him had come Fathers Isaac Jogues, Charles Raymbault, and René Menard, and after him would follow a procession of other missionaries: Nicholas, Marquette, Dablon, Drouillette, and André among them. All found the mission of Sainte Marie du Sault a place "very advantageous in which to perform Apostolic functions, since it is the great resort of most of the Savages of these regions, and lies in the most universal route of all who go down to the French settlements." On his first trip, Allouez would not stay long in the Sault. He would scoff at the presumption of the Indians who thought they could catch fish in the rapids just by casting nets, and then he would proceed up the lake which he chose to call Tracy after the Marquis, Alexandre de Prouville, who had shortly before levelled the Mohawk villages and guaranteed the safety of New France. Vicar-general of western missions, Allouez would serve for a quarter of a century in the region and baptize 10,000 Indians. He would also be the first white man to circumnavigate the lake, and he would assist in drawing an accurate map of it in 1672.

For a time, all along the front of contact, the white man's antics must have been a source of much amusement to the Indians. Sault Ste. Marie had nothing which could rival in sheer bravado the performance of Jean Nicolet. Landing on the west shore of Lake Michigan, Nicolet was so certain that he had reached the Orient that he donned a damask robe brought for the occasion, fired a salute from a brace of horse-pistols, and advanced ceremoniously on a party of astonished Winnebagos. But early in its history Sault Ste. Marie did have a strange and colorful pageant. On the fourth of June 1671, Simon-Francis Daumont, Sieur de Saint Lusson, took possession there of all North America west of Montreal in the name of Louis XIV. He did this simply by summoning the Indians and hoisting the King's standard, together with an enormous cross, "with all the pomp that he could devise". Hymns were sung, volleys fired, and Louis XIV—ruler of lands his subjects had never seen and of peoples no Frenchman had met—was cheered and eulogized. Claude Dablon, a Jesuit who observed the pageant admiringly, reported that it was received with "the delight and astonishment of all those people, who had never seen anything of the kind", and that the Indians were left literally speechless.

The son of one of de Lusson's retainers was more circumspect in his claims and more successful in holding them. Jean-Baptiste Cadotte was one of the first settlers on a seigniory granted by Governor Jonquière to Sieurs de Repentigny and de Miselle. In 1756 he married Anastasie, the

daughter of the chief of the Awausee clan, in both Catholic and Ojibway ceremonies, and he stayed on to prosper despite the Battle of the Plains of Abraham, which gave control of Canada to the English. After that battle and the departure of de Repentigny and de Miselle, Cadotte assumed ownership of a substantial fort and eighteen square miles on the south bank of the river. Here Alexander Henry found him in 1764, after accompanying Madame Cadotte from Michilimackinac, and here the two men formed a sound partnership which would send Henry voyaging robustly around the lake. Cadotte would live almost forty years more, long enough to see his land claims disallowed by the fledgling American government, but not long enough to witness, in July 1813, the burning of the *Perseverance* and the pillage of the Nor'Westers' post by marauding Yankees.

With the North West Company the history of Lake Superior's north shore as a commercial zone properly begins. During the late seventeenth and early eighteenth centuries the French had established trading posts around the shore—at Thunder Bay in 1679, at Nipigon in the same year, at Michipicoten in 1725, and at the Pic a little later. These posts, however, were kept by independent traders, weakened by competition and by the uncertainties of trade routes. Their buildings were probably only slightly more stout than those of their Ojibway customers, and their way of operating, involving as it did much travel and many risks, was closer to the Indians' than to that of the tough commercial enterprises which followed them. In fact, the French temperament was generally much closer to the Indians' than was the English, a difference noted by William Warren in his *History of the Ojibways*:

Their aim was not so much that of gain as of pleasure, and the enjoyment of present life, and mainly in this respect will be found the difference between the nature of their intercourse with the natives of America, and that which has since been carried on by the English and Americans, who, as a general truth, have made Mammon their God, and have looked on the Indian but as a tool or means of obtaining riches, and other equally mercenary ends. In their lack of care for the morrow, which in a measure characterized the French 'voyageur', and in their continual effervescence of animal spirits, open-heartedness, and joviality, they agreed fully with the like characteristics possessed by the Ojibways.

The North West Company, on the other hand, cared very much for the morrow. A cartel of seasoned traders, some of whom had been wintering in the *pays d'en haut* before 1760, the Company channelled the energies and expertise of all its people, fusing French zest and flexibility to granitic Scottish loyalty. One by one it absorbed the free traders who had previously worked on Lake Superior—Chabouillez, des Rivières, Blondeau, and Campeau—until in 1787, by bullying and intimidating competitors it could not buy, it dominated the trade on Superior and to the northwest. For almost half a century it would maintain its prominence despite challenges from the XY Company, the Hudson's Bay Company, and the American Fur Company. Like all successful commercial endeavours, it flourished by wearing blinkers, by eliminating the moral peripheral vision that leads to questioning, doubt, hesitation, and stasis. Its raison d'être was simple: profit. And profit came from furs. A few Nor'Westers, like Roderic McKenzie, David Thompson, and Daniel Harmon, were aware of the harm their trade was doing to Indian cultures and tried to cushion its impact; but in general the North West Company in its prime was no place for sensitive spirits.

On 10 August 1798, several Ojibway chiefs and elders sat down at Sault Ste. Marie to sign an agreement with the merchants from Montreal. On one side of the table were men with names like Melosake, Sirain, and Kakonse. They emerge only briefly from anonymity. Opposite them sat figures well known to Canadian history for their entrepreneurial skill and organizational ability—Simon McTavish, Joseph Frobisher, John Gregory, William McGillivray, and Alexander Mackenzie. The Nor'Westers were anxious to le-

galize their claim to the north bank of the river. For several years they had maintained a post at the foot of the rapids, and the previous season they had begun construction of a canal half a mile long and wide enough for their *canots du maitre* to be locked up the twenty-two feet of rise and into Lake Superior. The agreement which was made that day concerned a block of one hundred square miles of land adjoining the St. Marys River, from "Grass Point or Maguatuonagans", for ten miles west to Mitamigne Oshiuk, to "a large pine about five hundred yards above the extremity of said Pine Point . . ." For this block of land on which the Canadian city of Sault Ste. Marie now stands, the Nor'Westers paid two pounds, as well as "divers other goods . . . and valuable considerations . . ."

Today, the most prominent remnant of the Nor'Wester régime at the Sault is the dwelling of Charles Oakes Ermatinger, one of the last partners. Like many of his colleagues, Ermatinger married an Ojibway girl, Charlotte Kattawabide, but in other respects his life was very different from that of the average winterer. He settled very comfortably in Sault Ste. Marie. On the north bank he 'built a massive stone house where he lived "in a kind of grand manorial style, with his servants and horses and hounds, and gave hospitable dinners in those days when it was the fashion for the host to do his best to drink his guests under the table." Guests of Ermatinger in the last week of July 1816, Lord Selkirk and Miles Macdonell laid their hurried plans for the seizure of Fort William. Ermatinger's house has been reconstructed and refurbished as a museum. It has seen much worse times; when William Cullen Bryant visited it in 1846 he found that "the old splendor of the place" had departed, and that it was occupied "by a Scotch farmer of the name of Wilson".

Much of the old splendour of the Sault in general had departed by 1846. The Hudson's Bay Company, which acquired the Nor'Wester site in the 1821 merger of the companies, still maintained a stockaded post, its walk neatly gravelled and the whole bearing, as Bryant said, "the marks of British solidity and precision". But the functions of the Sault were changing rapidly; it was no longer a frontier entrepôt and religious centre. Settlers were arriving; civilization was closing in; and the aura of the wilderness was fading, never to return. There were still fishing encampments on Whitefish Island and in other places along the shore, but the village no longer belonged to the Indians. They had become visitors less welcomed than tolerated. In 1822, Fort Brady had been built on the south bank despite strong Indian protests, and after one ugly confrontation with white authority, the Ojibway wife of John Johnston, a prominent trader, urged her people to bow to the inevitable. Finally, they ceded the land for the fort in return for the empty pledge of perpetual fishing rights. In 1844, while excavating for the first large canal, the contractor Charles Harvey dug through an Ojibway cemetery with impunity. There were likely many grave houses standing at the time, delicate and unobtrusive cedar structures which William Cullen Bryant referred to as dog kennels.

Like Anna Jameson and other genteel visitors, Bryant wanted to shoot the rapids in a canoe, but he could find no Indians sober enough to paddle him; instead he talked to a citizen who told him of plans to rig a huge seine across the outflow, a net that would scoop 100 barrels of whitefish from the river every day. Suddenly, around 1850, fish catches declined so that there was no longer enough for everyone, and very quickly thereafter the city tightened its grip on the rapids, narrowing them, poisoning them, dredging away the islands, building canals and floodgates until not an inch of the river's flow remained unregulated and there was no more fishing for *attikumaig*. "The propinquity of the white man is destructive to the red man," Anna Jameson observed with unconscious irony, "and the further the Indians are removed from us the better for them." In 1890, having become impediments to the construction of yet another canal, the last resident Ojibways were moved from

Whitefish Island.

Despite European encroachment, the Indians had managed largely to retain their nomadic way of life throughout the seventeenth and eighteenth centuries. But as the forests fell, the game decreased, and white settlements consolidated and expanded, their prospects changed drastically. Never easy, life grew more difficult in ominous ways. Grim new plagues spread death among the lodges, and the white man's alcohol was always close at hand—that burning magic which brought cherished visions closer, gave illusions of peace and manliness, and for a little time took away the ache of incomprehensible failure.

By 1850, the pressure towards reserves had grown inexorably on the people of the lake, and in that year the Ojibway, amicable by temperament and softened by two centuries of white friendship, understood that they would have nothing at all if they did not accept what had been reserved for them. One by one, the chiefs made their marks on the Robinson Treaty: Mishe-Muckqua, Totomenai, Ahmutchi-Wagabow, Manitou-shanise. . . . "I explained to the chiefs," wrote William Robinson when his job was done, "[that] . . . the lands now ceded were notoriously barren and sterile, and will in all probability never be settled except in a few localities by mining companies, whose establishments among the Indians, instead of being prejudicial, would prove a great benefit as they would afford a market for any things they may have to sell. . . ." By the time it was advertising for settlers in 1885, the Sault *Pioneer* could boast of Algoma District, "there is no troublesome Indians nor other dangerous element in its population."

No one reveals the Ojibway dilemma more poignantly than John Tanner. Ironically, he was not an Indian, but an Illinois farmer's son kidnapped when he was eight years old and adopted by the people of the lake, among whom he spent almost all his life. Proud, intelligent, sensitive, and resourceful, Tanner was a man caught between two cultures, a haunting figure in the history of Sault Ste. Marie. Late in his life he tried to re-enter white society there, only to be met by misfortunes and rebuffs. Repeatedly his Indian attitudes brought him into sharp conflict with Victorian notions of civility, and he quarrelled often with leading citizens. Abel Bingham, a Baptist minister, told how Tanner once humiliated him and chose an Indian way to call him womanish: " . . . finding me alone in my study, he stealthily entered, crept up behind me, reached over my shoulder and wrung my nose most spitefully! For this dastardly attack I had him thrown into jail, and held there until he promised to keep the peace." Henry Schoolcraft, the Indian agent who on at least one occasion had broken his word to Tanner, said of him: "His habits were so inveterately savage that he could not tolerate civilization."

Schoolcraft was generous in calling the Sault of the 1840's civilization. "The most striking feature of the place," reported Elliot Cabot, "is the number of dram shops and bowling alleys. Standing in front of one of the hotels I counted seven buildings where liquor was sold, besides the larger stores, where this was only one article among others. The roar of bowling alleys and the click of billiard balls are heard from morning until late at night. The whole aspect is that of a western village on a fourth of July afternoon. Nobody seems to be at home, but all out on a spree, or going fishing or bowling."

As Tanner's wretchedness deepened, he told the story of his life to Edwin James, the surgeon at Fort Brady, who recorded it sympathetically. It is the tale of a wandering Indian's thirty years in a shrinking wilderness, full of peril and hunger, full of loss, lightened only a little by love, friendship, and humour. It is also a mournful saga of the diminishment of a people, of their degradation by disease and alcohol, and of their gradual indenturing to white traders and foreign governments.

At last, on 4 July 1846, matters came to a head for Tanner. He was accused of murdering Henry Schoolcraft's brother, James. Half mad with rage and disgust, he fled into

the wilderness to the north, leaving behind drifting smoke and a jittery population. That holiday afternoon, William Cullen Bryant's excursion boat, the *General Scott*, steamed slowly up the river with the journalist watching from its deck. "We passed the humble cabins of the half breeds on either shore, and here and there a round wigwam near the water; we glided by a white chimney standing behind a screen of fir trees, which, we were told, had belonged to the dwelling of Tanner . . . the country around was smoking in a dozen places with fires in the woods. . . ." The frightened citizens believed that Tanner had turned incendiary. Perhaps indeed he had. Perhaps, while docile Indians were collecting their treaty money elsewhere on the lake, Tanner had ringed this offensive village with a fire to match his rage. He was never seen alive again, and a body found in the woods months later was identified only by a few trinkets thought to have been his.

Today, Sault Ste. Marie is an affluent city, kept attractive by its shade trees and its river. Tourist brochures announce that "fun is the name of the game in Sault Ste. Marie and all of Algoma land. . . ." From Bellevue Park, at the foot of the rapids, Brûlé would not recognize Bawating. Nothing can be seen from there of the Nor'Westers' Sault. Nothing remains of Cadotte's fort, nor of Fort Brady. The most prominent features on the south shore of the river are the neo-classical hulk of a public utilities building and an angular tower, a shrine to local missionaries. On the north shore are yellow apartment buildings and gleaming white petroleum storage tanks. Between the banks, arcing in a sulphurous haze where the Great Fisher once danced to hold the shores together, is the iron link of the international bridge. Whitefish Island is deserted. Boats of many sizes pass up and down the river, but no one fishes. The glow of the steel mill has replaced the Wabeno's fire, and plazas sprawl where the tents of the Jessakkids once trembled to spirit voices. Along the shores walked by Jesuits and Récollets on their way to deprivation and death, new Pontiacs and Cougars pass in the dusk, their bumpers sometimes bright with fluorescent stickers: *Honk If You Love Jesus.*

La vie nomade—c'est là le grand obstacle
qui empêche d'agir sur les masses du moins
d'une manière constante.

Father Nicholas Frémiot, 1851

One morning in June 1798, two months before the North West Company formally purchased Sault Ste. Marie, the annual brigade of canoes bound for Grand Portage assembled at the head of the rapids. Each summer there was much coming and going on the Lake Superior as light canoes passed through the Sault and criss-crossed the lake between posts, carrying dispatches and company personnel. Early in that particular summer there would have been special activity, for the Company's new surveyor, David Thompson, was embarking on his first charting trip along the north shore. But only once a year did the heavy brigades from Montreal pass through the Sault, and in 1798 as the men and canoes gathered at the head of the portage they represented the Company in its prime. They were, in fact, both the symbols and the vehicles of its success.

No boat ever designed was better suited to Canada's waterways and to the hunting-gathering mode of life in the north than the birchbark canoe. It is buoyant, quiet, fast, and easily carried. When properly built and paddled it can ride almost any sea except one that crests above it. It can be made in various lengths, breadths, and depths to suit condi-tions. This vehicle, the standard means of transport throughout the pays d'en haut, the North West Company adapted and refined to the limits of its intrinsic materials, stretching it by careful lashing and firm support with *verons* along the floor into a vessel thirty-six to forty feet long and six feet in beam. This was the *canot du maître*, the Montreal canoe. In good weather such a boat, bearing three tons of freight and driven by ten paddlers—each man a human piston making forty or fifty strokes a minute—could journey from the Sault to Grand Portage in less than twelve days. It could be swiftly beached if storms struck; its seams could be caulked with specially-mixed flexible gum that would not harden in the icy lake; and its loads could be adjusted to compensate for Superior's swells. It carried fittings for a sail and for oars. Most important, it would last for a full season, weathering the trip from Lachine to Grand Portage and home again. The first logistical triumph of the North West Company was to organize several of these craft into a modular shipping unit, which would make the round trip once a year.

In an equally important achievement, the Company

concentrated and held the manpower it required. There is an Indian tale about an old woman and man sitting quietly in the shade, watching a line of ants. Methodically the insects were transporting eggs from one storehouse to another. Suddenly the old people were astonished to see that the ants had changed into white men, and that the eggs in their mouths had become giant packs. This fable could have originated at any of the thirty-six portages between Montreal and Lake Huron, or at the Sault, or anywhere in the pays d'en haut west of Lake Superior; but it is clearly a metaphor of voyageur activity. Essentially labourers, voyageurs were alternately marine engines and beasts of burden. The remarkable fact about them, however, is that through sheer élan and joie de vivre they transcended their drudgery, and through their love of wildness and of movement across the water, they left an indelible mark on the Canadian imagination. As one traveller noted, compared to the English, the French were not great fighters or great hunters, "but they have laughed in farther places."

The typical voyageur was short, no taller than 5'10", because there was no room for long legs in the canoes. Voyageurs wore neither uniform nor distinguishing badges, except perhaps the red ceintures fléchées used to bind up their groins and stomachs before portaging the 180-pound loads. Their most common causes of death were strangulated hernia and drowning. Many never learned to swim. All had a healthy respect for rough weather on the big lakes. According to Joseph Delafield, "It is fear . . . that in time of peril makes [the voyageur] the worst canoe-man possible. If overpowered by winds or waves, he instantly abandons his paddle or his oar & is worse than useless. . . ." But in the long days of calm travel, Delafield found them both willing to work and indefatigable: "They are . . . prodigious gluttons, eating like Indians, and never satisfied with anything, at the same time the most careless and probably the most happy people. They will work the whole day without eating, and eat and sing the whole night without sleeping . . . the gay

and singing faculties (are) always in use." A less appreciative passenger complained: ". . . was molested out of my life by the men singing their boat songs". Sometimes a voyageur was paid extra for a good voice and for remembering the melodies of the Loire; but in general a milieu earned between 250 and 350 livres (besides a blanket, a shirt, and a pair of trousers) for a season that began on the first of May and ended in September. Steersmen earned up to 600 livres, and guides who bore full responsibility for the brigade could earn 1000 livres.

In 1798, the North West Company had about 18 seasoned guides and 350 canoemen. At posts such as Sault Ste. Marie and Grand Portage, they would have fed well on bread and butter, beef, pork, fish, venison, and various vegetables, all washed down with tea, milk, wine, and spirits. In transit, however, the staple food was sagamité, a mixture of grease and either folle avoine or Indian corn husked by being boiled in lye, then washed and dried. The ration was one quart per man each day, and the cost of a quart of sagamité was about ten cents. According to one priest, it tasted like wallpaper paste. On this rudimentary fare, the "comers and goers" spent their summers paddling from Montreal to Grand Portage and back—three thousand wilderness miles— rising before dawn, working usually until after dark, sleeping on boulder beaches with no protection from mosquitoes, blackflies, and brûlots, the ubiquitous "no-see-ums" of the north. Despite their flamboyance they were obedient men, obedient to their Church and to the Company which had temporarily swept them out of a claustrophobic society. Few chose voyaging as a career; the turnover was high from one summer to the next, with only one man in seven or eight signing up for a return trip to the west. Most were young, and their summer's venture was probably comparable to trips west made by the harvest excursionists of the 1920's and 1930's, or to the jaunts of young hitch-hikers whose signs say "Anyplace But Here!" A few, however, were professionals often indentured to the

Company by prodigious debts, and it was they who brought continuity to the trade and made up the voyageur class.

After the amalgamation with the Hudson's Bay Company in 1821, the importance of the Nor'Wester canoeman declined. The route to Montreal was largely abandoned, and goods and furs were hauled by bateaux up the rivers and over the northern height of land to James Bay. Cautious planning prevailed. The flair which had characterized French and Iroquoian voyageurs gave way to more pedestrian English measures. By the last quarter of the nineteenth century only remnants of the voyageur class were left. In 1882, when Garnet Wolseley was quickly knitting together an expedition to relieve Gordon at Khartoum, he appealed to Canada for the skilled rivermen who had been invaluable on the Riel expedition twelve years earlier. He got 386 of the 400 he requested; only 56 of these were Caughnawaga Iroquois who understood white water, and most of the rest were bank tellers and storekeepers who knew nothing about boats at all.

In 1798, however, the North West Company was in its prime, kept strong by men like those who gathered above the rapids at the Sault, preparing for the last leg of their journey west. One by one the canoes were readied and held offshore to await marshalling by the guides. Then, when all had been assembled, the commands would be given, the vermilion paddles would reach and dip, and the brigade of thirty canots du maitre, a single organism, would move out into the current and westward towards Pointe aux Pins, five miles distant and bright in the morning sun.

Pointe aux Pins, in the opinion of one military traveller, was a "most desirable spot" for a fortification, with "the advantage of a fine bason, formed by the Point, where vessels lay in deep water within a few yards of the shore, equally secure in winter as in summer." The place had had an historical strategic significance since 1735 when Louis Denis, Sieur de la Ronde, commandant at Chequemagon, constructed a 25-ton bark there at his personal expense.

After that, timber from Pointe aux Pins went into many good ships. In August 1772, Alexander Henry launched a sloop of forty tons there, outfitting it with equipment to service his mining claims on the south and east shores of the Lake, and with swivel guns to protect them.

Another 40-ton vessel, the *Athabaska*, was launched in 1786, and in 1793 the *Otter* was built at Pointe aux Pins by a shipwright named Nelson. Under the command of Captain John Bennett, it would serve the North West Company for many years. The *Invincible* would follow, and then the *Mink*, the *Perseverance*, the *Fur Trader*, the *Discovery*, the *Whitefish*, and many smaller vessels. By 1807 John Johnston would note that the best of the red and white pines along several miles of sand bank had been cut by Nor'Wester shipwrights, and by 1823 John Bigsby would find the Pointe only "thinly clad with pines".

Through the nineteenth century, travellers west often preferred to camp at Pointe aux Pins rather than at the Sault, and in 1848, on the evening before he entered the lake with Louis Agassiz, Elliot Cabot explored the place where a village had once surrounded a flourishing industry. "No vestige of human habitation in sight," he wrote, "and no living thing, except the little squads of pigeons scudding before the wind to their roosting place across the river. . . ."

But the military use of Pointe aux Pins was not yet over. On 18 May 1870, a ship carrying Colonel Wolseley's troops to confront Riel was halted at the Sault and denied passage through the American canal. Within hours, the captain of the propellor *Brooklyn*, berthed at Detroit, received a significant sum of money and covert instructions from Wolseley's agent: "On passing through the Sault Ste. Marie Canal and immediately on entering Lake Superior you will take steamer Brooklyn to Point aux Pins, a fishing post four miles above canal on Canada shore, and lay at the wharf there, reporting yourself immediately on arrival to Colonel Bolton. . . ." Soon afterward, the *Brooklyn* arrived at the locks and, when Captain Davis lied flatly about his British connec-

tion, she was allowed to pass through empty. Free of the last gate, the steamer sailed blithely across to Pointe aux Pins where the expeditionary force was waiting.

Wolseley and his staff had already proceeded to Thunder Bay aboard the *Chicora*, a rakish side-wheeler originally christened *Let-Her-B*. During the Civil War this ship had been a blockade runner between Charleston and the Bahamas, and was once chased for fourteen hours by the Union gunboats *Atlanta* and *Connecticut*. During that pursuit the Captain's wife defiantly waved a British flag through the wheelhouse window, while the steward composed an heroic poem in several stanzas:

White-winged *Chicora*, make speed while ye may,
Leave the gulls in your wake, to the crumbs of to-day;
For those who would be at the feast of the morn,
Must come from the East where the sunshine is born. (etc.)

Today at the Pointe there is none of the bustle of either shipbuilding or of military movements. The pines preside, grown lofty since the last cuttings, spreading shade and needles over the sand hummocks at the water's edge. Great ships, slowed to appease shoreline cottagers, pass with a muffled thrumming of engines. Set back from the beach, a long and weathered cedar building—perhaps once a boat shed—serves as a general store for teenagers who arrive from the cottages on bikes, scuffing the toes of their Adidas past rusted signs that say *Coke, Sprite, 7-Up, Drink Doran's Root Beer*. It is cool inside, and there are white shelves of butter tarts and baby food. Behind the store are several naugahyde-draped snowmobiles, and half hidden in the brush is a commemorative plaque that tells about the ship-building of long ago.

West of Pointe aux Pins the shore curves northward, past Pointes Louise and des Chênes and then past Gros Cap, that brooding promontory which gives the best view of the entry to the Lake. To the south, across the straits, is Nado-wawegoning, the place of Iroquois bones, where 800 Ojibway enemies are said to have fallen. Due west is the expanse of the lake itself and a distant line which may be a cloud, or a mirage, or the shore of Whitefish Point. To the north is the long, beckoning finger of Ile Parisienne, and to the northeast the hills of Gros Cap rise still higher.

"These bold warders," said George Grant, "called by Agassiz 'the portals of Lake Superior', are over a thousand feet high; and rugged, primeval Laurentian ranges stretch away from them as far back as the eye can reach. . . . Those who have never seen Superior get an inadequate, even inaccurate idea, by hearing it spoken of as a 'lake', and to those who have sailed over its vast extent the word sounds positively ludicrous. Though its waters are fresh and crystal, Superior is a sea. It breeds storms and rains and fogs, like the sea. It is cold in mid-summer as the Atlantic. It is wild, masterful, and dread as the Black Sea."

Like Grant, journeying west with the Fleming expedition, most diarists made some entry as they passed Gros Cap and the lake opened before them. "We entered the great lake Superior," said one fur-trader simply, "the Mother & mistress of the other Lakes."

In June, when the North West canoes left the river, the lake would have begun to settle after the long turbulences of spring. Dense fog would shroud the coast for days at a time, and there would be calm periods when breezes would barely ruffle the surface and the groundswell would curl only a thin lip on the steepest beaches. Such calms might last long enough for the brigades to coast in easy strides, moving steadily from dawn to dusk without the frustrations of *dégradés*.

Several travellers have described the lake in this serene mood. "When it was calm," wrote Jonathan Carver, one of the first Englishmen to see it, "and the sun shone bright, I could sit in my canoe, where the depth was upwards of six fathoms, and plainly see huge piles of stone at the bottom, of different shapes, some of which appeared as if they were hewn. The water at this time was as pure and transparent as

air; and my canoe seemed as if it hung suspended in that element. It was impossible to look attentively through this limpid medium at the rocks below without finding, before many minutes were elapsed, your head swim, and your eyes no longer able to behold the dazzling scene." The trader John Johnston shared Carver's impression: "There is not perhaps on the globe a body of water so pure and so light as that of Lake Superior. It appears as if conscious of its innate excellence. . . ." And another traveller concluded: "It is only repeating what has been said before, and by almost every writer who ever entered this lake, when I say the prospect is *indescribably grand!*"

Grand, yes; also notoriously unpredictable. Within fifteen minutes the complexion of the lake can change dramatically. Even while the sky remains clear overhead, the swell begins to lift and deepen, the wind flicks white water off the crests of the waves, and a canoe caught in the open can be in mortal danger. "When it is least expected," wrote an awed Charlevoix, "the Lake is all on fire; the Ocean, in its greatest fury, is not more agitated, and one must have instantly some asylum to fly to for safety. . . ."

For safety, the brigades usually kept close to shore, but as they rounded Gros Cap, Goulais Bay opened like a gulf on their right, and Coppermine Point, their landmark, beckoned far northward beyond the Maple Islands. The guides would have had to decide on the length of the *traverse* across the mouth of the bay. Would they angle west of north towards the islands? Or would they edge eastward, where they could quickly take shelter behind Goulais Point? Probably they would compromise, leaving the bulge of Gros Cap and setting a course across the ten-mile stretch of open water towards the western flank of the point.

During this first traverse to be made on Lake Superior there would have been silence in the canoes, and many glances upwind towards the clouds on the horizon. Those new to the journey, shocked at the splash of ice-water across their wrists, would not need to be told that they would die quickly if they overturned. For a moment there would be talons of cold piercing the whole body, and then only a warmth, a heaviness, a last vision of clouds drawn like flannel comforters overhead.

Goulais Bay was called Kitchi Wikwedong by the Indians, Anse à la Pêche by the French, and Oak Bay by Alexander Henry. Here, in the cruel winter of 1767 when there was starvation in Sault Ste. Marie, Henry and his Indian friends drew enough fish through the ice to survive. Others were less fortunate, and Henry's party had an experience here which brought the horror of famine very close. Down the winter trail to the bay came a gaunt spectre of a man, reeking with such a stench that no one could approach him. He struck into their camp the wendigo terror which had stalked close that winter, and when runners sent back along his trail returned with ghastly evidence—a half-cooked hand which they had found staked beside his campfire—he confessed: he had killed first his uncle, and then four children one by one. He showed no desire for fish, but kept watching the children in the firelight—"How fat they are!"—and it was to protect the children that Henry believed that the stranger was killed, struck down by the blow of an axe. But the axe struck also at the terror behind the cannibal, the formless dread of the fate which might come to anyone.

The church at Goulais is called *Our Lady of Sorrows*. Stark white, it stands at the top of a gentle rise, looking south toward a tar-splashed government dock where fishing boats lie moored. Beyond is the misty sweep of the bay. Near the dock, the first watchful loons of Lake Superior cruise silently. It is very quiet at the church. Frederick Baraga, a tough and dedicated Slovenian, first said Mass here on the Feast of the Seven Sorrows of the Blessed Virgin, 1862, fourteen years after Father Hanipaux had made his first baptisms. "Converted from paganism": Marie Nissawanigog, Angélique Kapiotem, Philomène Nickwagijigak, Marie Ajitobikwe, Marguerite Chanagwatokwe—the names blend gently back into the susurrations of the forest.

Close to the road leading in from the highway, the bay is ringed by white cottages with careful fences and lawns; white motorboats nod at anchor off the hundred-foot lots. Signs and mailboxes line the road; but near the end, at the edge of the Indian settlement, they disappear. Over the years the reservation has dwindled to one tenth of its original size, but a human space is still maintained among its houses. Touched by wild bushes, they join in silence with the land in a simplicity that is the result of discretion and of certain notions of propriety. Sometimes quartets of tourists in cars shut tight against the dirt ("Thank God for air conditioning!") roll down as far as the government docks, but they do not stay. There are no motels, no restaurants, no craftshops.

Batchawana Bay immediately to the north is more accommodating. The name means "bad inlet", but it has given rise to a number of bad jokes which usually begin, "There were these two brothers, Batchawana and Batcha *don'*wana" For a period in the early nineteenth century the Nor'Westers maintained an outpost and fishing station there, and at Batchawana early in this century Frank Lapoint caught the largest fish ever recorded in the great lakes—a 310-pound sturgeon, 90 years old, 7½ feet long—which he sold to a New York buyer for $150.

Usually by that time, sturgeon were simply destroyed. Ancient and majestic, long a figure in Indian lore and a staple in Indian diet, the sturgeon could rip to shreds nets set for tastier species. It took only a few lashings of its shark-like tail, and a few twistings of its spiny body. Sturgeon were nuisance fish; so for a time they were caught in their thousands, stacked like cordwood on the beaches, and burned. No doubt there were nights when the twenty miles of beach flickered with their pyres, and Indian canoes watched in silence from the shores of Batchawana Island, near the graves of ancestors. Today, virtually nothing is known about sturgeon in the lake except that few are left. They require twenty years to mature, and they are not

getting the time needed to spawn and reproduce. Casual depredations, blockage of spawning streams, and poisons sifting through their feeding grounds are completing the job that the commercial fishermen began, and biologists fear that the sturgeon is a doomed species.

Off the mouth of Batchawana Bay is a group of three small islands—Maple Island and North and South Sandy islands. If the weather was promising, the voyageur brigades would angle west on a long traverse and skirt inside these islands, taking a chance, saving an hour's work. "In making this traverse some time ago," wrote Joseph Delafield when he passed in 1823, "a canoe was stranded upon Maple Islands & a clerk and several of the crew drowned. The tale is always told with all its horrors by the voyageurs and the spot seems to them to have peculiar dangers"

The canoe he referred to was one of three sent east in 1816 by Thomas Douglas, Earl of Selkirk, after his force of Swiss mercenaries had seized Fort William. Among the Nor'Westers surprised and captured at the Fort were some of the most illustrious: Simon Fraser, John McLoughlin, and the urbane William McGillivray himself. Under guard, they were sent down to Sault Ste. Marie, en route to Montreal to stand trial for the killings at Seven Oaks earlier that year: but on 26 August at the Maple Islands they were struck by a sudden storm. Two of the canoes reached shelter but the other, an older one carrying McLoughlin and Kenneth McKenzie, foundered and broke. Nine of the 21 paddlers and passengers drowned, including a de Meuron sergeant, an Iroquois chief, and Kenneth McKenzie. Tradition says that some of the bodies were taken to Sault Ste. Marie and that some were buried where they washed ashore.

Maple Island today receives few visitors. Its profile is low and uninteresting, its beaches stony, its bush tangled and forbidding. Sometimes trolling fishermen pass close, but if they are circling the island they must be careful as they approach the northwest corner, for there treacherous shoals reach like claws beneath the surface. Running southbound

for shelter before a storm, a boat could be upon those shoals in an instant. Suddenly, bared in the trough of a wave, they would rip through skin and ribs together. For an instant the boat would lurch sickeningly before the following wave would crest above it and fold down.

To John Bigsby, breakfasting at the scene of the drownings seven years afterwards, "everything looked innocent and pretty...." He had experienced many voyageur landings in rough weather, however, and he could imagine the struggle for life that had taken place there.

When a brigade of fur-trading canoes . . . are compelled to land suddenly, it is done one by one in rapid succession. The first makes a dash at the beach. Just as the last wave is carrying the canoe on dry ground, all her men jump out at once and support her, while her gentlemen or clerks hurry out her lading . . . Every brigade of canoes has a well-paid guide. If he permit his goods to be thus injured, he loses his place

Wet goods and torn canoes meant at the very least tedious delays for drying and repairs. Gently-sloping sand beaches were therefore favoured for landing, provided they were large enough to bivouac the entire brigade and had plenty of firewood on their upper levels. Thirty miles from Gros Cap was an ideal campground; it was called Pancake Bay from the Montreal-bound voyageur practice of feasting there before being reprovisioned at the Sault. Northbound brigades frequently stopped there also, to spend their first night on Lake Superior; for thirty miles was an easy day's journey for the voyageurs. When Daniel Harmon travelled west as a Nor'Wester clerk in 1800, his brigade averaged 47 miles each paddling day on the lake, and at the end of one especially good day during which the men had hoisted their sails and tossed encouraging tobacco to La Vieille, the old woman of the wind, Harmon guessed they had covered ninety miles.

Landing would be made at dusk: supper would be cooked, bales stacked and covered, canoes overturned and perhaps lashed with oilcloths to form rudimentary shelters. Minor repairs would be made by torchlight, drams drunk beside the fires, jokes told, songs sung. Then by degrees the camp would grow quiet, until at last the only sounds blending with the lapping of the lake would be the crack of dying embers, and here and there the murmur of a sleeping man, prodded by some private fear or memory in his dream.

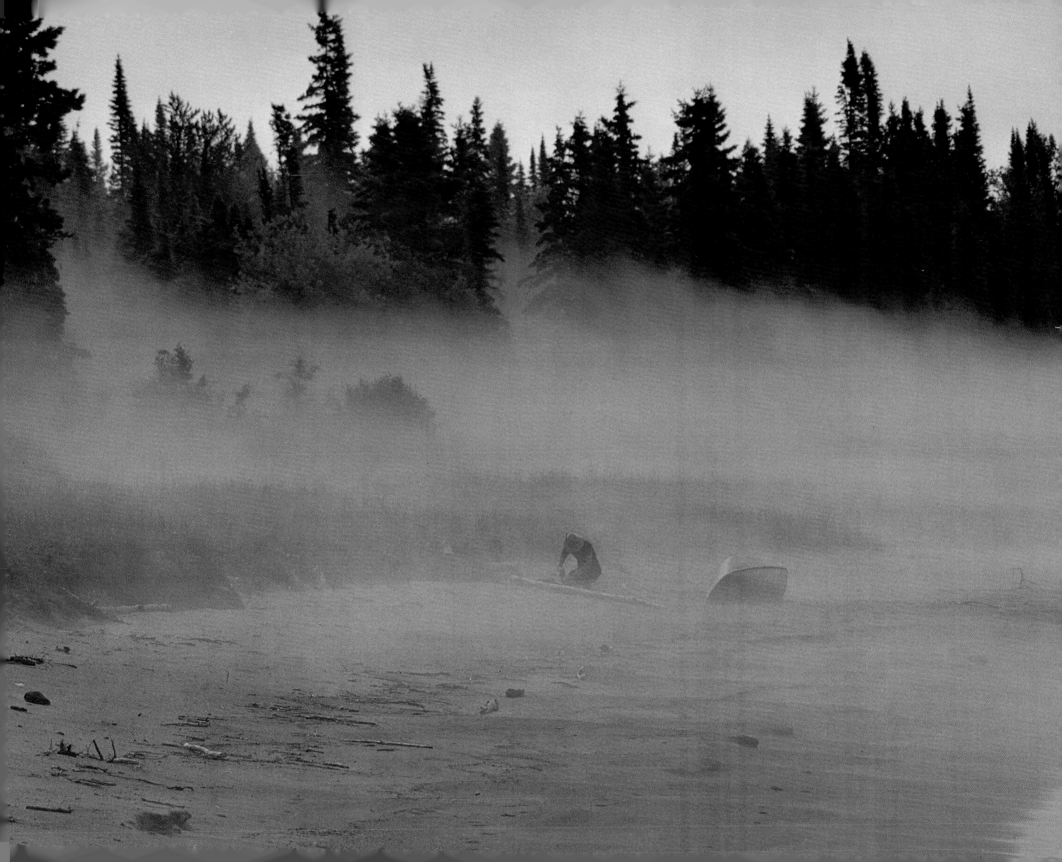

We will begin with the lowest forms of Indian belief . . . To the Indian, the material world was sentient and intelligent . . .

Francis Parkman, *The Jesuits in North America*

In the past, certain places along the shore have acquired magical significance. Power has resided at them, and by association with them certain men have grown powerful. Lining the eastern shore from Coppermine Point to Wawa are locations where power has been found specifically in hard substances within the earth. If these places were animals, they would be drawn by the Ojibway with the magical force-lines radiating from them: Hibbard Bay, Mamainse, Mica Bay, Pointe aux Mines, and Theano.

Mining was not unknown to the Indians. For seven thousand years before Brûlé carried his lump of copper back down through Bawating, the inhabitants of the lake had been mining and crafting copper, fashioning the tools that have come to light in the past century. In 1872, in a garden at the juncture of the Kam and McKellar rivers in Fort William, seven or eight copper instruments were found in a bed of ashes. On Mountain Avenue in 1914, the skeleton of a man was discovered lying with several copper implements, including an adze. The previous year, also in Fort William "many copper tools" had been found forty feet underground in the path of the Stanley Street sewer; and in 1918, again at a level of forty feet, a "finely-made" spearhead was unearthed in another excavation near the Turning Basin. At Nipigon, in a grave to the south of the lake, open-socket knives and projectile points have been found, together with triangular spikes and punches, tubular beads, an axe, rods and needles, and various hammered nodules. During construction of the CPR bridge at Pic River, a large copper gaff was uncovered from beneath twenty-five feet of clay and gravel, dating back several thousand years to a time when the lake was 128 feet higher than it is today. This gaff is similar to the ones that fishermen sometimes draw up in their nets.

Prehistoric miners got the metal either by laborious prying with stone and bone chisels, or by heating the ore-bearing rock and then cracking it with cold water. Once extracted, the raw copper was then pounded into rough bars for carrying and trading. Further working involved cold-hammering and annealing until the instrument or container took the desired shape; smelting was unknown on the lake until Alexander Henry built a furnace at Pointe aux Pins in 1769.

47

Perhaps fearing verdigris poisoning, Indians in historical times seemed reluctant to use the copper. Much deep feeling—what Allouez and his missionary successors would have called superstition—attached to the old mines and to the fabulous ingots which lay concealed in the forest, and reports of giant guardians filtered through to the white explorers. "All Indians believe," said Raudot, "that, if they were to point out a mine to anyone else, they would die within the year." Visiting Mamainse expectantly in 1798, David Thompson never reached the old mines he had been told about:

There were five or six canoes of Indians, who informed me they were then at the old path of their grandfathers who used to come here for pure copper for heads to their lances, arrows, axes, knives, and other necessaries; by their description the place was about five miles in the interior. I requested to be shown the place, but they said they did not exactly know it, and dreaded the mosquitoes

Eventually, however, organized mining commenced. By 1798, the first phase of exploration and speculation had already passed. Both the French and the English had attempted to exploit the ores of the region, but with only middling success. In 1845 a period of renewed interest in the area north of Coppermine Point began, and several companies opened new locations. They brought fresh reserves of men, technology, and capital to the shore, and villages sprang up at the scenes of their operations.

By 1849, the effects of mining on the landscape were everywhere to be seen—shantytowns, pits, headframes, and tailings—and in that year the Indians of the area, whom the Canadian government had not troubled to consult before granting licenses, took action. Led by the formidable Shingwauk and by Chief Nebinagojing from Batchawana, and accompanied by two English adventurers named McDonald and Metcalf, they descended upon the Quebec Mining Company's townsite at Mica Bay, woke Superintendent Bonner from a sound sleep, and drove him from the location with his crew—about 100 people in all. Troops were quickly dispatched from Montreal, but the season was too far advanced for the *Independence*, on which they had embarked from Sault Ste. Marie, to steam through to Mica Bay. Shingwauk and Nebinagojing were later arrested, together with Peter Boissineau and the Lesage brothers, Eustace and Peter, of the Ojibway band at Garden River. All were jailed in Toronto for several weeks before being released.

The next year the Robinson Treaty was signed, but the discomfort about mining continued, and in 1891, when Captain T. H. Trethewey and his two sons were running the Hurley Mine at Sand Bay, they felt it necessary to mount cannon in plain view of restive Indians—cannon reminiscent of the swivel guns with which Alexander Henry had launched his mining venture.

Why did mechanized mining so excite native hostility? Part of the answer obviously lies in the Indians' deepening sense of loss as one hunting ground after another became depleted, as fish were skimmed from their shoals and shipped away, and as white settlements took root and blossomed on traditional camping grounds. The claim for recompense for lands seized was nothing if not just, and yet the poignancy of that claim lay not only in the fact that it was met with arrogance, force, and niggardliness, but also in its bitter irony. For the Ojibway, the game was lost before it was begun, before they understood that they were in a game. In order to be made intelligible to the white man, their plea for the essential integrity of the land had sooner or later to be cast in terms of ownership, and when that happened they entered a dispute of polarities which could be resolved only by violence or through the European notion of legality—that amalgam of stasis, balance, order, compromise, and measurement which is even now parcelling sections of the Superior shoreline into 100-foot lots. By 1849, when the miners had begun to work in earnest, it was too late for any violent resistance not suicidal, and the only recourse left to the Ojibway was to claim ownership of

lands already seized, ashamed and bewildered that they had been diminished inchmeal to that point.

A deeper reason for their protest, however, may have lain in their sense of the violation of the body of the earth. We should try to imagine how it was for them, an animistic people who perceived earth as a womb, whose cultural past existed wholly in cyclic regeneration, to see that body unceremoniously pierced. What lodes of fear were opened with those shafts, what compacts broken? It is one thing to chip copper or silver from an exposed vein for a spearpoint or a fishook by which life might be continued, or for a ring or a bangle to gladden a woman's heart. That is human and immediate, no different from flaking off a useful chert or agate, or gathering the vegetable bounty of the land. Even to deepen the work of one's ancestors on such a vein, and generation by generation to participate in it and to share it, bringing to it need, respect, memory, and whatever apologies were necessary to placate the spirits of the place—that was different from what the white man did: as different as a skin wound from a body thrust. But to pierce the earth itself, and then to enter that wound and burrow there like a maggot—how could that be on honourable endeavour for a man? Clearly, those who did such things were diseased, without respect for themselves and for the land they walked upon, and the powers that so degraded free men could be nothing but evil. Full of foreboding, the Ojibway watched that power spread around the lake, straddling two of the most sacred places on the eastern shore: Agawa and Gargantua.

Agawa means "the curve in the shore"; or perhaps, "shelter". Legend says that silver was once found there. For three miles the beach sweeps northwestward, each of its pebbles rich with colour; but the whole white, made whiter by the bleached and contorted arms of driftwood lining its upper reaches. Baked, washed by rain and surf, patrolled by gulls and ravens, the beach is clean despite the littering of travellers who each year find it irresistible and stop to camp in its approved locations, or to comb it for treasures like fishnet floats and notes in bottles ("Help, I am a prisoner") or just to linger for a time with the sun on their bent backs. Often there is some flotsam from freighters and pleasure boats—cans, lightbulbs, Chlorex jugs, ropes, bottles, condoms, Frisbees, and sometimes even ladders; but so far the beach has remained indifferent to these things, ingesting them together with natural detritus. It is clean despite generations of lumbermen, fishermen, and auto-wreckers who have worked there, despite the Hudson's Bay servants who once kept a post in the meadow near the river, who took what they wanted, built what they required, and now lie buried facing east, Indian and white together. Among them, perhaps, is the woman who planted the rosebushes grown lush and wild in the shadows of the pines.

At Agawa, canoes can pass along the beach just outside the surf; and many times travellers must have drawn close here, brown canoes on turquoise water, attentive to the wigwams and the cooking fires beyond the prancing dogs. Greetings would be exchanged; and perhaps there would be further exchanges of gossip or food or goods before the travellers would again move north, around the end of the beach where granite palisades stand inland like brooding giants, and out through the islands towards Wazhe-naubikini-guning Augawong, "The Place of the Writing".

A canoe approaches the pictographs by gentle degrees. First there are indecipherable drawings—ochre lines so slender and faint, so overshadowed by recent enamellings, that they could easily be missed. But they are pictographs beyond doubt, little harbingers, messages, prayers, or tributes. After them, past an indentation in the shore, Inscription Rock properly begins, a towering façade with a water-smoothed ledge where the painters stood. The first group of drawings consists of a canoe with two paddlers, a sturgeon, and a stiff-legged, horned quadruped with a long tail, and bristling back. Then there comes a space, and then two beguiling figures dancing or making love; then an exuberant

49

gathering of signs, circles, figures, and serpentine lines; then the main group of paintings. The crane and the whitefish may be totem signatures, calling cards, while others—the cartoon horseman, the bow-legged moose, and the trio of wraithlike canoeists—probably have a more specific message or a more potent magical capacity. But there is no doubt about the potency of the central figures—the undulating water snakes and the dragonlike monster they attend. These are among the most venerable manitos in Ojibway mythology. Together, Missikenahbik and Missipeshu, they symbolize all the latent power of the lake. When serpentine squalls chase across the water, or when canoes are drawn among the sinuous currents off a point or a reef, Missikenahbik is active. And on those nights when the lake is churned by a giant tail it is Missipeshu who is enraged. Missipeshu: spined cat, beach-stalker, child-stealer. He is here at Agawa even as he appeared to battle Nanabozho, kept fresh through years of veneration, an embodiment of fear itself. The lake is his, and it is appropriate that he should oversee it from this sanctuary, flanked by islands reaching like arms, by arcs of shore stretching like the wings of a thunderbird. It is fitting too that he should be shown poised, turning as if he had just heard an unaccustomed sound . . .

Automobiles can drive close to Inscription Rock now. Buses, vans, house-trailers, truck-houses, and motorbikes can all drive close. Their occupants emerge, lock their vehicles, visit the toilets nearby, and start on the path to the Rock. They have been invited in by a highway sign that says *Indian Pictographs* and by a road that is as broad and lushly gravelled as any campground's. In general these visitors are gregarious and noisy and fond of eating substances in paper wrappers. Most do not care for the trail, and feel that the few hundred yards to the Rock is a needless expenditure of energy. When they arrive they will rarely venture beyond the metal scaffolding provided for easy viewing: they will take a picture and perhaps lean forward to touch the paintings, depositing their modicum on that patina of human

grease under which year by year the figures fade. Then they will go back up the stairs and along the trail, having done the pictographs. If someone just arriving should ask, "Is it worth it? Is it worth walking down there for?" they will often tell him no, indignantly. "Just little paintings no bigger than this!"

Speed and ease diminish. Let the tourist make his own way in a birchbark craft from Grand Portage to this point, or from the Sault, or even—against the wind—from the beach at Agawa, and let him see then how large the figures on the rocks have grown. Easy access and tepid interest have reduced this image of Missipeshu until it is little more than a curiosity, about as significant as the Sault locks or the Wawa goose. Any night it could be obliterated by sprayed-on enamel or by the blows from a drunken hammer. It could be mutilated or destroyed for the same reasons that cause men wantonly to cut the bark off birches or to smash beer bottles on those rocks which seem most beautiful. If these pictographs were destroyed, as others have been elsewhere in the province, the event would be met with as much private relief as official outrage. The authorities would no longer be reponsible for so ambivalent and disturbing an inheritance, an inheritance too closely attached to the forests which are being levelled with official sanction, and the rocks being shattered, and the estuaries being poisoned by upstream leakage. Should the Missipeshu disappear, those who have approached the pictographs respectfully, taking time and making an effort to grasp their ancient relationship to the lake, will know that it is only the image that has been lost. The spirit itself, resident, will remain untouched, will rest and wait.

Beyond Inscription Rock the way north passes the beaches of the Sand, the Coldwater, and the Baldhead rivers, and finally Beatty Cove and the rock where the steamer *Telegram* foundered near the turn of the century. The aspect of the shore changes, gradually contorting, becoming less predictable in its shapes and substances. Gargantua approaches,

its islands cloaked in haze. "A more sterile, dreary-looking region I never saw," wrote John Ryerson, Methodist missionary, in 1855, "one barren waste of rocks rising above the other."

At the mouth of Gargantua Harbour is the island where three generations of the Miron family tended the light, automatic now and surrounded by the charred ruins of their old structure. Behind, the harbour curves northeast into the mainland. Once the site of a busy resort and fishing village, it is deserted except for occasional yachtsmen and for motorists willing to risk the treacherous road from the highway. The buildings sag, the docks are crumbling, and the hulk of an old vessel lies barely submerged near the northern bank. The place is returning to wilderness, and before long even the chains and hawsers that lie rotting in the undergrowth will have crumbled to powder and vanished.

When Lefroy was detained here by wind storms in 1844, his voyageurs dedicated a lob-stick to him, shaving a tall pine of all its branches except a tuft on the very top. "A compliment," he said, "in my case all the more sincere as I had nothing [i.e., no liquor] to give them." Twenty years earlier, when John Bigsby and David Thompson had journeyed through, the whole region had been swept by a forest fire, and the hills bore only the skeletons of pines "looking most desolate". Near the water, however, fir copses, birch, and aspen had survived, as well as "a profusion of mosses". John Macoun, the botanist who accompanied Sir Sandford Fleming's 1872 expedition, spent several hours here gathering rare moss samples "and beautiful specimens of Aspidium fragrans, Wood sea hyperborea, Cystopteris montana, and other rare ferns".

The harbour has the lush and timeless atmosphere of a grotto, and is a fitting entrance to the assemblage of strange promontories and islands that surround the Gargantua Peninsula. The rock here is volcanic—soft, and porous. Where it meets the lake, waves have sculptured it on several levels, licking out seacaves, piercing promontories, and carving the northern extremities into sloping prows. In some places pillars stand severed from the shore, wrapped in creepers, and on the outcroppings ancient cedars crouch like bears, snouts to the wind.

Gargantua is an enchanted landscape, and it is easy to see why it was a major spiritual centre for the Ojibway. From here Nanabozho presided over the moods of the lake and granted a calm journey to those who paid him homage. "It is consequently," said Delafield, "one [place] out of the many where they signify their devotion by leaving small presents of tobacco...." Alexander Henry found curiously-shaped copper nodules on the shore, perhaps also votive offerings.

Offshore rocks and ridges rise starkly out of the water. "One of these," in John Bigsby's description, "is a rude pyramid from fifty to sixty feet high. Its strange shape, dark colour, and the surrounding gloom, have induced the Indians to worship it as an idol. It has given to the place the name of Gargantua." This was likely the rock now called the Devil's Chair, a lozenge-shaped and solitary structure. Viewed from one side it is a reclining man. Viewed from another, it becomes a bowl with a perpendicular opening at water level. Such a blend of masculine and feminine imagery would not have escaped the Ojibway imagination, ever alert for correspondences between the human body and the earth.

"One of the common Indian legends about the deluge and the creation of the earth attaches to this rock," wrote Elliot Cabot, "and the Indians still regard it with veneration. According to one of the men, 'the Evil Spirit', (N.B. The gods of the aborigines here as elsewhere are to their Christianized descendants nothing but the devil, the *elder* spirit of all mythologies) after making the world, changed himself and his two dogs into stone at this place, and the Indians never pass without 'preaching a sermon' and leaving some tobacco. Even our half-breeds, though they laughed very freely about it, yet I believe left some tobacco on the top."

The top is covered with green and orange lichens, and tiny plants have rooted in the fissures—wormwood and sedge, yarrow and rock cress. One can gaze thirty miles across the lake from here. To the north, the shore stretches around to the shadowy arm of Point Isacor. To the south, beyond the other islands of Gargantua, lies Leach Island; and due west, floating like a mirage above the haze, is Michipicoten Island.

Probably the voyageurs gave Gargantua its name, seeing some similarity between the frolics of Nanabozho and those of the Rabelaisian hero; or perhaps it was simply the spot where they would climb to the roof of the 'Gorgon' to see what offerings had been left. Christian influence, however, was responsible for keeping references to Nanabozho off later maps of the area, and for the stern renaming of the Devil's Warehouse and the Devil's Chair; for as Cabot realized, the god of the vanquished became the devil of the conquerors—a simple inversion that Christianity had employed successfully in its conquest of northern Europe and Britain. Those places where legend crystallized, those places essential to the spiritual élan of the society, were most vulnerable to this strategem of casting darkness where there had once been light, and fear where there had previously been joy.

So with Gargantua. Yet the transformation is incomplete even to this day. Bizarre stories of human sacrifice and of sinister shapes moving through the fog have been told about the Gargantua, but despite them its atmosphere remains warm and friendly. More than such tales and such conjuring with the Devil's name will be needed to darken the wild beauty of the place, or to erase the memories of Nanabozho. More than a missionary chill will be needed to cool the promise of Gargantua's ochre cliffs at sunrise.

Andrew Whitikane
Ex chief Michipicoten
Died Aug. 30, 1925
Aged 105 years.

Gravestone, North bank of Michipicoten River

For centuries before the white man came, the Michipicoten River had been the major route to James Bay, and many parties of travellers had camped just inside its mouth. Archaeologists have uncovered here not merely "a veneer of cultural debris", but no fewer than nine levels of habitation, the earliest dating back to 1100 A.D. Further work will no doubt confirm the belief in still older habitations.

Michipicoten is one of the most beautiful areas on the shore. Approaching from the south the canoeist passes those bluffs that gave the place its name, and then inside a group of small islands off the end of the beach. North from these islands to the mouth of the river the beach stretches for a mile and a half rising in broad terraces, and exposed to the whole sweep of the lake. Behind it lie the dunes with their acres of beach pea, hairgrass, and juniper, and behind the dunes the forest gradually thickens.

Long ago, maple syrup was among Nanabozho's gifts in the forest here. In 1768, Alexander Henry and his men boiled several hundred pounds of sugar from sap gathered near Michipicoten, and as late as 1823 John Bigsby noted "a ridge of sugar maples several miles long". Today, however, no maples remain; they dwindle out of the forest a few miles south and in the Michipicoten area boreal species prevail—fir, cedar, white and black spruce, tamarack, aspen and birch, and mountain ash. Under the forest canopy and in the meadows grows a profusion of shrubs and plants necessary for Ojibway life. So varied was the bounty here that the women could have gathered almost constantly—birchbark for canoes, *mokoks*, and wigwams; spruce and hemlock roots for wattap bindings; cedar for paddles, canoe ribs, cradle-boards, toys, and utensils. In season they would pick blueberries and raspberries. Medicinal leaves, twigs, and roots were easily picked along the borders of the beach, dried, and stored against future need: ladyslipper for toothache; pearly everlasting for paralysis; lady fern for urinary problems; red-osier dogwood for eye irritations; tamarack for burns; Labrador tea and sweet cicely for stomach cramps; and wild rose for fatigue. Leaves, flowers, stems, and roots were used for different purposes: some were mixed as poultices, some ground into salves, and some brewed for beverages.

Children were drawn early into adult activities. Girls of

53

eight or ten helped with the harvesting, as well as with other feminine tasks such as sewing, pot-making, and hide-scraping. Boys of the same age were learning to make the arrows and knives necessary for the hunt, and to track, snare, and fish. Game was plentiful: moose and caribou; hare and fox; otter, muskrat, and beaver; ducks, geese, ruffed grouse, and pigeons; whitefish and trout.

The river's mouth changes as the dunes shift, but it is always narrow, and the current makes the entry treacherous. Once inside the crooked thumb that marks the end of the beach, however, travellers are scarcely aware of the current, unless they pass near the bank, where grasses drift down like women's hair into the darkness, and flotsam eddies in the embrace of fallen trees. There is shelter here from even the worst gales, and here, following the Indian example, the white traders built their forts.

The French came first. Michipicoten is shown on the Jesuit map of 1671, and on Jaillot's map of 1685. The first substantial post was likely built here about 1725. In 1739, Beauharnois granted a *congé de traite* to the traders Marin and Douville, and by 1756 their post was "well-established and prosperous". Alexander Henry arrived in 1767, and in 1780 two other free traders, Nolin and St. Jermain, purchased the post and operated it for three more years. After that, Michipicoten became part of the North West Company.

In 1780, Michipicoten House consisted of two rooms, one for the master and one for the men, each with an outside door. About twenty feet away at the western end of the palisade, was the trading house, constructed of cedar logs with mud chinking. In the fashion of the time, these logs were likely tenoned at the ends and slipped into grooved uprights. Inside the enclosure there were auxiliary buildings, and in the clearings outside were the lodges of Indians who adhered to the fort partly because it was built on old camping grounds and partly because the closeness of the whites promised a degree of luxury.

Until 1797 the North West Company controlled the mouth of the river and, hence, the route from Lake Superior to James Bay. But in that year the Hudson's Bay Company challenged their monopoly by building a post across the river. The English stayed only six years before abandoning the area, but they returned in 1816, when events at Red River and Fort William radically changed the balances of trade and power.

The North West factor in that troubled year was Donald McIntosh, whose six uncles had died together at the Battle of Culloden, and who had recently been made a partner of the company that he had served faithfully for twenty-six years. He was forty-three. "You'll say," he wrote to his sister, "it is better late than never...." His portrait survives: a smile slightly cynical, eyes generously spaced, brow narrow, auburn hair obviously uncontrollable. A kind, mild man.

Much later, when the Nor'Westers had been absorbed by the Hudson's Bay Company and Governor George Simpson was assessing his personnel on the lake, he would write of McIntosh: "A very poor creature in every sense of the word, illiterate, weak-minded, and laughed at by his colleagues ... Speaks Saulteaux, is qualified to cheat an Indian and can make a fishing net, which are his principal qualifications, indeed he would have made a better canoe man or fisherman than a 'partner'. 'Tis high time he should make room for a better man"

Sir George Simpson on the other hand, was a very efficient creature in every sense of the word. He was curt, vain, intolerant, and feared by his staff and colleagues, who called him "The Little Emperor." He was well qualified to make money for The Concern, but, unlike Donald McIntosh, could never have made a fish net. Often, "turning off" an Indian woman who had been his "bit of Brown", Simpson would leave instructions like these:

"If you can dispose of the lady it will be satisfactory to me as she is an unnecessary & expensive appendage ... If she is un-

marketable I have no wish that she should be a general accommodation shop to all the young bucks at the factory . . . a padlock may be useful; Andrew is a neat fellow & having been in China may perhaps know the pattern of those used in that part of the world" And: "Pray keep an Eye on the commodity and if she bring forth anything in the proper time & of the right color let them be taken care of but if any thing be amis let the whole be bundled about their business."

Compared to the brisk Sir George, Donald McIntosh would remain a minor functionary. His real success was personal, not professional. One summer evening in 1816, after the day's accounting had been completed and the journal brought up to date, he sat at his desk in Michipicoten House and wrote to his sister about his half-breed children and the woman who shared his life. From nearby came the talk and laughter of his men, and the calls of children playing on the river. To the west, seagulls wheeled above the lake which for a little time yet would preserve him from Selkirk's wrath.

I have some of the HB people for neighbours this year at this place. If they behave peacable, I will . . . In case anything should happen to me, I thought it prudent to make a testament on account of my woman and children; don't be alarmed at this: Every man that has a family and [is] worth a little money should always have one made, when most secure, our life hangs upon a thread, which is often cut on a sudden, when we least expect it . . . You request me to let you know the stature of my woman. She is about as tall as you are, but very slender

The graves at Michipicoten lie on a wooded rise opposite the mouth of the Magpie River. To the east is the white spire of the Mission church. No headstones remain, and the original wooden crosses have long since rotted back to earth. The site of the house where McIntosh and his family lived is a meadow full of juniper and alder, of steeplebush, hawthorn, and bearberry. Not even the foundation is left.

Year by year the forest thickens, covering all trace of the other people who once lived here and who built Michipicoten into a major entrepôt. Stables, residences, boat-works, fish-sheds, tinsmithy, stores, and warehouses have vanished completely under the exuberance of wild new growth. Of the Big House that factor Peter Bell built in 1877 to the dismay of Company accountants, nothing remains but a crumbling cellar and a few piles of bevelled fire-bricks. To those who look closely, however, living remnants of the old days can still be found; for among the indigenous plants are others nourished by women who sought to surround themselves with a few reminders of gentler times and places—lilacs, spiraea, and Live-forever.

On September 27th, 1848, Paul Kane stopped at Michipicoten and painted a portrait of the chief of the Ojibway band. The chief's name was Maydoc-game-kinungee, I Hear the Noise of the Deer. He stares glumly from the canvas, a bald and thickening figure wearing the red jacket "given by the Company to such Indian chiefs as have been friendly and serviceable to them", listlessly touching the Queen's medal on his chest. Two years later, the Robinson Treaty of 1850 established Michipicoten House as the centre for the distribution of government annuities, thus ensuring that the Indians would stay closer to the post and not form alliances with independent traders as they had been doing when they journeyed down to collect annuities at Manitoulin and Drummond islands. The treaty also established a reserve "four miles square at Gros Cap, being a valley near the Honorable Hudson's Bay Company's post of Michipicoton, for Totominai and tribe". Thus the Ojibway were officially displaced from the mouth of the river.

Today, a branch of the Algoma Central Railway runs through their reservation, linking the Algoma Ore Division at Wawa to its docks at Michipicoten Harbour. This spur line was built in 1899 by Francis Hector Clergue, a compulsive entrepreneur who was interested in iron and therefore in Michipicoten. One by one, he named promising deposits

in the area after his sisters: Helen, Lucy, Ruth, and Josephine. Almost single-handedly Clergue industrialized Sault Ste. Marie at the turn of the century, and his syndicate eventually controlled the power company, the pulp and paper mill, several nickel mines, the Algoma Central Railway, and a steel mill.

In 1903, Clergue's Lake Superior Corporation was involved in a local political scandal. Officers of the Corporation brought a score of men across from the American side, sent them by train to Wawa and Michipicoten, and bribed them to vote in the names of dead and absent miners for the Liberal candidate. All subsequently swore at least once that they had worked the requisite ten years at the Helen Mine. The Company boat which ferried them across the river was the *Minnie M.*, and the affair was immortalized by an anonymous Conservative poet in "The Cruise of the Minnie M.", which concludes:

O, Captain, whence these fine cigars,
These bottles, black and green?
And kegs of beer are everywhere,
Oh say, what can they mean?

For Clergue, Michipicoten became not only an extension of his empire, but also a retreat. Sharing the mining venture was his brother Ernest, who lived on a small island in the harbour, guarded by trained bears and connected to the mainland by a cable-car. To this island Francis H. made frequent visits, gliding out of the Sault in his dark yacht, *Siesta*.

The contract for the actual construction of the spur line was given to James Conmee, MPP for Algoma West and an ex-cavalryman who in 1883 and 1884, under a similar contract for the CPR, had hired Mormon muleteers to haul rails and supplies northward from the Harbour. The construction of these railways brought radical changes to Michipicoten, ending forever the old commercial patterns based on the lake and the river. The influx of CPR materials occurred when the fur trade was in the final stages of its

decline, and the Hudson's Bay Post at the mouth of the river, soon to become the headquarters for the new provincial department of mines, was long past its prime.

At the harbour a village sprang up and expanded rapidly, swollen by gangs of navvies. After them the proprietors of service industries inevitably followed—whiskey pedlars and ladies with names like Boxcar Rosalie and Caboose Susie; when Michipicoten had its first police raid, in October 1884, at least thirty whores left town. The police had been summoned from Toronto to subdue a gang of ruffians led by one Charles Wallace, and the reports of what happened when they landed read like a slapstick comedy complete with wild gunfire, smashed whiskey kegs, stereotyped injuns, and the escape into the hills of the evil Wallace, armed like a Mexican bandit.

When gold was discovered at Wawa Lake in 1897, use of the Harbour once again increased, and an army of prospectors and miners joined the 300 to 400 resident lumbermen. Scheduled steamers arrived heavy with passengers, and the hotel bar rooms and billiard rooms ("Keep One Foot On The Floor!") did a steady business.

Until 1941, long after the gold boom had died, the lake steamers brought tourists to Michipicoten. Sometimes visitors rented boats to row across the bay to the site of the old fur post where the Big House, once the factor's pride and the Headquarters of the district, still stood. Inside, they found strewn on the floors hundreds of mouldering documents from the last days of the fur trade—indentures, shipping bills, invoices, journals, and correspondence. For a time, before the last papers were destroyed or taken as souvenirs, it was possible to catch glimpses of a stern order in the midst of this disarray, and to see what the Hudson's Bay Company had once meant to its servants in the outposts of the district—Batchawana, Agawa, Missinaibi, Pic, Long Lac, and Nipigon. For a time the reports of lonely men, dedicated still but bruised by the vagaries of nature and commerce, were there for all to read:

April 30 1858: Dear Sir I embrace this opportunity to inform you that the Indians has a good hunt but the Martens is not so numerous as last Winter their is two of my Indians that died last Winter and their is another Sick he is one of the best hunters at the place and their is another of my Indians that has been informing Some of the Indians at this place to Cash Some of their furs on purpose to trade with a man from the Saut St Maries by name Clark but I will try to get hold of the furs if possible and in regard to Que Sic I have hard that his Wife two children is dead and their father very Sick not expected to recover this is a remarkable Spring scarsely any Geese to be Seen at this place and I would be very Glad if you would give me permission to take my Wife to Mishipicoton along with me....Please Sir condescend to send me the Books that you promised for I am like to die for this place is very lonesome...

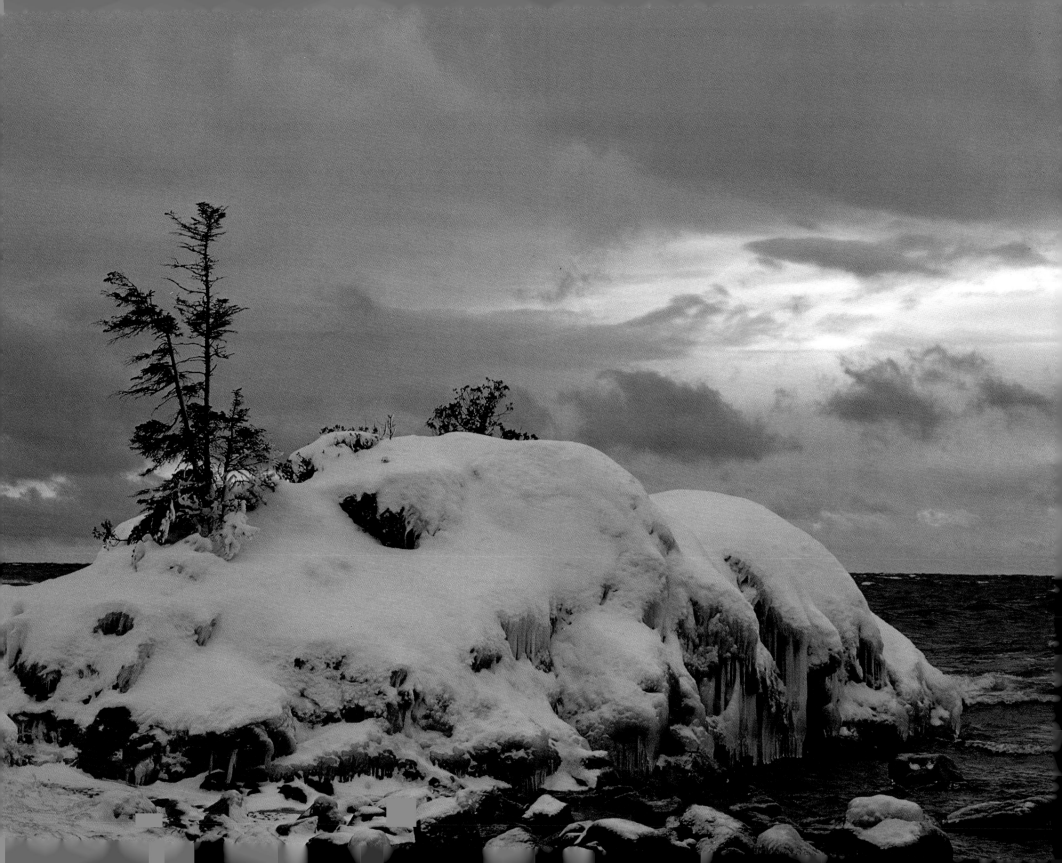

The night had been calm, and the water,
when we left the island, was perfectly smooth.
We had proceeded about two hundred yards
into the lake, when the canoes all stopped
together, and the chief, in a very loud voice,
addressed a prayer to the Great Spirit
he then threw into the lake a small quantity
of tobacco, in which each of the canoes followed
his example . . .

John Tanner, *Narrative*, 1830

Even if they made the widest reasonable traverse of Michipicoten Bay—from Grindstone Point to Point Isacor—the North West brigades would not touch at Michipicoten Island. It would lie on their left throughout the crossing, sometimes close, sometimes distant, its peaks rising through the clouds like watchful heads.

"The savages," wrote Father Dablon, "say that Michipicoten is a floating island, which is sometimes far off, sometimes near, according to the winds that push it and drive it in all directions. It is not incredible that the mists with which it is often laden, by becoming thin or dense under the sun's rays, make the island appear to the observer sometimes very near, and at other times farther away."

The French named it Maurepas, after Louis XV's Minister of Marine, but the Indian name prevailed—after Sault Ste. Marie the second oldest geographical name in Ontario. The legends remained also: the island was made of beautiful stones and shining metals; it was the home of giants; it was the home of gods; it was as dangerous as it was enticing, for it contained lethal substances and was surrounded by poisonous vapours. "They all imagine that it is the abode of

an evil spirit . . . and say that they have seen around it fishes with the form of a man." Raudot went on to report an incident in which four Indians had died from verdigris poisoning on the island. Jonathan Carver preserved an even more dramatic tale:

One of the Chipeway chiefs told me, that some of their people being once driven on the island of Mauropas . . . found on it large quantities of a heavy shining yellow sand, that from their description must have been gold dust. Being struck with the beautiful appearance of it, in the morning, when they re-entered their canoe, they attempted to bring some away; but a spirit of an amazing size, according to their account sixty feet in height, strode into the water after them, and commanded them to deliver back what they had taken away.... Since this incident, no Indian that has ever heard of it, will venture near the same haunted coast....

At least part of their fear was well founded. The canoe journey to and from the island is extremely dangerous. Even if the crossing is made where the flanks of island and mainland draw closest to each other, the gulf is still more than ten miles wide—at least two hours' paddling on a calm

day. As Charlevoix and other travellers noted, within fifteen minutes the surface of the lake can change from a gentle undulation to a maelstrom of cross-currents and tumbling breakers, and to capsize halfway on such a journey would mean certain death. Many times Michipicoten must have lured travellers by drawing close, so close it would seem only a few minutes' paddle to those bluffs and enticing valleys, and then by receding as their prows pushed towards it, wrapping itself in mist at last and leaving them to rain squalls and to the mounting wind.

But others followed, for the rewards were great. The island was rich in game. Caribou either swam across or journeyed over on the ice; wolves followed. Mink, marten, and muskrat abounded on the island, as did lynx, rabbit, silver fox, and beaver. Waterfowl inhabited the inland lakes and marshes. Like other large islands, Michipicoten is a natural wildlife sanctuary, and there have always been those with sufficient daring to take advantage of its bounty.

When Alexander Henry journeyed out in 1769, however, he was less interested in hides and meat than in valuable minerals. Indians had reported that the island

contained shining rocks and stones of rare description. I found it one solid rock, thinly covered with soil, except in the valleys; but generally well wooded. Its circumference is twelve leagues. On examining the surface, I saw nothing remarkable, except large veins of transparent spar, and a mass of rock, at the south end of the island, which appeared to be composed of iron ore.

The "stones of rare description" were likely agates, washed down out of the volcanic bluffs and polished smooth on the beaches. These are the most intriguing of all stones, unobtrusive and delicate but infinitely rich in pattern and colour. They suggest all the subtlety of the North, holding suspended the curving shapes and near repetitions of its beaches and horizons, absorbing light rather than reflecting it, asking to be looked into, not at. Like diamonds and pearls they are crystallized time, but beside them diamonds seem crass, and the lustre of pearls grows bland. The colours and textures of agates combine to yield a generative warmth, a perfection freed from symmetry.

Although he travelled observantly around the island, Henry failed to find in agates the beauty which the Ojibways had seen. Agates are useless, after all, and Henry was a practical man in search of malleable ores. He was only the first of many. After him would come Mathews, Jones, Grierson, Griffiths, Bonner, and Fletcher, and they would find copper and dig it out. At great expense, and against the opposition of the Indians who in October 1854 raided the mines and drove the miners, temporarily, to the Sault, ore was hauled by wagon across the island and shipped from Quebec Harbour on the south side. Despite the involvement of several companies, however (notably the Quebec and Lake Superior Mining Company, Michipicoten Native Copper, and Standard Oil), the venture proved uneconomic and the miners departed for good. Brush covered the roads, pits caved in, and head-frames rotted. Today, the most conspicuous evidences of Michipicoten Island's mining past are congregations of decaying claim stakes.

Another industry was more successful. At Quebec Harbour, the Hudson's Bay Company had maintained a summer fishery for many years, and other commercial fishermen followed their lead, guiding their schooners through the island's fog and into shelter. A little village grew up in the northeastern corner of the harbour, and two log buildings remain from the old days. In one, an imposing square-timbered structure, a hand-lettered sign stretches along the wall above the litter of decades: "A Place For Everything and Everything in its Place."

With the mining activity and the growth of the island's population, shipping increased. Ore boats and supply vessels regularly arrived from the mainland, and Quebec Harbour became a port of call on the steamer route from Sault Ste. Marie to Fort William. Entering the harbour in

1872, Sir Sandford Fleming's party found the *Manitoba* aground on a sand bar. For three hours Fleming's ship, the *Frances Smith*, added her efforts to those of a tug summoned to free the luckless side-wheeler. John Macoun, the expedition's botanist, was delighted with the delay and used it to explore the harbour which, like Gargantua, proved to be a treasure-trove of rare species.

Another visitor that year found less to gratify him. Isaac Hope was likely sent to the island to supervise the construction of its first lighthouse, at the entrance to Quebec Harbour. On 11 July he wrote to the Postmaster General:

Michipicoten is an exceedingly dreary and desolate place, entirely destitute of any accomodation whatever. I have laid over a board every night since I came here, and have to live in a small shanty 10 feet by 12 feet and 5 feet high, in which there are twelve men boarding besides myself. This is the best accomodation the Island affords. I will have to remain here until the Contractor, Capt. Perry, finishes the lighthouse... My health here is not nearly so good as I could wish... Should it not improve, I am not quite certain but that I will have to give up my appointment....

Captain Perry's lighthouse was a squat structure, attached to a residence at its west side. Its foundation is there still, overgrown with skunk cabbage and littered with rusted square nails and grey cedar shingles. From its vantage point one can look inland where air currents generated by the land and by the warmer water of the harbour keep the fog at bay, often letting the sunlight through while the lake elsewhere is thickly shrouded. Half a mile south, the foghorn at the newer installation on Davieux Island moans at intervals, and the new light which replaced the kerosene apparatus ("Manufactured at Dominion Lighthouse Depot, 1917, Prescott, Ontario") winks rhythmically, both a beacon and a warning.

Like others on the lake, the Michipicoten Island lights are tended with pride and diligence, and like others they have their tales of sacrifice. Before World War I, the lightkeeper here was lost on an autumn journey to the Sault. His wife and children carried on, and after the war one of these children, Frank Sherlock, brought his English bride back to the island. Perhaps intending to trap, they stayed on after the close of navigation in 1928, and in January of that winter they lost everything to fire. They and their infant daughter survived on what could be shot and foraged until the lighthouse tender reached the harbour in May.

Despite the lights and the sacrifices of those who keep them burning, the island has taken its toll of shipping. The charred hulks of three fishing tugs lie inside Quebec Harbour, and the outside beaches are strewn with relics of other misadventures—shattered boat sections with rows of nails bared like teeth; oars evilly splintered; snapped cork life-rings trailing canvas cerements. In May 1914, Indians hunting on a western beach were confronted with the most grisly evidence of disaster imaginable. Rising and falling in the off-shore swell, was the corpse of a man held upright by the ring which in a warmer lake might have saved his life. It was the body of Chief Engineer John Gallager of the *Henry B. Smith*, sunk the previous November.

Two wrecks are known at the island's western end. In three fathoms just north of Shafer Bay, the ribs of the *Strathmore*, foundered 8 November 1906, reach like raised arms around the shattered boiler. In the alders a mile to the south are two flattened metal lifeboats from the *Chicago*, a freighter that grounded and sank 23 October 1929, while groping its way north in a driving snow storm.

These are the known wrecks; but others must lie on that screen of islands off Michipicoten's southern shore—Green Island, The Breeders, Antelope Rock—and on the reefs which surround its western end. On the shores of the island itself there must surely be many more, schooners, brigs, side-wheelers, and propellors. Where is the little schooner *Otter*, sunk before 1822; or the *Merchant*, lost somewhere in the lake with fourteen people in 1847; or the *Leafield*; or the *Bannockburn* which vanished in a great storm on

21 November 1902; or the *Henry B. Smith*, or the *Lambton*, the little lighthouse tender; or the *Kamloops*; or the mine-sweepers *Cerisoles* and *Inkerman*? Of the 280 vessels known to have sunk on Lake Superior, twenty-four vanished without a trace, and it is not possible to stumble upon the *Chicago's* pitifully squashed lifeboats in their shrubbery, or to look out across the reefs foaming in a storm at the west end of Michipicoten Island, without hearing the phantom splintering of timbers and the shouts of frightened men. How would it have felt to hold the wheel of the *Griswold* running under one headsail before the gale, struggling to keep the ship from wallowing in the troughs, and not to have seen the surf until you were in it, realizing too late that the darkness beyond was not the gathering dusk as you had thought, but headlands? What would it have been like to have been a stoker on the *Sovereign*, black with coal dust and sweat, surrounded by the clatter of shovels on steel plates, and the clang of furnace doors and slice bars, and the grinding of crossheads dodging up and down and of cranks revolving in their pits—to have been that stoker shouting to the engineer or to the oiler making his rounds, and suddenly to have heard through the clamour the futile pipings of your captain, and a moment later to have felt the death-shudder of your ship?

"We brought up chains in our nets," the fishermen say, "Also pieces of oak and rock-elm. And sometimes, bits of clothing...."

On calm evenings the caress of the lake on the island's beaches is so gentle that it moistens only a narrow band of pebbles. Gulls curve over the eddies beyond The Breeders, and skimming so close to the surface that they lose themselves in reflected sun, little flocks of mergansers sprint from one bay to the next. On such evenings the calmed elements unite. Journeys cease. Earth and sun move imperceptibly together, fusing at last into ochre and grey striations as delicate as agate. Sometimes with dusk the *jebi-ug nee-idewand*, the spirits of the dead, will begin a high restless dancing among the stars, and sometimes the aurora will fall in shimmering wings to the horizons, spreading like a benediction across all the meetings of earth and water.

All true wisdom is only found far from
men, out in the great solitude, and it
can be acquired only through suffering.

the shaman Igjugarjuk, to Rasmussen

Between Michipicoten and Heron Bay, the shore sweeps out like a flenser, keen and hostile on all charts except those of largest scale. Shelters seem few, and the course that first recommends itself is to stay far offshore to avoid reefs, and to move with all speed to Michipicoten, to Heron Bay, or to the intermediate harbour at Otter Island.

Seen from a mile offshore as most of the eighteenth- and nineteenth-century diarists saw it, settled among the packs in a canot du maitre or wrapped up on the deck of a steamer, the shore is indeed inimical and barren. "Rocks and pines," one traveller complained. "Rocks and pines!" Contours, beaches, even separations between islands and the mainland become lost in haze and distance. From one mile offshore the traveller will see no sign of life, and even in full sunlight this stretch will be for him the most desolate on the lake. "The northern coast," Raudot concluded, "is terrible because of a chain of rocks and mountains."

But for those prepared to take time and to use a canoe, this wild place at once becomes inviting. Much of its threat vanishes simply because one's craft can be taken off almost anywhere. What seemed a formidably monolithic coast is actually intimate, enticing, screened by rows of islands and dented by hundreds of tiny bays, some with entrances just large enough to admit a canoe. Streams drain into many, sometimes tracing surreptitiously through the undergrowth, sometimes plunging boldly out from overhanging cliffs. Many have beaches—coarse boulder beaches or beaches with sand as fine as powder. Hidden in some bays on the north shore are beaches where every pebble is a separate world of colour.

The rock here is granitic and unequivocal. It is the most implacable of rocks, bearing glacial scars ten thousand years old which lichens and weather have scarcely begun to erase. On a stormy day, surf striking its flanks will rise seventy feet, caught, like the harebells in their crevices and the white-throat singing "poor Canada Canada" behind the beach, in a process older than time.

The contrast of elemental force and resilient delicacy is the most intriguing aspect of this shore. Here the human traveller, like other animals that have left spoor along the beaches, enters a labyrinthine complex of checks and tensions. To all but the most arrogant, the notion of man's

63

stewardship fades to nothing in such places. For a little while we participate, and then we go.

Scattered all down the length of this shore are mementoes of human passage. Behind a cairn that is bare of lichen and conspicuous in its newness, is a camp left from the previous autumn, the tent collapsed on its contents, the area littered with hacked brush and lengths of nylon cord. At the back of a deep bay, sheltered by a copse of spruce and a bend in the shore, lie the remains of a trapper's cabin, door hanging by a leather hinge, lower logs crumbling, moss chinking long since sifted away. No one knows how many such cabins have been built along the shore by tough and reclusive trappers who ran lines far inland: Some of their names survive: Dave Catasson, N. W. Foster, and Ross Hamilton; Madji Nugent, for whom the Dog (now University) River was perhaps an ancestral hunting ground; William Richardson, who gave his name to Richardson's Harbour; William Newman from Otter Bay; and that elusive woodsman who left carefully chiselled records in Les Petits Morts and on the flank of an islet in Ganley Harbour.

FRANK KUSHICK.

Many people have vanished here, dead by accident or starvation, and many more have survived only by taking drastic action. Stormbound just west of Otter Head after a deserter had pilfered his supplies, William Keating lived for a short time on the barest subsistence the land offers—tripe de roche, *wendigo wahkoonun*, the green-black fronds of lichen that can be cooked into a glutinous porridge. Keating claimed that he had "never tasted a more nauseating food," and John Long reported the dysentery of traders who had eaten nothing else for two weeks, "which weakened them exceedingly. When the disorder does not terminate in a flux, it occasions a violent vomiting, and sometimes spitting of blood, with acute spasms in the bowels."

The only settlement of note on this portion of the shore was Pukaskwa Depot, before World War I a lumbering village of several hundred people tucked into a deep bay

between the Pukaskwa River and Pointe La Canadienne. Today at Pukaskwa the Imogen River flows through the tangle of timbers that was once a bridge linking the halves of the village, out into the bay behind a long finger of beach. The sand steams in the sun, and gulls paddle close, heads zig-zagging, alert for morsels in the current. The meadow to the east is dotted with the collapsed hulks of buildings. Of the homes, warehouses, workshops, implement sheds, and stables that once composed this village, only one remains erect—an office with living quarters behind. Carved into its door are the names and initials of travellers. Inside: a punctured tin washbowl, a broken bed, a remarkably good pair of woollen socks.

Behind the beach to the west, surrounded by daisies, wild roses, bunchberries, and scores of rotten cans, is the graveyard. Only one grave is fenced and marked, its wooden monument topped by an extravagant metal cross. The name has long since been eroded away, and there is no way of telling whether the blacksmith shaped this cross for a friend crushed by boom logs, or for a woman, or for the children killed here in the burning of their cabin.

The mouth of the Pukaskwa River itself was probably more favoured by the Indians than the site of the later European settlement. In 1849, Thomas G. Anderson, the Superintendent of Indian Affairs for Canada West, visited the region for the first time, and after forming an opinion of his charges at Fort William ("... aborigines luxuriating in all the filth, want and misery which an indolent and improvident parentage could for ages bestow ..."), after carefully recording the details of Indian sexual arrangements at Pic, he travelled eastward to be romantically overcome by the Pukaskwa gorge:

... passed Puc-kus-wah Sr-be and went into the most beautiful spoon shaped basin to the falls, which come tumbling down a tremendous chasm in the rocks. It hastens down with the wildest speed conceivable, as if to escape the threats of the over hanging precipise on either side—im-

mense rocks have fallen into it from the height, against which, in its furious progress to the placid basin below, it dashes head-long throwing its spray all around and creating rainbows innumerable

More restrained, John Bigsby called the gorge a "dell of considerable beauty", and lingered long enough to trade with Indians fishing there, speculating on their thoughts at the sight of the "ill-concealed confidence of mastership" in the white faces. He reported a man with a leaf stuck where his nose had been, perhaps an adulterer on whom the husband had taken customary vengeance. The name Pukaskwa itself, made homophonous to a blunt English suggestion, has spawned several not very imaginative tales about travellers and cuckolds.

Only one story, however, truly captures the sense of menace in the gorge at Pukaskwa. According to this legend, a marauder once stole a young woman from her father's lodge at Michipicoten and fled with her along the north shore, hotly pursued by her kinsmen. When he reached this river he turned inland, but finding the woman a serious encumbrance and enraged that he could not escape with her, he killed her. The story concludes by telling how the soul of the girl was transformed into a white doe of such radiance that the sight of her caused death, and how to this day, a peril to all who journey on the river, she roams in search of her murderer.

Partly because of such tales and partly because of the romantic associations of its gorge and its dead village, the *orenda* of the Pukaskwa is unique to the shore, a restive and disquieting atmosphere.

The Pukaskwa has given its name to the most enigmatic artifacts yet discovered on the north shore. Behind the present beaches are others, higher and often broader, devoid of all life except rudimentary lichens spreading crusty greys, blacks, and greens across the stones. These are the strands of ancient lakes, abandoned thousands of years ago but still holding the shapes of the last waves to wash across them. The cobbles which compose them may be as small as a man's fist or as large as his head. In some places elfin clumps of forest have rooted and persevered against the winds, but usually these beaches are barren except for the lichens. They stretch up behind the screen of shrubbery which separates them from their sandy counterparts, grey-green relics from an ancient world. Extinct species paced them once; strange fishes probed them. To leave the familiar surroundings of the lower beaches and push up through the fringe of undergrowth onto a large cobble beach is to leave time behind. Usually the only creatures to be seen on these beaches are members of a most venerable family—dragonflies which have not changed appreciably in 135 million years.

Of all natural phenomena on the north shore, the cobble beaches most successfully defy the lens of the photographer. In pictures they seem flat, but they are not; they undulate, curve, and insinuate themselves under the flanking forest cover. Nor are they as pallid and inert as they seem in photographs, for the lichens create a haze as chimerical as the coming of spring to an April forest. A camera cannot suggest their muffling silence or the miragelike fluctuations that play across their surfaces.

For archaeologists and ethnologists, these beaches hold a special fascination. Although many are bare of all signs of human activity, others are dotted with the remnants of old structures. On several, cairns—too far back to serve as navigational aids at the present water level—are arranged in curious patterns. One beach has forty-seven in two meandering lines. No one knows who built them, or when. We know only, from the patterns of lichen growth on them, that most are at least several centuries old. They are bleak relics, the most elementary archaeological finds imaginable—a rude mound of rocks. Yet their challenge is appropriate to their setting.

Even more intriguing are the shallow depressions often found with them. These are "Pukaskwa Pits". They were

made simply by removing the boulders from round sections of beach, varying in diameter from three to seventeen feet, and in depth from a few inches to about four feet. Some pits have walls roughly three feet high above ground level. A few are rectangular. Sometimes they occur several to a beach and sometimes singly. A few may have been caches or smoking pits for hides or fish, but some contain evidences of habitation. They would have been excellent overnight shelters, for they could be quickly made and they give almost complete protection from the cold winds off the lake. Also, their exposed position is the best defence against surprise by hostile parties. If security was not a factor, they could easily be roofed with hides or bark, or warmly covered with an overturned boat.

A few Pukaskwa Pits seem placed for maximum exposure to the elements. These are usually the highest and the smallest, situated on the most remote beaches. They were very probably vision pits, retreats for shamans and for youths on their first and most important quest. To understand their use, imagine yourself travelling on the lake in another time, drawn by a glimpse of a plateau across a bay. At first it is unclear in drifting fog, but seen closer it is unmistakably an upland beach, a sterile band, paler green than the surrounding forest, paler grey than the dark lake. There is no movement on it, although a man sits erect in its centre, a tiny, vulnerable figure gazing out to the place where lake and sky join together. What he hears you do not hear; what he sees you do not see. If you are tired and hungry, he silently reminds you that there are journeys which do not begin until the body is forgotten. If you are frightened of the winter circling with the wind, he reminds you that the human dread behind such fears can be confronted, can be disarmed and absorbed in unknown repositories of courage. A seer, he is alone by choice. Time to him is nothing. Perhaps he will return among his people, perhaps not.

Or imagine a slighter figure there; not a boy but yet with the suppleness of youth, not a man but with a man's strength latent in the curve of back and shoulders. This figure is less assured, an explorer approaching the boundaries of his courage, learning its extent. His immobility says: "I can be found here; I will not hide." Soon there will come to the boy from the formless visions induced by hunger, and sweating, and exposure, conjured with the recollections of hybrid figures in the firelight, a single dependable image, a guide to serve through the phantasm that is life—perhaps a fish, perhaps a bear or a cat, perhaps a bird, perhaps none of these but instead an amalgam bound together in his person, waiting for consecration in his name. Imagine your canoe passing, the fog closing behind.

Fog often hid the beaches. In June, the fur brigades would sometimes travel for days as they are shown in Frances Ann Hopkins' brooding canvas—in close line astern with their pitch-pine torches forming a serpentine trace of fire. In the lead canoe the guide would listen to the surf on his right, gauging his position from its distance and from his experience of many passages along the shore. Except while rounding dangerous points like Isacor or La Canadienne, or while passing Otter Head (a remarkable rock shaped as its name suggests, marking the half-way point of the trip), the passengers would doze on such days, and the paddlers, subdued, would journey in separate reveries. The old beaches and their relics would be well hidden, just as on clear days they would often be veiled by distance and boredom; "...altho I enjoyed the view as beautiful," said Lefroy, "the satiety produced by repitition even to the sense of sight, denied the admiration it deserved...." It is curious, nonetheless, that the Pukaskwa Pits are not mentioned in any of the early journals and that they escaped the notice of such keen observers as Agassiz, Houghton, Thompson, and the ever-alert John Bigsby, prowling the shore "hammer in hand and ink-bottle on button-hole". Perhaps they were so common and used so regularly that they were in no way remarkable, the fabric of Indian life having not yet unravelled sufficiently to expose them. Perhaps they

66

were simply overlooked amid the profusion of more interesting botanical and geological phenomena. Or perhaps like much else along the shore they have long been known to quiet men for whom they were just further evidence of human transience, like the decaying cabins behind the shore or the caches whose owners never returned.

On a point not far from the Julia River stands a unique cairn. It is man-shaped, dwarfish, ragged with old lichen. Its rotund little body supports a triangular head canted slightly away from the lake in a raised-chin posture of defiance. It appears to mark nothing in particular and may, like some other cairns, have been a voyageur memorial to drowned comrades. No durable artifact could be simpler or more symbolic of the human relationship with this shore. For ten thousand years we have journeyed here, settled briefly, passed on, and been forgotten. All we have achieved in that time is an insignificant re-arrangement of the materials we found. It may be no more than other animals have achieved unthinkingly; but it is human.

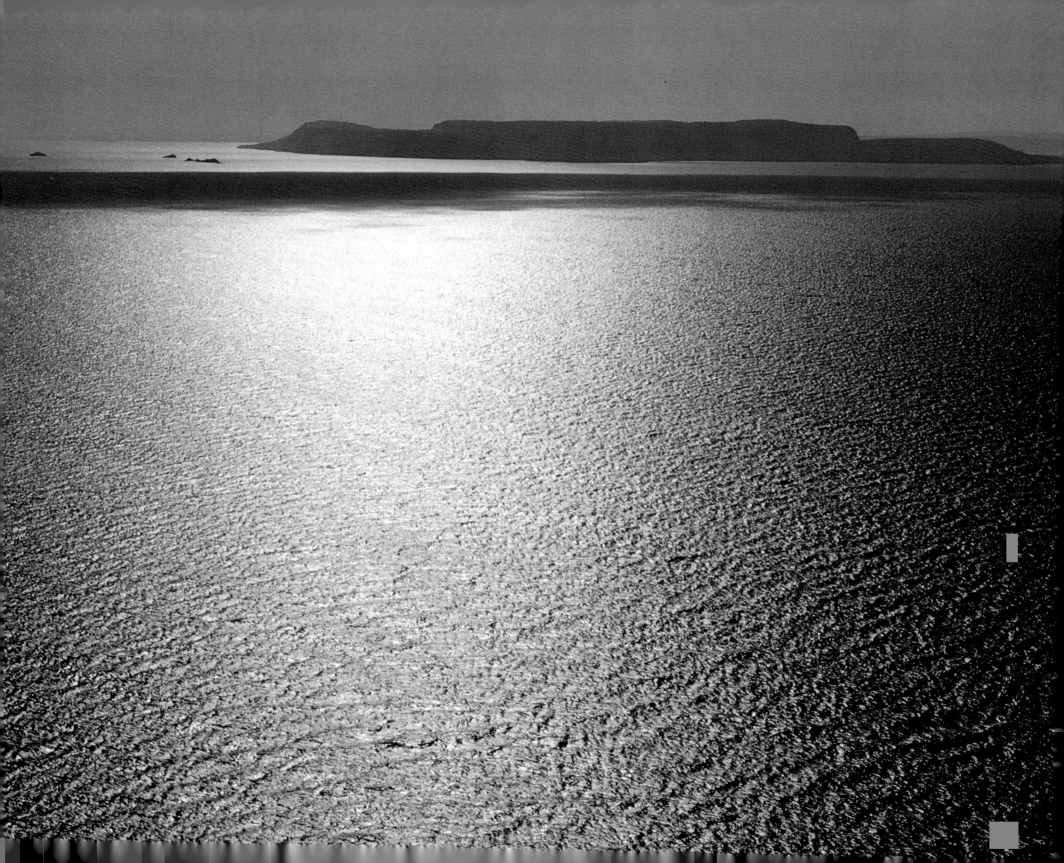

*Mystery, or unknowing, is energy. As
soon as a mystery is explained, it ceases
to be a source of energy. If we question
deep enough there comes a point where
answers, if answers could be given,
would kill*

John Fowles, *The Aristos*

The Pic River is a highway to Long Lac in the interior. It is sluggish, muddy, broadened by many creeks and marshes. For forty miles canoes can travel on it without portage.

At the mouth of the Pic is a spectacular beach sculptured by the wind into high dunes. Indian children once tobogganed here on scraps of birchbark as they did at Michipicoten, and, as at Michipicoten, their parents' lodges stood just inside the mouth of the river. Here the white traders found them, and here they settled also and built their forts.

Stopping in the spring of 1793, John Macdonell's brigade camped half a mile from Gabriel Coté's trading post, near a cemetery which had eleven new crosses. Coté's fort was a modest establishment, enclosing less than an acre with its nine-foot pickets and consisting of only two small buildings, a warehouse and a residence, both made of cedar logs. Coté's roof was cedar bark and his fireplace and chimney were stone chinked with baked mud. He owned a frying pan, a copper kettle, two wooden platters, twelve chairs, two poplar tables and a desk, eight crystal goblets, and two "miserable" bedsteads.

The North West Company also built a post here, with a "big house" of squared timbers, roofed with boards. Their upstart rivals, the XY Company, Les Petits (or "Potties"), also built here and traded briefly until the Nor'Westers absorbed them in 1804. There were other settlers as well: James Evans, a Methodist who journeyed from Michipicoten to minister to 120 heathen souls; and Thomas Hurlburt who, after three years of lonely work, three years of squinting out through rawhide windows, would report brightly to the Methodist General Conference that "a whole people were shaking off the slumber of years and casting their idols to moles and bats"

In 1821, the Hudson's Bay Company brought consolidation and British order to the Pic, with red-trimmed white buildings grouped around a planked square. Its palisade was formidable, and sported a barbican above the entrance. Here the English traded, fished, grew potatoes, and made York boats to be outfitted from the forge at Michipicoten. And here, as elsewhere on the shore, the post journals contain a record of the round of daily life, as well as a record of deaths. Most were Indian deaths, caused by tuberculosis,

69

smallpox, cholera, diphtheria, and even measles. Erland Erlandson's journal from 1846 is typical:

November 12... Little did I think when I adverted to the illness of the Indians yesterday that one of them should so soon have departed from this world of troubles. About noon old Borgue was sitting at the fire of his lodge, conversing cheerfully with his children and grandchildren when he suddenly fell over and expired without a groan... Poor La Perdix Blanche died on the 22nd leaving a wife and five children wholly unprovided for... Nov. 29... At 2 p.m. the wife of the late Per Blanche departed this life leaving 5 children, the youngest a helpless infant... Dec. 20... Mowisse arrived with the melancholy news that his sister died ten days ago, and his mother the day before yesterday....

Almost a century after Erlandson made these entries, long after the last brigade had passed, and the schooners *Recovery* and *Discovery* had anchored for the last time off the mouth of the Pic, a young teacher at Heron Bay was walking the beach with a friend. There had been a great storm the day before and the lake, perhaps lifted by a seiche, had swept far up across the beach. Near the river the two men saw that the storm had exposed a line of rotting logs, the butts of a palisade. They began to dig, and soon uncovered a large roll of birchbark, carefully stitched as if it contained something of great value. Inside was a wicker wrapper, and inside that was a soft doe-skin. Suspecting by then what they had chanced upon, they gently unfolded this last covering. Before them lay the skeleton of a little girl with a string of beads clasped in her hands.

They reassembled the coffin and returned it to its grave. They told no one. The contours of the beach changed; the sand sifted back over the remnants of the palisade. The teacher moved to another community and his friend, a Mountie, was posted elsewhere.

Years passed. Archaeologists came to the mouth of the Pic and began their methodical procedures, writing reports considerably more detached than Erland Erlandson's:

"...surface debris is to be found scattered... Stratum I... trade goods and pottery suggest a mix... three components, ranging from historic to A.D. 950 (plus or minus 800 years)...many aboriginal remains...."

What Rose Macaulay called "the familiar tragedy of archaeology—the sacrifice of beauty to knowledge" inevitably began with the first dig. Besides expanding knowledge, archaeology obviously brings much beauty to light. But archaeologists would be the first to admit (for they are lured on by it) that the larger beauty lies beyond reach of the technical aspects of their discipline. It is a beauty compounded of mystery and imagination, based in a shared humanity. The arrowhead discarded because of a slight imperfection and the sherds of an impeccably decorated pot are our imaginative links across time to the man and the woman who crafted them. Probably we are so constructed that we must strive *to know*, even while understanding how knowledge can be violation, even while admitting that facts are only facets on the surface of mystery. But at the same time we yearn to keep intact an imaginative space safe even from archaeology, the gentlest of sciences. That is why a found arrowhead or pot sherd is more exciting than the same object in a museum, and why it is easier—in the place where it has lain for centuries—to evoke something of the laughter, anger, fear, hunger, pain, passion, and sorrow of the human drama which once surrounded it.

This need for mystery is also why it is gratifying that the grave of the child, chanced upon years ago by the two friends, has never been rediscovered by archaeologists. Protected once again, the grave is the resting place of a child, not of an object or a collection of objects. And the scene to which the imagination reaches back remains intensely and immediately human—a man and a woman kneeling together and alone in the dunes, tiny against the huge sweep of the beach and the lake behind them.

"... the essence of the trouble is that
compromise is held to be a virtue of
itself."

James Agee, *Let Us Now Praise Famous Men*

After Heron Bay, the brigades made two traverses in quick succession: across Peninsula Bay to Pic Island, and from Pic Island across Ashburton Bay to Bottle Point. "I had", wrote Lefroy,

"some experience of the dangers of the lake the day we left the Pic. The brigade had as usual pushed on, while I remained behind to finish my afternoon observations; meanwhile the wind and the sea got up, and they were forced to put ashore at Pic Island. It was pretty rough when I started, but got so much worse that I would have gladly turned back, but this was impossible. A heavily laden birch-bark canoe is no craft to face a heavy sea, but we had to keep on, and by God's good providence and the strength and coolness of my two *buttes*, we effected the transit in safety, though our companions, when we rejoined them, declared that they had given us up, and were considerately engaged in erecting a cairn to our memory."

In 1823, John Bigsby climbed a hill on Pic Island, while David Thompson bargained for fish with Indians below. "As I turned towards the land, tall, casque-shaped islands were seen here and there, bordering the north shore, full of sinuosities, and over looked by pleasingly-grouped hills of conical or waved outline, from 600 to 800 feet high. I was well repaid for the trouble of the ascent."

The mainland that Bigsby gazed down upon is now called the Coldwell Peninsula, named for the CPR contractor who lies buried near the tracks at its eastern edge. German POW's and Nisei families uprooted from British Columbia were brought here during the Second World War to cut pulpwood for the Pigeon Timber Company. Some of the scows they used lie stranded and rotting on a point just east of the Neys campground. At the turn of the century, the Pic Channel was the scene of a particularly bizarre murder, when three Moses brothers, Antoine, Louis, and Peter, all giants, killed their brother-in-law and sank his body in his own sailboat.

The "casque-shaped" McDonald and Sullivan islands remain the same as they were when Bigsby saw them, backed at a distance by the pitted beaches of Detention and Monmouth islands, and by brooding, elevated strands of Red Sucker Point. Except for the railway winding near the shore, and the double ranks of hydro towers marching across the hills, the scene is much as it was when David

71

Thompson charted the coast in 1798. But if they were to pass this way today, Thompson and Bigsby would be wise not to bargain for fish. Sewage from the town of Marathon, and mercury and other chemicals from the chlor-alkali plant of American Can, have laced the sediments of Peninsula Harbour with poison. How far this poison spreads into the lake depends on the winds, on the body chemistry of fish and bottom organisms, and on the circling currents of the lake.

Ontario law provides for imprisonment and for a fine of $10,000 for every day that such pollution continues, but it continues every day at Marathon, at Terrace Bay, at Nipigon-Red Rock, and at Thunder Bay. It is allowed to continue because of the gap between law and policy, a gap that is both economically sound and humanitarian. Put briefly, the policy is not to enforce the law too stringently, because to do so would cause profitable enterprises to close and families to be more than a little inconvenienced. Because North America is paper hungry, pulp mills on the north shore flourish, drawing workers and their dependents; and because these men are industrious and skilled, the lake, where the tentacles of bush roads and highways converge on the shore, is being poisoned. Everyone wishes it were not so. Much money has been spent on filters, settlers, and systems to recycle and retrieve useful chemicals and metals. But we assume that there must still be compromises, trade-offs, and for this reason, and because nature's laws are less flexible than man's, Lake Superior water in some areas is unsafe for drinking and bathing, and there are fish roaming the lake bearing asbestos fibres and mercury in their flesh.

Much money has also been spent on simply disguising pollution. Pulp from the mill at Terrace Bay, 36 miles west of Marathon, is used for Kleenex, toilet paper, and napkins. The packaged products stress sanitation and convenience, and Terrace Bay itself, built by Kimberly-Clark in 1947, is both clean and convenient. It is, in fact, a planner's dream, "the gem of the north shore". It has modestly prosperous

homes lining a network of interlocking crescents, a decent golf course, and a convenient shopping plaza. The local Chamber of Commerce pamphlet which announces that pioneering has come a long way, is accompanied by a map that shows the lake as an angry black line at the town's edge, tossing up waves as tall as the Kimberly-Clark mill itself. Aguasabon Beach, behind which Ojibway and voyageur canoes once took shelter, is now called Kiwanis Beach. There are no canoes in the basin anymore, but only runabouts with flaring bows designed to confront and master the lake.

Terrace Bay fears the lake and more deviously than other north shore communities has poisoned it. Effluent from its mill runs through a drainage ditch into what was once Blackbird Creek, and hence through meandering wetlands into the lake at Jackfish Bay, four miles away. Because Blackbird Creek passed in some places embarassingly close to the Trans-Canada Highway, and because the appalling stench and the sight of billowing froth offended motorists, the Ontario Ministry of the Environment recommended that these "aesthetic problems" be eliminated, and that "the Kimberly-Clark Pulp and Paper Company ... develop alternative treatment methods to the existing Blackbird Creek system." The plan agreed upon was simply to install sewer tile and bury the creek wherever tourists might be shocked to see what it had become. Its drainage pattern remains the same; what it spills into Jackfish Bay is little changed. Sometimes foam drifts three quarters of a mile into the bay; and because of the absence of all bottom-dwelling creatures at the mouth of the creek (even highly-adaptable chitinous forms like scuds and sowbugs, even organisms that thrive on pollution like sludgeworms and rat-tailed maggots) the Ministry's 1972 report concluded that the effluent was toxic.

Jackfish is thus joined to Terrace Bay by a noxious link, a union poignantly ironic in view of Jackfish's setting and history. After working here in 1925, A. Y. Jackson wrote,

I know of no more impressive scenery in Canada for the landscape painter. There is a sublime order to it, the long curves of the beaches, the sweeping ranges of hills, the headlands that push out into the lake. Inland there are intimate little lakes, stretches of muskeg, outcrops of rock...It was this country that gave Harris the motives for many of his best known canvasses. There was a feeling of space, dramatic lighting, the stark forms of rocky hills and dead trees and beyond, Lake Superior, shining like burnished silver.

Indeed, Lawren Harris felt his spirit merge so completely with this region that after a summer spent at Coldwell, the Slate Islands, and Jackfish, he stopped signing his paintings. "We found," he wrote, "that, at times, there were skies over the great Lake Superior which, in their singing expansiveness and sublimity, existed nowhere else in Canada...," and he sought to capture this spaciousness both in his painting and in his poetry:

And light has no weight,
Yet one is lifted on its flood,
Swept high,
Running up white-golden light-shafts,
As if one were as weightless as light itself—
All gold and white and light.

A. J. Casson and Franklin Carmichael also lingered at Jackfish, painting the scattering of pastel, sun-bleached houses on the hillside. Oddly barren of human figures, the paintings presage the ghost town that Jackfish would soon become, as if the artists were already wishing it back to wilderness.

No one lives at Jackfish now. The huts where General Middleton's forlorn troops sheltered on their march to confront Riel have long since gone. The CPR factory that made one ton of explosive every day is gone. The whiskey shops have gone, as have the sheds where section hands gambled away their pay. Gone too are the hotels and boarding houses where rough men slept, drank, whored, and brawled....Port Arthur *Weekly Herald*, 1885:

...It appears that on the morning of the 16th of November [McMartin] had a quarrel with a man named Herritt, a boarder of Mr. James McKay, who keeps a boarding house at Jackfish Bay, which led to a fight ending in the beast McMartin biting off the nose of Herritt. This had the effect of causing McKay to order the man from his premises. . . .

The mountains of coal have been burnt away, gone with the last steam locomotive. The boardwalks that once connected the station to the pier lie rotting under mats of humus; and of the station itself, only the basement and the concrete platform remain. No trains stop. Most of Carmichael's light-hearted houses have vanished, either stolen piece-meal or burnt. In the back porch of one of the few left, littered with beer-bottle glass, are burlap sacks of oiled pine fishing-net floats, a type not used for thirty years. A little distance west of the main town site is a cluster of older log buildings, their rafters sawn out, their floors sodden with refuse.

Eight miles offshore from the dead community of Jackfish and the living one of Terrace Bay are the Slate Islands, a roughly circular archipelago of eight large and several smaller islands, still, as Cabot saw them in 1848, "high and blue". On the outside of the Slates is a lighthouse from which, at the turn of the century, the two young sons of the keeper would row to Jackfish for the mail. Twice a week they crossed the channel in a seventeen-foot skiff, returning at dusk with a lantern lashed to the bow and a reflecting frying pan tied behind it. The family rarely got any mail. What drew the boys was the challenge—the open water, the blue shore beckoning in the distance, and the sheer exhilaration of the journey.

Jackfish Channel is still crossed frequently, for the Slates have become a favourite weekend retreat from Terrace Bay. On summer Saturdays there is much activity around the

launching ramp in Aguasabon basin. One by one, boats venture through the river's mouth and out into the lake, the antennae of their ship-to-shore radios trembling. Most make the crossing in twenty minutes or less.

Through the years, the Slates have been trapped, timbered, and mined. Nets have been strung across the mouths of their bays and harbours, and their fish stocks have been depleted in indiscriminate hauls. Recently, however, commercial fishing has been banned in the vicinity of the islands, and the trout have returned to them in considerable numbers. The islands are also the southernmost resort of Woodland caribou, and, except for Otter Island and perhaps Pic Island, their last resort on Lake Superior. Caribou trails cross and recross the interiors of all the Slates, and are often so wide that two people can walk comfortably on them side by side. No one knows how many caribou live here; "the only way to count them," said one biologist, "is to take planes out, helicopters maybe, right after a fresh snowfall...." Called *ah-dik* (he that goes) by the Ojibway, caribou are restless, broad-hooved creatures that travel almost constantly, searching for the lichen browse which suits them best; the labyrinth of trails on the Slates may therefore have been made by the wanderings of only a tiny herd. Until late in the last century caribou lived as far south as Sault Ste. Marie, but settlement and lumbering disturbed them and opened the forest canopy to the sun, thus drying out the lichens on which they prefer to browse. Gradually they wandered north, leaving the settled areas to the more tolerant white-tailed deer. Caribou are shy, graceless, probably a bit myopic, weighed down by an oversized rack of antlers. Plodding along absent-mindedly, they have been known to come within a few feet of down-wind observers.

When Alexander Henry visited Caribou Island in 1771, he found a sizeable herd and enough skeletons to suggest a long inhabitation. He speculated that the animals had been carried out on ice floes; but Woodland caribou are excellent swimmers, buoyed up by hollow hair and propelled by broad hooves, and it is not impossible that they swam to Caribou Island, remote though it is. The last survivors were shot there within living memory, and with them went the opportunity to observe a prime example of specific homeostasis—the self-regulation of a species living in a restricted habitat without predation.

That opportunity is offered once more on the Slates, but it involves some hard decisions. The caribou herd must compete with a rampant beaver population which, by opening the forest, destroys reindeer moss as surely as would fire or lumbering. The question raised by the presence of caribou on the Slates is: To whose benefit ought the islands to be managed, if at all? Having denied so much of the shore to these shy ungulates, do we owe them a refuge here? Or should matters be allowed to take their course without man's further interference, in hopes that some balance will be struck as it was long ago on Caribou Island, a balance that would allow the caribou to live, to propagate, to wander the island trails and to swim the channels in response to their questing nature?

In theory, rarity ought to force us to protect any species, because "harvesting" should become uneconomic before a critical point of depletion is reached. If this theory were fact, bird, fish, and mammal species would not be dying into extinction at such an alarming rate. Its weakness is that it makes no allowance for either disease or destruction of habitat. Furthermore, where man's whim and technology are concerned, rarity often increases demand, as we have learned to our shame in the case of the whaling industry, or in the case of furriers, foolish consumers, and great cats. "You'll love yourself in fur ...", said a recent American Fur Industry advertisement, "Top right: Canadian lynx."

Although formally protected from hunters, the Slate Islands caribou are often harassed by week-end power boaters, and sometimes the game of chasing them becomes particularly nasty. "We saw a cow and a calf swimming," reported one boater, "and we chased them right out of the

water. They kept trying to climb a cliff to get away, but they kept falling back, falling back." If such harassment is allowed to continue and to increase, it will result in as much devastation as unregulated hunting. For the moment, however, the caribou endure, a link with the old wilderness that once stretched around the north shore of Lake Superior.

In fact, the Slate Islands themselves retain the flavour of that wilderness, despite their recent history of logging. Long ago, when caribou roamed the whole shore, crossing to the islands was a hazardous undertaking, requiring a good eye for weather, and an hour or two of tense, hard paddling. To the generations of Indians who made that crossing, the Slate Islands would have appeared much different than they do to a modern visitor. The islands are still mysterious and alluring, beckoning hazily across the seven miles of open water. They still promise safe shelter and good fishing in their inland coves, and if the wind is kind it is pos-sible to escape into them from Terrace Bay's rotten-egg stench of pulp. But with the speed of motorboats and the ease of access, something vital and intangible has been lost. Perhaps it is the zest for life felt when real danger lurks near, a zest which sharpens all perceptions and experiences. Al-though the Islands and their surroundings have not changed appreciably in the last few centuries, our view of them—our appreciation—has. Ease has diminished them; when less is risked, less is gained.

Like other once-remote and mysterious areas of the shore, the Slate Islands are in danger now of dwindling to a definable set of managerial problems, just as Jackfish Channel, churned by propellers, has grown narrower since Indian canoes lay on the beaches of Delaute Island waiting for calm, or since the two sons of the lightkeeper, rowing smoothly in the swells, last rounded the capes of Patterson Island, homeward bound from Jackfish in the dusk.

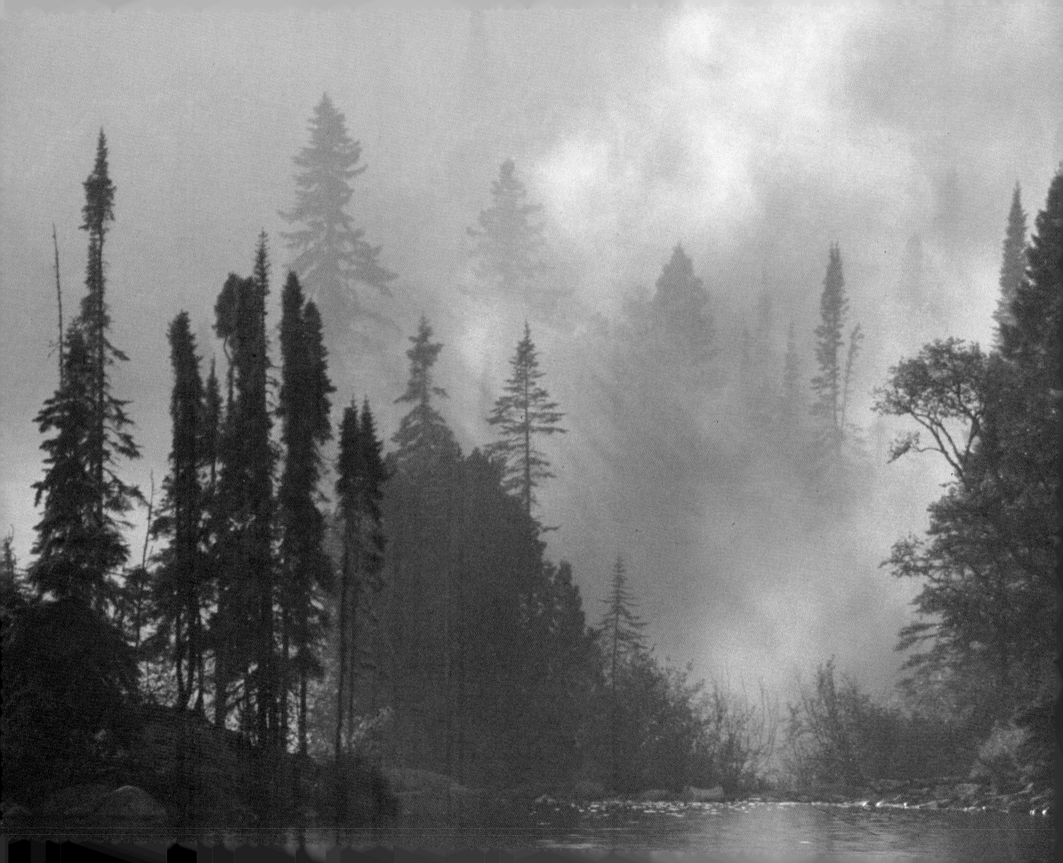

Usually the brigades would stop for a pipe at a small group of islands called Les Petits Écrits. "The place," wrote Delafield, "is composed of granitic cliffs presenting perpendicular faces to the lake. Upon these walls are figured images of deer, moose, canoes, Indians with bows, canoes, all pretty well delineated, some by Indians and some by voyageurs. The base of the rock is a red feldspar, so that when the rust and lichens which now cover them are rubbed off by a stone or iron, a bright red surface is produced which forms the images. . . . " It was, he concluded, "the picture gallery of Lake Superior."

Beyond Les Petits Écrits, the voyageur route led past the favourite Indian campgrounds west of Hemitsa Creek, where a great battle is said to have occurred, and through the offshore screen of islands leading to Pays Plat. The name of this area probably derived from *payagua schinkg*, referring either to the shoals in the region or, as Henry thought, to "the flat country between the water and the hills". Its largest settlement is Rossport.

Like many other locations along the shore—Coldwell, Neys (from Doheyneys), Schreiber, Selim (Miles spelt backwards)—the village owes its present name to a builder of the CPR, John Ross. But for centuries before the shore was blasted and levelled to make the railway, people dwelt in the bays, and fished the fertile shallows between the mainland and the islands, and ventured out to the larger islands where moose could be taken in the marshes of inland lakes. Some of these first residents lie buried on the eastern slope of Rossport, and on the islands and the mainland alike they have left the usual evidences of their presence—stone tools and weapons, charred bits of bone and pottery, and lines of cairns across the beaches. They have also left descendants—tough, humorous, and self-reliant people who live unostentatiously close to the lake, out of the mainstreams of commerce.

Many have spent their working lives on the lake itself. For generations boats have come home to Rossport heavy with fish, and early travellers commented on the abundance of fish in the area. "A place called Gun Point," said Delafield, ". . . affords an excellent fishery," and half a century earlier, Jonathan Carver had described the fish caught there:

. . . the principal and best are the trout and sturgeon, which

77

may be caught at almost any season in the greatest abundance. The trouts in general weigh about twelve pounds, but some are caught that exceed fifty. Besides these, a species of white fish is taken in great quantities here, that resemble a shad in their shape, but they are rather thicker and less bony; they weigh about four pounds each and are of a delicious taste.

Nets were linen at first (sometimes tied by women who unravelled old clothes to get the thread) and then cotton. They were set in "gangs" six feet wide and 600 feet long, and sunk in up to 100 fathoms, depending on the species being fished. Lead sinkers weighted their bottom edges, and floats strung at the top kept them perpendicular. The ends of the gang were marked with distinctive flags on cedar or bamboo poles tall enough to be seen over the waves. In the early days, nets were hauled on deck by hand, but the arrival of steam power brought the refinement of the automatic lifter, and nets are now gathered with comparative ease.

The lifter is only one of several technical innovations to improve the lot of the fisherman. Diesel power, radar, closed-in decks, and nylon monofilament nets are others. Ironically, however, while the fishing process became more efficient, the fish stocks themselves declined drastically, assaulted by a combination of over-fishing, pollution, and unnatural predation. In the early 1900's the herring stocks were already seriously depleted, and the lake trout was threatened. By 1946, the sea lamprey had worked its way through the canals linking the lower lakes and established itself in Lake Superior, and by 1960 trout catches had fallen from a 1903 high of seven million pounds to a mere five thousand pounds. Whitefish and walleye stocks were also radically reduced. At ports all around the shore—Sault Ste. Marie, Mamainse, Gargantua, Michipicoten, Heron Bay, Nipigon, Dorion, and Thunder Bay—the collapse brought hard times and in some cases disaster.

At Rossport, Adolph King met the crisis just as he had

boxed years before: flat-footed. ("And I used to give away ten pounds just to get into the fight!") Once again, he increased his risk. In 1930, in the centre of Lake Superior, a shoal had been discovered by a vessel testing new sonar equipment. Roughly eight miles in diameter, it rose to within seven fathoms of the surface. It was named Superior Shoal, and Adolph King was among the first to take fish from it. For nine seasons, in good weather and in bad, he headed his boat through Simpson Channel to Battle Island Light, and then southeast, across fifty miles of open water. The trout he caught on Superior Shoal were unlike anything he had seen; "snakes", he called them, "reptiles". They were lean and dark; their eyes were sunken and their teeth grew twice as long as trouts' teeth elsewhere. On deck they snapped at the legs of the men. They were repugnant creatures, but they were edible and saleable once decapitated, and they kept the Rossport fishery alive until restocking programs and lamprey poisons began to take effect.

Other Rossport fishermen have had a similar resiliency—Paulmart, Dampier, Gerow, and Schelling—men who have spent their lives freely among the islands and on the lake beyond. Often their wives and sons have gone with them. They are people polished to their bedrock by the lake, scornful of pettiness, blunt in a way often discomforting to city visitors. They have no time for dissembling. Life is short. To do an honest day's work, to keep a clean record, and to be rewarded with a good catch and a safe passage—that is, after all, more than a man might properly expect. No Europeans have lived more respectfully of the lake or with a more acute sense of vulnerability than the fishermen, except perhaps the wintering trappers, or the men and women who kept the early lights.

In the Pays Plat region, the first lighthouse marked the shipping lane on the outside of the islands. It was built on Talbot Island in 1867 and it cost $605.03. Like other lights up to the 1950's, it burned kerosene, and the keeper had to tend it throughout the night, every night until the close of

the shipping season in late fall. The first keeper at Talbot Island perished in an autumn storm while rowing for the safety of the mainland. The second, Thomas Lamphier, sickened and died shortly after taking charge, leaving his wife to winter alone, between the frozen corpse of her husband at the back of the house and the grey lake in front. Andrew Hynes, the third keeper, rowed for eighteen days after shutting down the light in the autumn of 1872, and died of exhaustion upon reaching Silver Islet, fifty miles away. After his death the lighthouse was abandoned. For years it stood dark and hollow, a hulk sometimes drummed by fishermen to guide in fog-bound boats.

In 1877 a lighthouse was built on Battle Island, and a Pays Plat trader, Andrew Dick, took charge until the official keeper could row up from the Sault. In September of that year Charles McKay arrived, and the mainland community was named McKay's Landing in his honour until the arrival of the CPR surveyors and the contractor Ross. For years, McKay's reputation as Battle Island's first lightkeeper went unchallenged, but when he was a very old man he was visited by Andrew Dick's grandson, Adolph King, who was troubled by inaccuracy and wanted the record put straight.

"Now Mister McKay is it true, as they say, that you rowed up here from Sault Ste. Marie in 1877?"

The old French Canadian remained very solemn. "No, Dolph, that is not true."

"Well they say that you came alone that year in a skiff, to take charge of the light."

"Yes, I was alone. But I did not row all the way. I sailed sometimes."

"But the important thing is that you were not the first. Because when you got here Andrew Dick was already tending the light."

"Yes, Dolph," said Charles McKay, "that one is true."

The islands off Rossport have been much used and abused since the last child was born in a wigwam there. They have given up timber and pulpwood. Blocks for city buildings have been quarried from them—from the Thompson Quarry on Simpson Island, closed in 1906, and from an older site on the south side of Quarry Island. On Nichol Island, named for an early fish buyer, the butchers Smith and Mitchell had their slaughter-house, and herds of cattle were driven across the shallows to become beef for CPR labourers. Hidden in coves and beside the inland lakes of the larger islands, in various stages of decay, are many old camps of hunters and trappers.

Few hunters camp on the islands anymore. For most, time is short; what is important is the moose, the ownership of the dead animal, and money is no barrier to killing one. They can afford to hire aircraft—often helicopters—and "guides" who will spot the animals and sometimes even shoot them. These hunters are attracted not by danger, or by beauty, or by the honest need for food. They make no commitment to the land. What attracts them is the isolated symbol of prowess. They buy a success they have not earned—an atavistic, vicarious success. And for the pleasure of such men, the moose of Simpson and St. Ignace islands have been butchered one by one, until some residents now question whether—on Simpson Island, at least—there are any left.

Each spring, as he has done for many years, a certain man returns to Rossport and takes up residence in a modest cabin near the lake. He will stay for the whole summer. He is small, slightly stooped, no longer young. His hands and face, even the creases around his eyes, have been darkened by days of wind and sun in an open boat. He is a peerless sport fisherman, but for him the sport is far more than the trophy. Often he uses a barbless hook. He knows the islands very well, and sometimes he goes out to them and hikes to the island lakes with no intention of fishing, but just to watch the moose browsing. Perhaps he is a privileged man because he has such time; or perhaps he is a wise man because he has taken time. Year by year, he has seen the moose grow scarce. He has seen float planes coming and

going, and helicopters buzzing the islands like hornets. He has heard gunfire both in season and out, and often he has returned to favourite ponds to find that old friends are there no longer; all have gone—bulls, cows, and calves. He is a gentle man, a lone and private person. Seventy years have taught him something about motivations, his own and others', and he is not disposed to rage or bitterness. Sometimes he will try to describe the moose in their island habitat, their singularity and beauty, their dark bulkiness against the pale green of the marsh. Sometimes too he will try to set the matter in a larger ecological perspective; but sooner or later he will shrug, and offer a placating gesture which is also an expression of loss and impotence, and say, "Ah, when they're gone, I'm just going to *miss* them, that's all."

At Rossport, as at few places on the shore, the nearness of the lake and the intimacy of the commingling islands has offset the grosser effects of railway and highway. Rossport has been a thriving tourist centre, and it may become one again, but for the moment it is quiet. Sometimes squadrons of flared-bow cruisers moor at the dock, having arrived with lights, and sirens, and anxious circling antennae. Hastily their owners unstrap motorbikes and lower outboard runabouts in order to take in the local sights in the time their schedule allows. For an hour or two there will be a flurry of activity around the harbour and along the half mile of road through town—down the north slope, across the tracks, past the meadows criss-crossed by the paths of dogs and children, past the disused school with its curved corner of 1949 glass bricks, past the gas pump and grocery store, CLOSE-D down the south slope, over the Indian burial ground, and so finally past the lumber mill with its blackened sawdust, its belts drooping dingily from rusted pulleys, its brick ovens chilled forever.

Usually, early the following morning, the fibreglass yachts gather their paraphernalia and leave for more congenial moorings. There is little here for affluent pleasure-seekers, nothing to stimulate senses jaded from the idle grumbling of diesels and the tedium of rocks, sky, and water. Compared to Terrace Bay on one side and to Nipigon on the other, Rossport seems at first glance to be impoverished. In fact it is far richer than the others, but to understand how, one must approach the village with recollections of a time when time itself was not a commodity, when there was more kindness in human dealings, and more honesty. And one must observe how the village reaches to embrace the lake, turning its back on railway and highway. Rossport's choice was made years ago, and like Joseph King, now over eighty, its people have few regrets:

My heart was my ship, and I was its captain
 And its rigging was freedom, and love was its keel.
But still from above me the seagulls they thrilled me,
 I followed with wonder each swoop and each dive;
And I longed to be with them, to dance o'er the waters,
 For I spurned the base treasures for which other men strive.

*There have been strange electrical phenomena
over the hills of Thunder Bay for almost a
week past, in the midst of which Ojibway
Indians from the Mission Bay claim to have
seen the sacred thunder eagle depicted in
the fire and in full flight over the lake.*

Winnipeg Free Press, 7 March, 1918

West of Pays Plat, three huge bays stretch around to the international border–Nipigon Bay, Black Bay, and Thunder Bay. They are separated by two formidable peninsulas, and surrounded by mountains. "The scenery of Nepigon Bay," wrote George Grant,

"is of the grandest description; there is nothing like it in Ontario. Entering from the east we pass up a broad strait, and can soon take our choice of deep and capacious channels, formed by the bold ridges of the Islands that stud the Bay. Bluffs, from three hundred to one thousand feet high, rise up from the waters, some of them bare from lake to summit, others clad with graceful balsams. On the mainland, sloping and broken hills stretch far away, and the deep shadows that rest on them bring out the most distant in clear and full relief."

Nipigon was off the main voyageur route to the west, but it is an historically rich area that has always been important to the fur trade. The name has been spelt at least six ways by diarists and cartographers. It may derive from Annimigon, "the lake that you cannot see the end of", or from Aweenipigo, "the water that stretches far", but it probably comes from Alemipigon or Nemipigon, "deep, clear water".

On the west bank of the river's mouth, controlling the entrance to the big lake to the north, Sieur de la Tourette built Fort Camanistigoyan in 1678. For a century thereafter posts at this site would serve as an entrepôt between Lake Superior and James Bay. Radisson and Groseilliers passed north this way, and at Nipigon in 1727 an Indian named Ochagach drew a strange, gut-shaped map of the route west for Pierre Gautier de Varennes, Sieur de La Vérendrye. The North West Company's Fort Nipigon and the Hudson's Bay Company's Red Rock House were both situated on the site of the old French post.

Legend says that there are subterranean passages here, and that these are used by the Maymaygwayshi, the water spirits, to journey back and forth between Lakes Superior and Nipigon. Often in the old days the canoes of the Maymaygwayshi were seen here vanishing into the cliffs. Opposite the site of the fort, behind Cook Point, are pictographs which may pay tribute to these dwarfish little spirits–"a canoe rather over-loaded, like one of Charon's, on a heavy trip . . ." and ". . . a portrait of the devil, with arms outstretched and an animated expression". This central

figure, a rotund imp with spindly arms and fingers, is crouched as if poised to leap out at passing canoes and to dance ahead of them across the water, his laughter summoning other Maymaygwayshi from their crevices.

Westbound, the brigades would push on past Point à la Gourganne, through Nipigon Strait, and down past Fluor Island, Roche Debout Point, and the sea caves of Brodeur Island. Les Mamelles, a generous pair of matched hills on the Black Bay Peninsula, would cause jokes in the canoes, but when they passed Shiminitou where Indian mothers once brought their children to be cured of illness, the voyageurs would fall silent, and perhaps drop tobacco into the water. They would not enter Black Bay, but would head straight across Montreal Channel towards Silver Islet and Thunder Cape beyond.

Thunder Bay is enclosed by mountains. To the south are the flat-topped mounds of Pie Island. To the west, across the Kaministikwia River from the site of old Fort William, is Mount McKay, *Animikie wakchu*, the ancient residence of thunderbirds. This mountain is the northernmost of the Nor'Westers, a solemn range stretching away from the lake into the mists of the southwest. To the east, at the tip of the Sibley Peninsula, is the monumental Sleeping Giant, its cliffs dropping sheer for hundreds of feet into the lake, its foot towering above the little agate-strewn beach where the lightkeeper Perry died, and the islet where, the following spring, the pick-axe of a labourer named John Morgan would expose the richest vein of silver in the world.

The bay is well named. It is notorious for storms. Passing through in 1873, Catherine Moodie Vickers wrote to her mother, Susanna:

. . . we had a thunder storm which for grandeur I never expect to see surpassed—the vivid flashes of lightning lighting up the mountains on each side of us and showing the black waves with their white caps around us on every side; then from all sides of us ribbons of fire ran up the sky in all shapes, more like rockets and fireworks, whilst the thunder leaped from mountain to mountain in a continued roar like nothing I ever heard before, and followed by a low growl . . . If I were an artist I would choose Thunder Bay in a storm as the grandest representation of the end of the world. I could not help fancying when I looked over the side of the vessel that I would see old Charon launch his boat from the foot of Thunder Cape.

Heavy with foreboding, thunder rumbles through the region's legends and history. Many stories describe the origin of the Sleeping Giant, but only one is chillingly final, and rings true to the bitterness of a dispirited culture and its dying gods. According to this story, a time came when the animals grew so scarce along the shores of the lake that not even Nanabozho was successful in his hunts. Famished, frightened, all his humour gone, he endured as long as possible the scorn and taunting of his wife; but then, goaded past endurance, he rose up in a rage and slew her. Immediately he was stricken with remorse, for he had loved her dearly. He fled howling into the night until at last, exhausted from famine and grief, he fell back into the body of the lake and was mercifully turned to stone.

Until 1804, brigades southbound for Grand Portgage frequently landed at the tip of Thunder Cape, waiting for the winds to drop before attempting a traverse of the bay. In later years, however, the Nor'Wester depot was much closer, and the route led straight across to the mouth of the Kaministikwia ("the river that goes far about") where in 1798 Roderic McKenzie, foreseeing the imposition of heavy American duties at Grand Portage, had rediscovered the older French and Indian route to the west. The Nor'Westers began to build in 1800, and by 1804 they had completed Fort William, named for McGillivray, an extensive conglomeration of buildings enclosed by a bastioned, fifteen-foot palisade.

It was the third known fort in the vicinity. DuLhut had established his headquarters here in 1679, on the south bank about half a mile from the river's mouth, and Zacharie

Robutel de la Nöue had constructed a second post, on the north bank, in 1717. La Nöue's immediate successors, Jean-Baptiste de Saint-Ours Deschaillons and Jean-Baptiste Janet de Verchères, traded here until at least 1727, and the post was not deserted and destroyed for another thirty years. It was to this second fort that La Vérendrye came in the summer of 1729, preparing for his western explorations; but long before, Jacques de Noyon, quick and elusive, one of Brûlé's breed of coureur de bois, had already followed the Sioux warpath westward from the Kam perhaps as far as Lake of the Woods.

There were sound practical reasons why the Nor'Westers did not rediscover the Kam before they were forced to do so. David Thompson reported that the route was so much more difficult than the Grand Portage route that the voyageurs had to be "coaxed and bullied" to use it. But use it they did, taking Thompson and Fraser on their astonishing voyages of exploration, and bearing other Nor'Wester officers from their wintering posts in the pays d'en haut—A. N. McLeod from Swan River, John McDonald from Upper Fort des Prairies, Angus Shaw and Donald McTavish from the Upper English River, John McDonnell from the Assiniboine, Roderic McKenzie from Athabasca, Charles Chaboillez from Red River, Peter Grant from Lac La Pluie, and William McKay from Winipic.

In the summer rendezvous at Fort William, the ritual of exchange and festivity for so long held at Grand Portage was continued. Here the up-country brigades met those from the south, and Company business was transacted by the partners in the Council House. Washington Irving described the scene inside:

These grave and weighty councils were alternated by huge feasts and revels, like some of the old feasts described in Highland castles. The tables in the great banqueting room groaned under the weight of game of all kinds; of venison from the woods, and fish from the lakes, with hunters' delicacies, such as buffalos' tongues, and beavers' tails; and

various luxuries from Montreal, all served up by experienced cooks brought for the purpose. There was no stint of generous wine, for it was a hard-drinking period, a time of loyal toasts, and bacchanalian songs, and brimming bumpers.

Outside, the exchanges were equally boisterous but often less friendly. The northmen, the elite canoemen of the trade, taunted the mangeurs de lard, out for what they considered to be a soft summer from Montreal. At the peak of the rendezvous, there could be 400 northmen camped on the plain above the fort and as many pork-eaters on the dirtier and more disorderly plain below, an army of two rival factions, "a mongrel legion of retainers, Canadian voyageurs, half breeds, Indian hunters, and vagabond hangers-on", whose major entertainments were drinking, whoring, and fighting.

From 1804 to 1816 (when Selkirk, a good man who believed in families and husbandry—"the Bible peer", McGillivray called him—descended on Fort William like an avenging angel) was the period glorified by Irving and other historians as the great days of the fur trade. The Nor'Westers were in their prime and David Thompson's map, "comprising all their trading-posts, from Hudson Bay to the Pacific Ocean, and from Lake Superior to Athabasca and Great Slave Lake", stretched across their wall to tell them so.

Two years after the amalgamation of 1821, however, the fort was already in decline. Delafield dined there in 1823 with half a dozen companions in the echoing hall built for 200, and earlier that summer Bigsby had also dined there, listening to a conversation that "was wholly north-west and Indian", and confronted by the figure of a "pale and wasted" young man who had been living on tripe de roche and rawhide window panes.

By 1843, Lefroy found the fort falling into ruins:

Ranges of sheds and stores are empty, and the old mess house, sixty feet long, in which so many hardy traders used to tell of their exploits, is now a shed of canoes, half a ruin. It is situated in a swamp, on artificial ground, without any

advantage of scenery, although below it, on the lake and all the way above, the scenery is beautiful. There are a dozen or two Indian wigwams about it

At the middle of the century, Cabot recorded the passing of the last physical link with the past. "The old blockhouse is falling to pieces and the banqueting hall has probably been burnt up for firewood, at least, we saw nothing there that looked like it. Even the little flower-garden opening out of the stone-paved courtyard was overgrown with weeds." No one knows which woman tended the garden last. Like her predecessors, she was probably a strong, shy daughter of the country, good enough for bed and table service but scarcely fit to be seen in Montreal. In fact, she may even sometimes have been hidden from distinguished visitors. Her arrangement with the white trader was à la façon du pays, a convenience, assumed from its beginning to be temporary. Daniel Harmon and David Thompson were among the few Nor'Westers who gave their names to the mothers of their children; the epitaph for William McGillivray's country wife reads simply: "To the Memory of Susan, the Mother of Simon, Joseph, & Peter McGillivray, who died 26 August 1819."

The forest returned, creeping across the fields and over the remnants of the fort itself, filling pastures with sumac and seedling pines. Winter by winter, frost lifted the corners of unheated buildings; roofbeams shifted, rotted, sagged, collapsed. The paintings of Nelson and of the Battle of Trafalgar were taken to York Factory, and thence to England. The bust of "The Marquis", lordly Simon Mc-Tavish, disappeared. The Indian finery gathered from all the Nor'Wester regions dwindled piece by piece, given, bought, traded, and stolen until all was gone. In the bedrooms the leather trunks were closed for the last time, and the oval mirrors abandoned. In the kitchens, fine cruets, decanters, salt cellars, pewter, frail blue teacups, japanned mugs and tumblers, earthenware and Queensware, all carefully brought from Montreal, were now cluttered un-

ceremoniously together, chipped, cracked, shattered, and cast away. In the offices, the ink powders sifted across the sealing wax, the blotters and quills, the blank paper and abstract books, red and black together. In the hospital, uncomprehending eyes looked at the library left behind by John McLoughlin—Bell's Surgery, Skinner on Poisons, Rush on Fevers, Twelfers Pharmacopia, Nisbitts Medicines, Douglas on Muscels, . . .

No figure haunts Fort William's declining years more poignantly than Selkirk in the winter of 1816-17, after he had seized the stronghold of his enemies. Surrounded by de Meuron mercenaries ("little better," according to Nicholas Garry, "than a lawless banditti, and, almost to a man, Drunkards") he lingered on at the centre of their power, the "rendezvous of robbers and murderers and the receptacle of their plunder", making notes, making drawings, making lists until, still dissatisfied with his victory, he bought the keys to the fort itself from a sottish Daniel McKenzie.

Today the site of Fort William is covered by a railway marshalling yard, and nothing of it remains above the ground. But at Pointe de Meuron a facsimile has been built as a tourist attraction. Colorful flags flutter above the parking lot. Buses debouch schools of children. The price of admission includes a slide-show capsule history and gives access to the pop and ice cream concession. Trees flanking the quarter-mile path to the fort site bear identifying placards. Inside the palisade, visitors are directed from one impeccably-hewn building to the next, and when enough people have gathered in any room, guides in appropriate costumes begin their presentations: "You are now in the hospital. To your right . . ."

Despite the careful attention to detail, the make-believe Fort William must lack certain elements of the original. Its "realism" is incomplete and visitors to it will experience only a pleasing and sensuous nostalgia. Textures of wood, fabric, fur, and bark will be spread for their delectation, and much care will be taken to ensure that atavistic aromas prevail—cedar and spices, wood smoke and baking

bread. The visitors will not be threatened by dysentery, or cholera, or smallpox, or syphilis. Nor will they be visited by lice and fleas. Their sensibilities will be spared the stink of unwashed bodies in warm rooms, and the odours from stock yards, abattoirs, and privies. They will not be accosted by men demented by loneliness in the winter posts, and above the charming period costumes they will see few faces twisted by disease or hatred, by drink or despair. They will not encounter women whose bodies are chattel goods to be passed from one man to the next. If they stroll beyond the palisade, they will not discover the huts and hovels of worn-out voyageurs, nor the wigwams of indentured Indians. They will hear no blind cursing, no drunken laughter inside the *cantine salope*, no groans of beaten Indians, no keening for dead children and wasted lives. They will not be treated to such commonplace fur trade horrors as incest, murder, mutilation, rape, infanticide, and bungled self-destruction. Health officials will ensure that the food is relatively clean, and the fire marshall will guarantee so far as possible that they will not be burned or scalded. They will be given wholesome entertainment.

If you would see the true descendant of the Nor'Westers' fort, climb to the top of Mount Mckay, Animikiewakchu, where Nanabozho, transformed into a rabbit, stole fire for man. Choose a day when the breeze is off the lake, for if it is westerly you will climb all the way in so acrid a stench of pulp that you will arrive nauseated at the top, eyes streaming.

On a clear day, the view is magnificent. The whole city stretches beneath. At the first bend in the Mission River is the site of DuLhut's Fort Kaministiquia. Across the islands and the north branch of the river is the site of de la Nöue's fort, and about half a mile northeast, at the mouth of the Kam, is the site of Fort William itself. Trains, trucks, and ships converge on the waterfront, and more tons of merchandise are shifted through the entrepôt than were dreamed of in the days of the old commercial empires. Food

from the prairies (grain; no longer pemmican) moves east, and trade goods (automobiles; no longer fabrics, muskets, pots, and beads) move west. Industries line the river banks and circle the mouth of the bay. Because of them, and because of municipal sewage, fish taken in the estuary can no longer be eaten safely, but this is considered of small consequence in the prevailing economic climate. Thunder Bay is flourishing. Each year it stretches farther to the northwest, sealing more of the fertile delta under a concrete crust. Each year the "inter-city" between the one-time communities of Fort William and Port Arthur has thickened with residences, factories, and plazas until no separation is now discernible from the top of Mount McKay. This confident, industrious, and affluent agglomeration is the living legacy of the first Fort William and the Nor'Westers.

In honour of the Duke of Connaught the northeastern side of this urban complex was named Prince Arthur's Landing by Garnet Wolseley in 1870. A few years later the name would be shortened to Port Arthur for the convenience of CPR telegraph operators and sign painters. Here, among a few shanties, in a scene of "funereal mourning" desolated and still smoking from a forest fire, the young colonel disembarked his troops from the *Algoma* and the *Brooklyn* and marshalled them for the trek westward to Fort Garry. The Red River Expedition was an early test of the young Dominion's strength, and Wolseley would handle the job with diplomacy and dispatch. He was a superb commander.

Many years later, when he had become Field Marshal Viscount Wolseley, OM, he would think back to Thunder Bay and to the people he found there, the remnants of a once-proud culture. He would remember the birchbark canoes, insignificant under the bows of the steamers, slipping to and fro across the bay. He would remember the tattered chieftain and the pathetic little band who protested the army's transgression of its territory, and he would recall the amused condescension of his staff and his own glib promises. He would remember finally the resignation of an

old Indian watching the young gunners and sappers disembark: "What a lot of white people there must be in the world!" Then Wolseley would continue his memoirs with a sentence that came as close as he ever could to questioning the values of the Dominion and the Empire he had served so brilliantly: "In the course of my North American wanderings, I have never encountered any Indian tribes without experiencing a feeling of remorse. . . ."

Civilization advances by extending the
number of important operations which we
can perform without thinking about them.

Alfred North Whitehead

Travellers between Thunder Bay and Grand Portage some-times stopped under the dome of Pie Island, where a deep bay provides shelter from northern winds. Here, on 3 May 1782, a trader named Vincent Venant St. Germain saw something that would haunt him the rest of his life, and cause him to swear an affidavit—part report, part confession—thirty years after the event. He and his party had stopped for the night, and just after sunset, as St. Germain was returning from setting a net, he saw an extraordinary creature in the water not far away

... about the size of ... a child of seven or eight years of age, with one of its arms extended and elevated in the air. The hand appeared to be composed of fingers exactly similar to those of a man; and the right arm was kept in an elevated position ... The eyes were extremely brilliant; the nose small but handsomely shaped; the mouth proportionate to the rest of the the face; the complexion of a brownish hue ... the ears well formed and corresponding to the other parts of the figure ... The animal looked the deponent in the face, with an aspect indicating uneasiness, but at the same time with a mixture of curiosity ... the deponent thinks the frequent appearance of this extraordi-nary animal in the spot has given rise to the superstitious belief among the Indians, that the God of the Waters had fixed upon this for his residence

The God of the Waters. Nepii-Naba. St. Germain's description of his hand raised in peace, warning, and farewell, is the last report of him before side-wheelers began to work in earnest up and down the shore, carrying troops and missionaries, miners and machines. After that, to the eyes of a new rationality and in the light of foreign needs, he grows invisible. He fades like Missipeshu sinking beneath the waves; like the thunderbirds, their taboos shattered, lifting off Animikie-wakchu for the last time; like the May-maygwayshi guiding their stone canoes into the seacaves, never to reappear.

One by one as the nineteenth century proceeded, the Indian names for the points, bays, and islands south of Thunder Bay were pushed aside by English replacements. One by one the names of new mines—Spar Island, Jarvis Location, Point Ignace—replaced those of old fur posts on official correspondence, correspondence which occasionally revealed the uselessness of the Indian in the new scheme:

Prince's Bay, Jan. 31, 1847 . . . As regards the Indians 'loitering about me, making frequent visits, and being fed for days at a time', I do assure you is not the fact; and though they have not visited me often, yet I have complained if they did not leave, after stopping over night, as soon as they got something to eat in the morning; (poor creatures I could not turn off, scarce as I am of supplies, without something to eat;) and so far from encouraging them, the contrary has been the fact; and Lasage fell out with me about it, and quit cooking on account of it

The last Montreal brigade to go south from Pie Island to Grand Portage probably passed in June of 1803. The final day of their journey began, like the others, at 3 AM. It began with the sound of moccasins in the beach cobbles, and with the clatter of iron kettles, and the thud and crackling of fresh logs tossed on the embers. It began with cries of "lève!" along the beach, and with the sluggish movements of men waking to the dark. Perhaps there would be a little tea for breakfast; perhaps there would be time to eat a little cornmeal before the canoes would have to be launched and loaded. Then there would be a rough marshalling of the brigade and then the progress southward, at first stiff and awkward, but quickening as the shoulders of the paddlers warmed and a gradual light spread across the lake and filled the bays, showing the *gouvernails* the course which lay before them.

The brigade would be funnelled between the shore and the islands until it passed the tip of Victoria Island and emerged once more into the open lake, the misted hills of Cloud and Little Trout bays on the right, Isle Royale a distant presence on the left, and Pigeon Point beckoning ahead. Beyond Pigeon Point lay Pointe aùx Chapeaux, where the paddlers would stop to change into their most colorful and impressive clothes for the entry to Grand Portage, the village's major annual event.

Of the fort itself John Macdonell left this description:

The pickets are not above fifteen to twenty paces from the waters edge. Immediately back of the fort is a lofty round Sugar loaf mountain the base of which comes close to the Picket on the North West Side . . . All the buildings within the Fort are sixteen in number made with cedar and white spruce fir split with ship saws after being suquared, the Roofs are couvered with shingles of Cedar and Pine, most of their posts, Doors, and windows are painted with spanish brown

The most imposing building of the sixteen was the Great Hall, where the partners consulted, dined, and partied during the rendezvous.

Surrounding this principal establishment, the property of the North West Company, was the usual assortment of other buildings—huts and wigwams, some the factories of rival traders, some the residences of ex-employees unable or unwilling to return to Lower Canada, and some the lodges of Indian and half-breed hangers-on. As at Fort William after 1803, this community was crazily swollen each spring by the arrival of the Montreal brigades from one direction and by north brigades from the other.

The actual portage was a nine-mile trail snaking over the hills to Fort Charlotte at the lowest navigable section of the Pigeon River. It was the start of the easiest route from Lake Superior to Lake Winnipeg and the Athabaska country beyond. A French officer named Pachot had recommended its use in 1722, and La Vérendrye had followed it within a decade. Shortly afterward, the French likely had a post at the beginning of the trail, and in 1768 John Askin cleared a spot for the first known British establishment on the site. The Europeans had arrived at Gitche-onegumeg, and they took what they required. Writing as commissary of troops at Mackinac in 1778, Askin appended a routine personal request to an order to construct a barracks: "I need two pretty Slave girls from 9 to 16 years old. Have the goodness to ask the Gentlemen to procure two for me."

In its heyday, as many as a thousand men gathered annually at the fort and hauled several loads each across the trail. Trade goods went west, furs came east. The transfer

and the negotiations in the Great Hall were completed as quickly as possible, for before the snow flew there were many lakes to be crossed and rapids to be faced; there was meat to be shot and there were crops to be harvested. So, sometime early in July the rendezvous would conclude and the brigades would go their separate ways leaving only a small staff to care for the fort. The groups of camp followers would leave tent by tent until only those who were too ill, or too old, or too despondent to move remained.

For a quarter of a century the rendezvous had been the great white man's event on the north shore, comparable to the legendary gatherings of the Ojibway totems at Chequamegon and Bawating. For twenty-five years European largesse had crossed this threshold, and the peltries of the country had moved out, pressed and packeted each year deeper in the pays d'en haut. Then, in 1803, the period concluded abruptly. American duties would not be paid; American conditions would not be met. The North West Company gathered its belongings and its servants and moved north to Fort William, abandoning the emptied buildings to those who wanted them. For awhile, the American Fur Company maintained a fishery at Grand Portage which consisted of "1 Coopers Shop, 1 Fish Store, Stable Barn, Roothouse, &c . . . placed here and there without order or symetry", but even this was abondoned in the 1840's.

For a little time after the white men had gone, before the forest began to close in on the trail and before the buildings became too dank and filthy for even the humblest transient, Ojibway canoes passed close to the beach, drawn in by good memories, or by cruel memories softened by time and distance, or by simple curiosity, or by that element in the human temperament that relishes deliquescence and the reassuring triumph of nature. They crossed in front of the sagging pier and the stumps of pickets hacked off for huts and firewood, close enough to look into the empty eyes of the Great Hall, close enough to understand that even the white man's works returned to earth, and to learn that the shouts and footfalls of even a thousand carriers could fade to nothing, leaving only the birds and the wind in the trees.

Then the canoes would leave swiftly and silently, passing out into the innumerable shelters of the islands and the timeless rhythms of the lake.

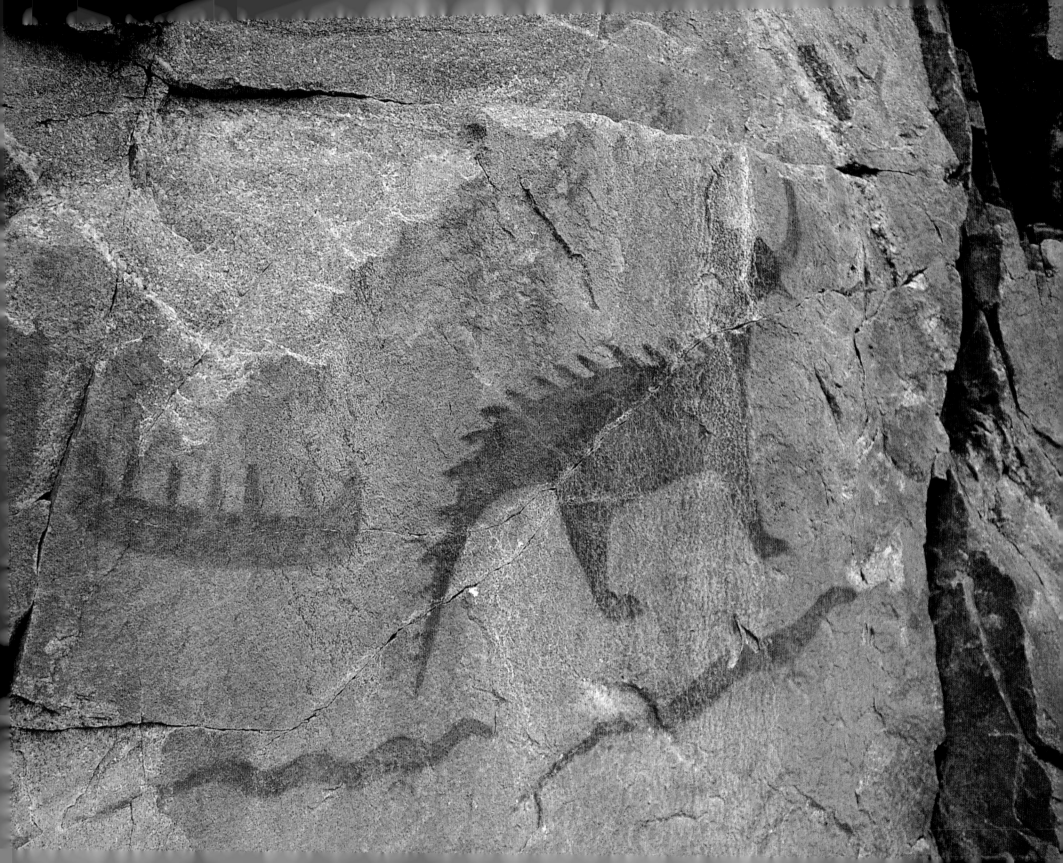

Indeed indeed
The ancient of days
now speaks in light
now speaks in the hosts of light
now speaks in tree limbs and leaves
in silver winds and silver running waters

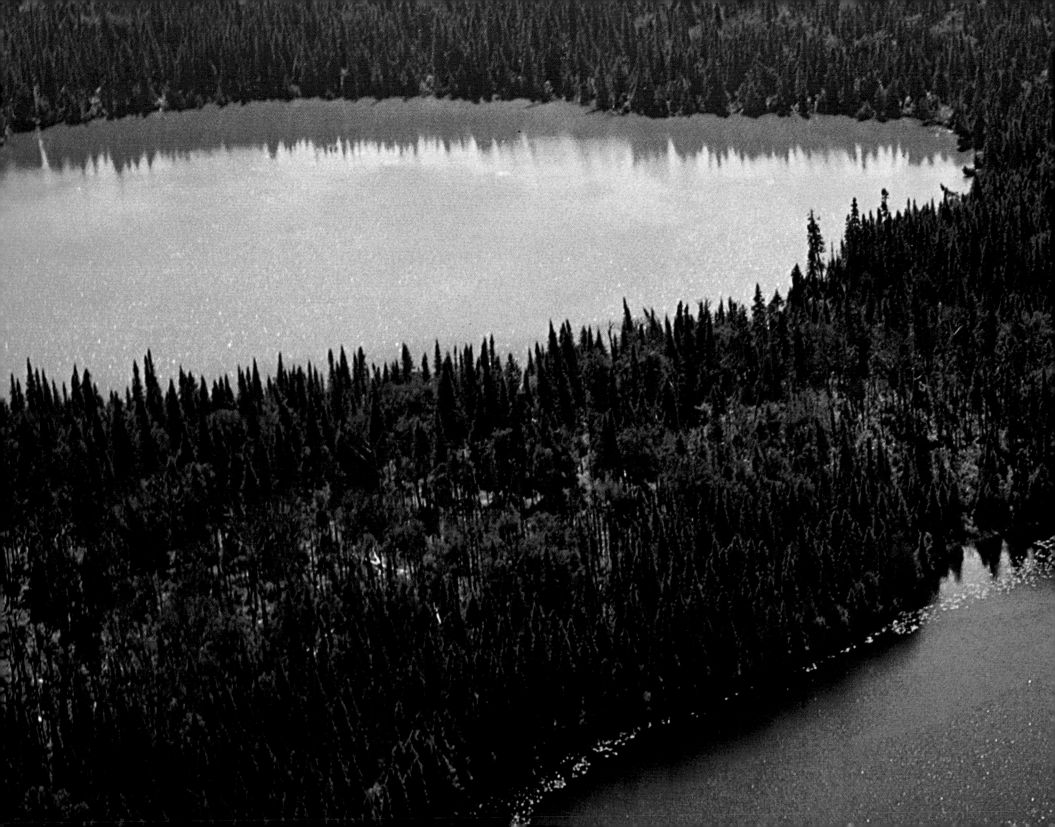

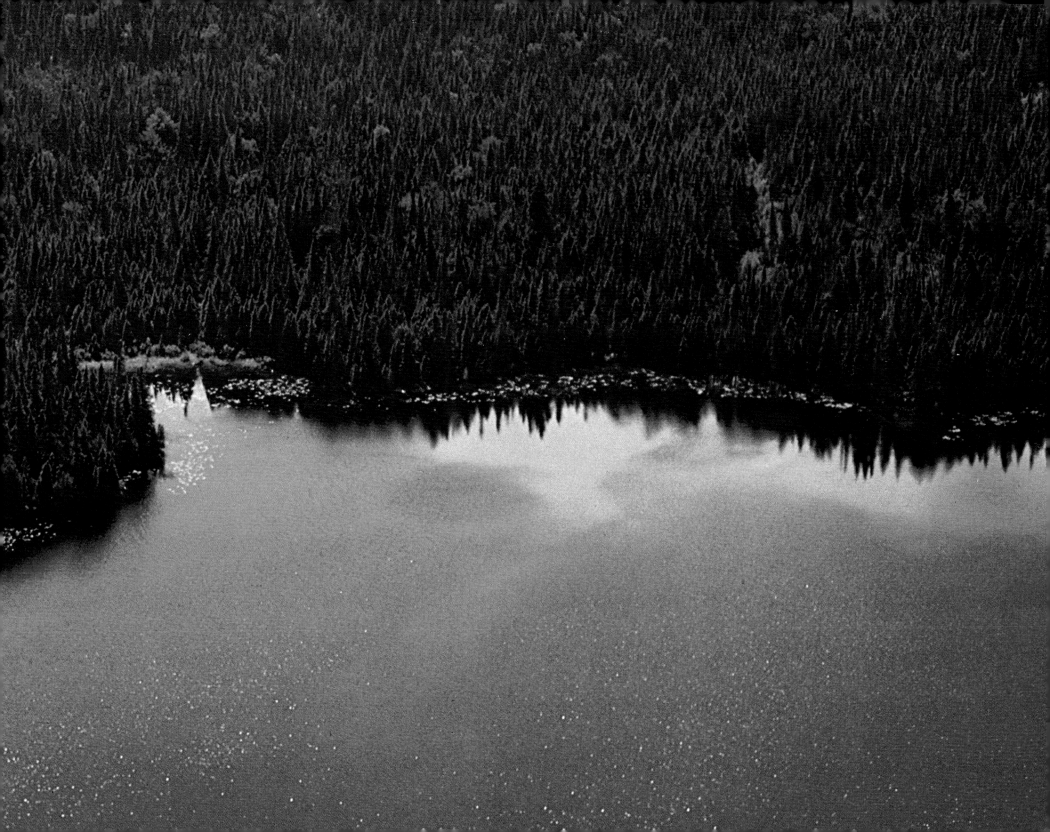

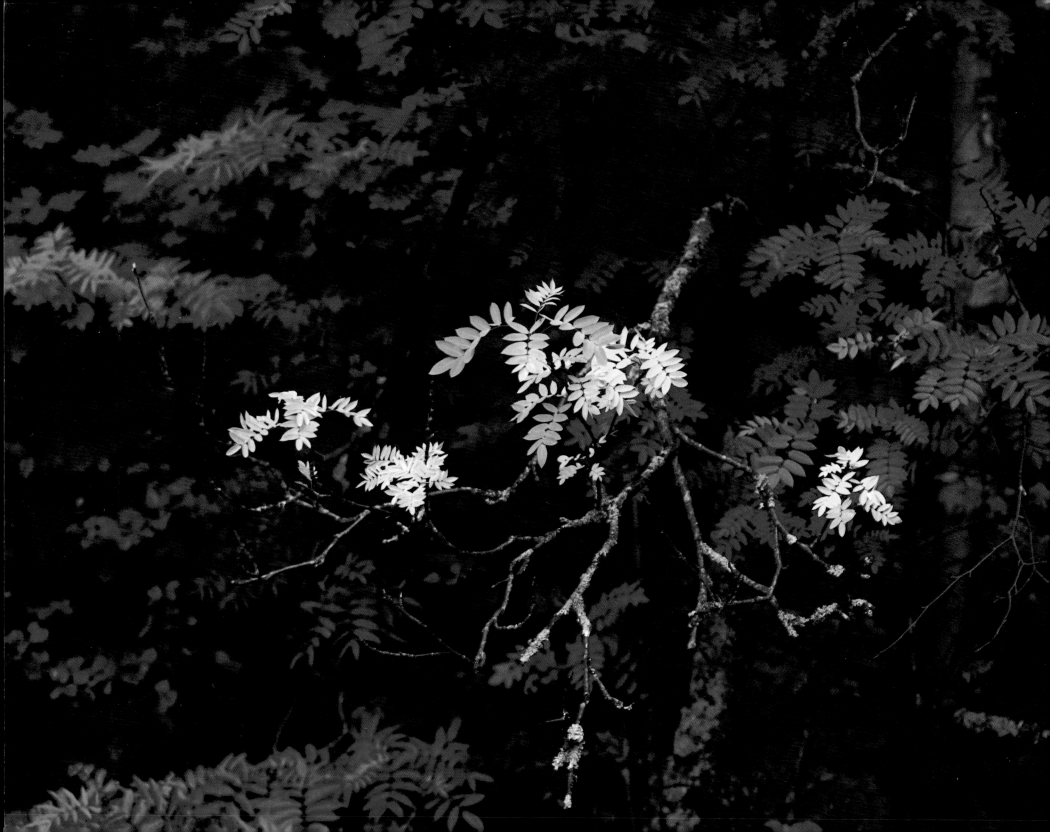

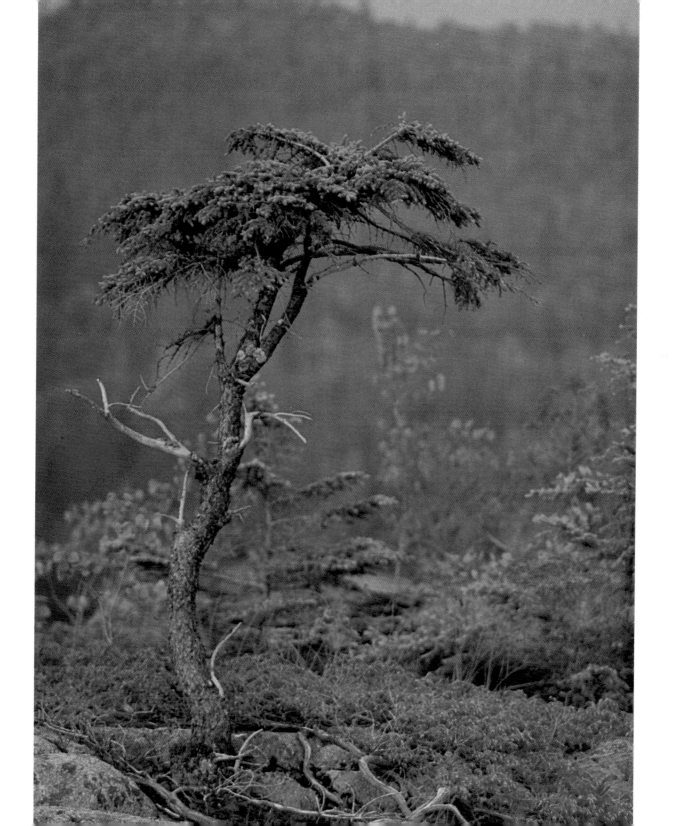

23

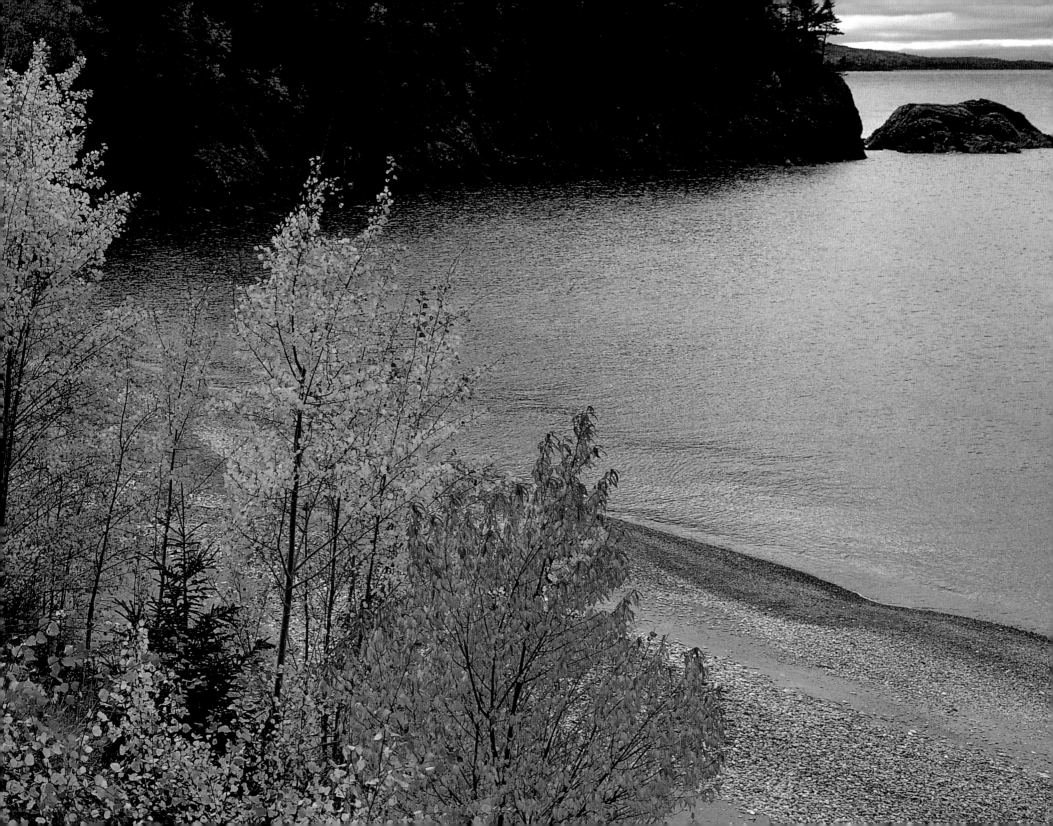

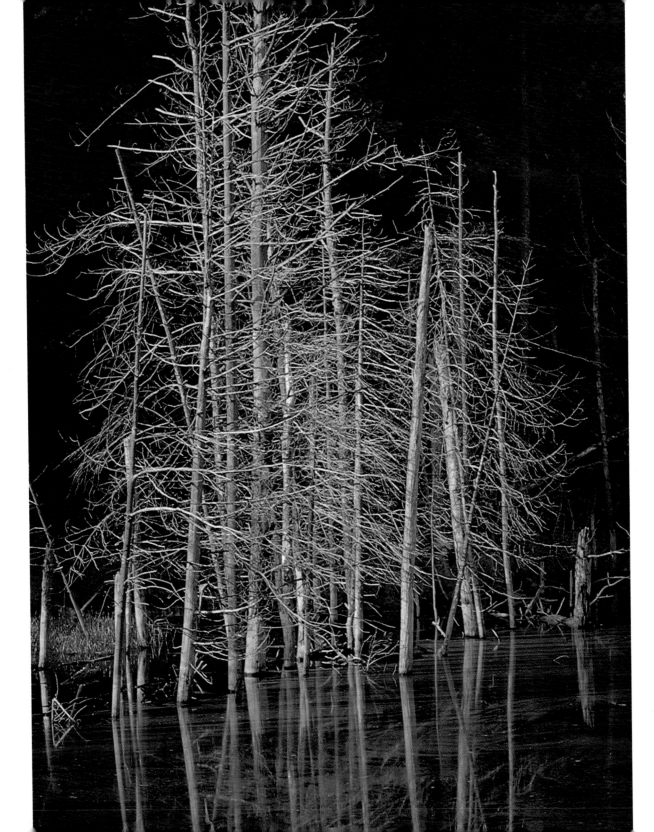

26

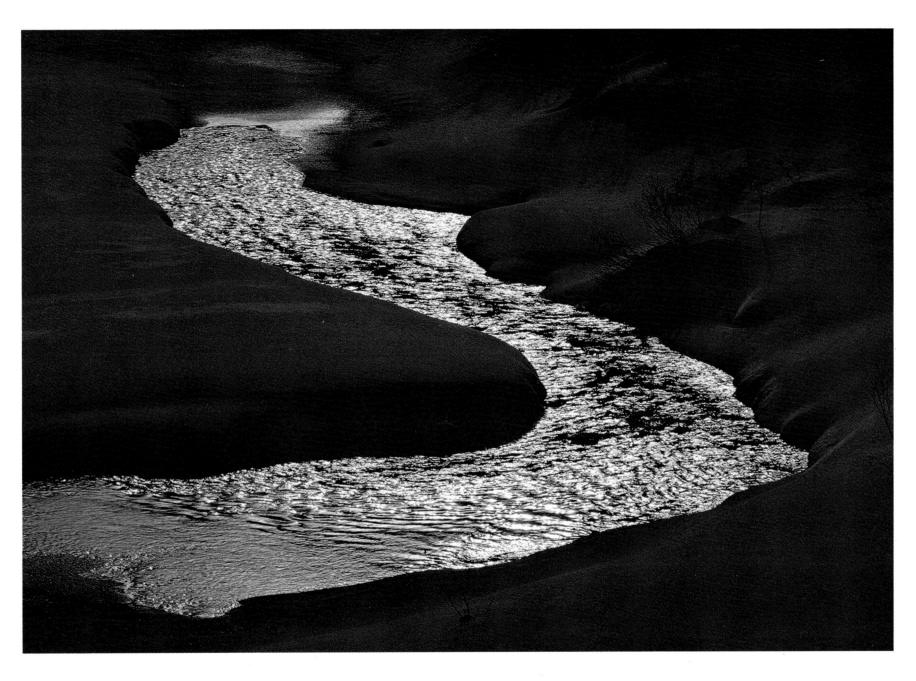

27

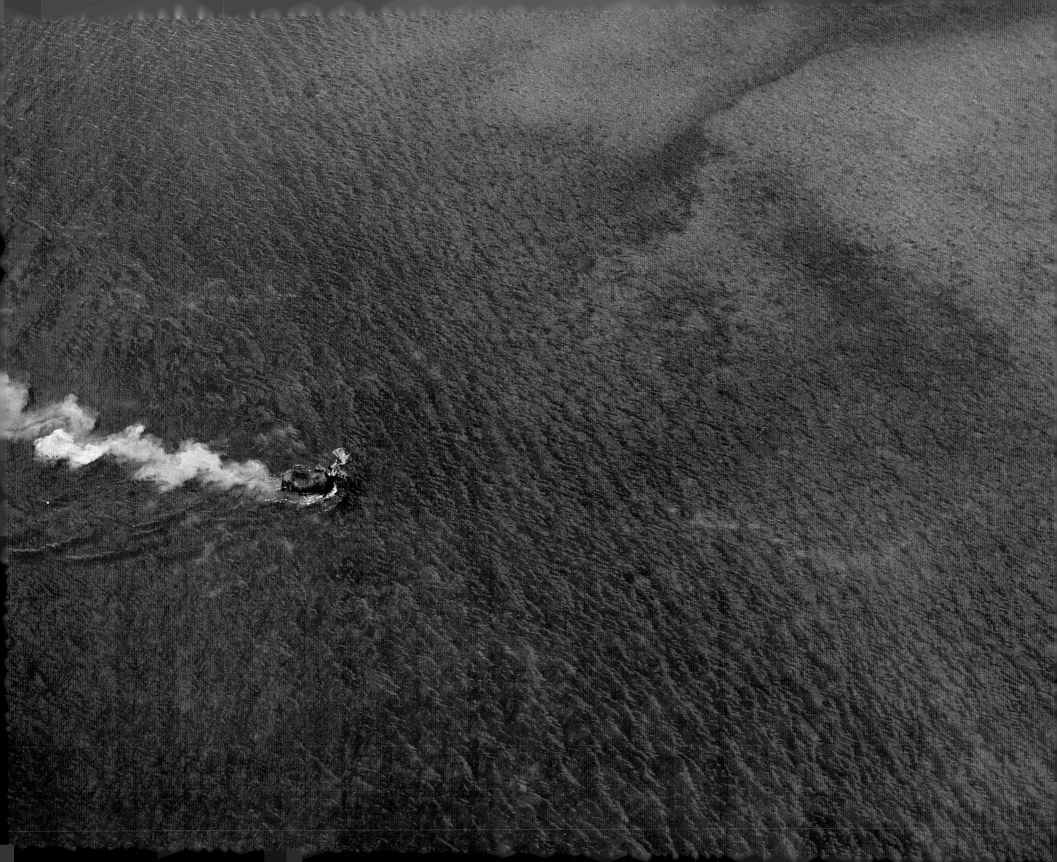

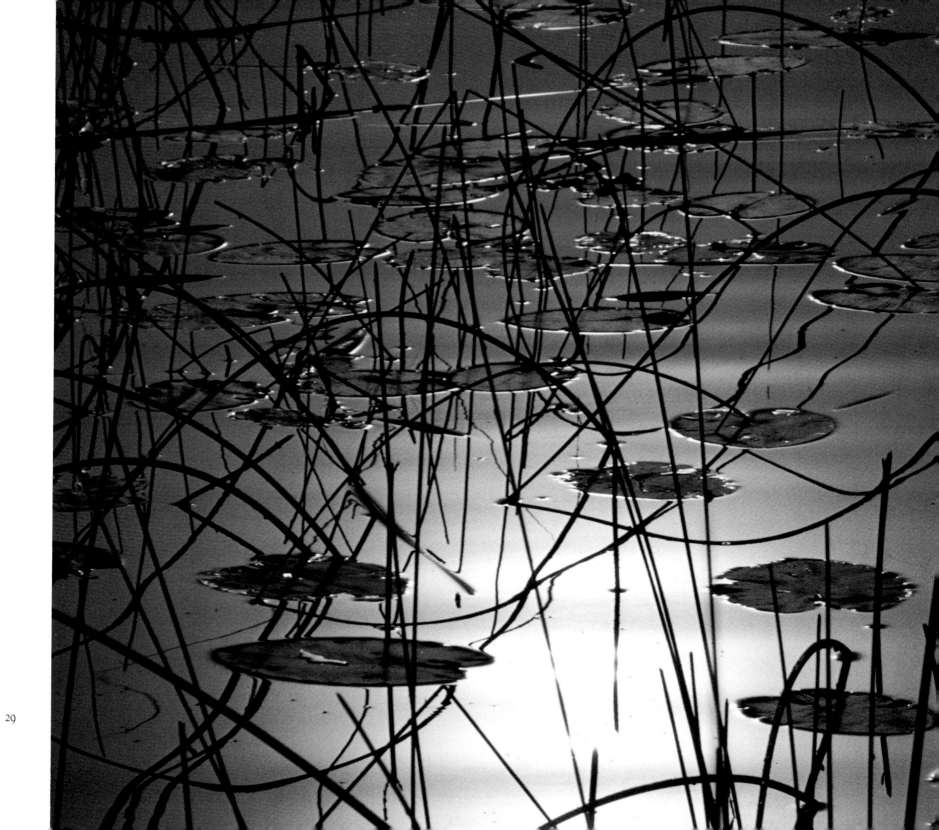

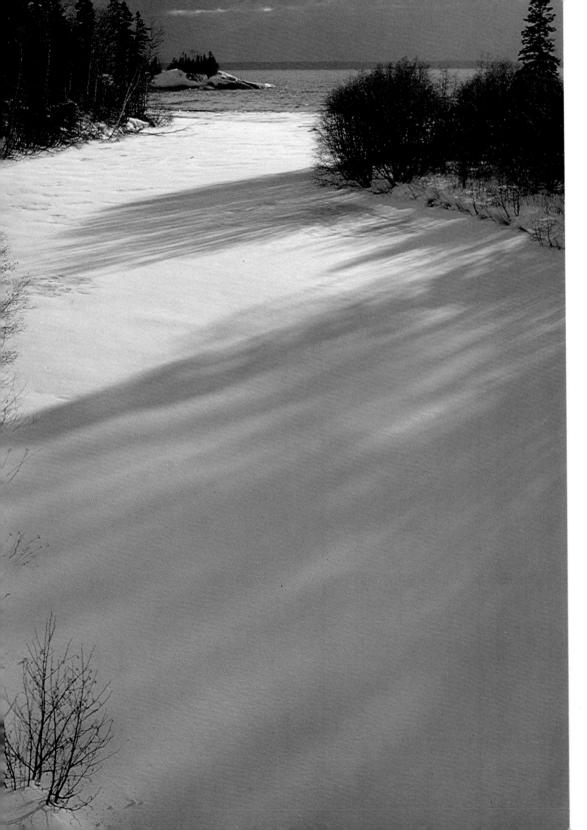

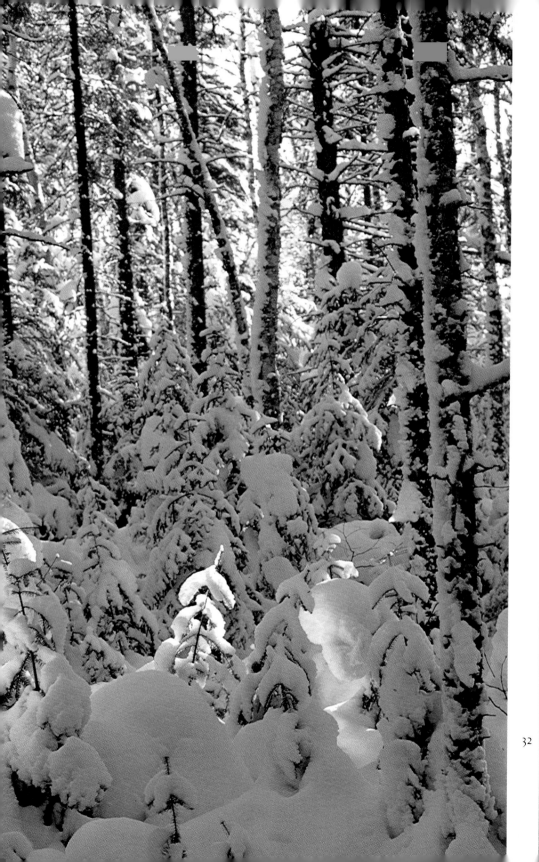

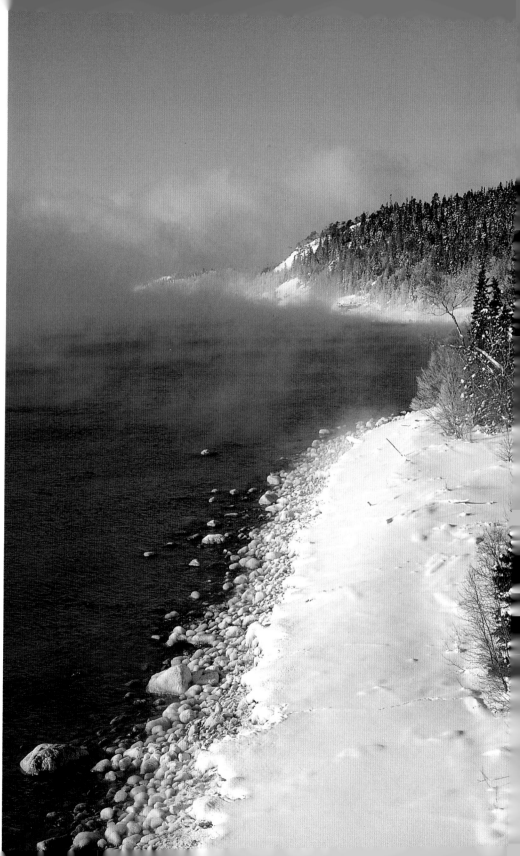

32

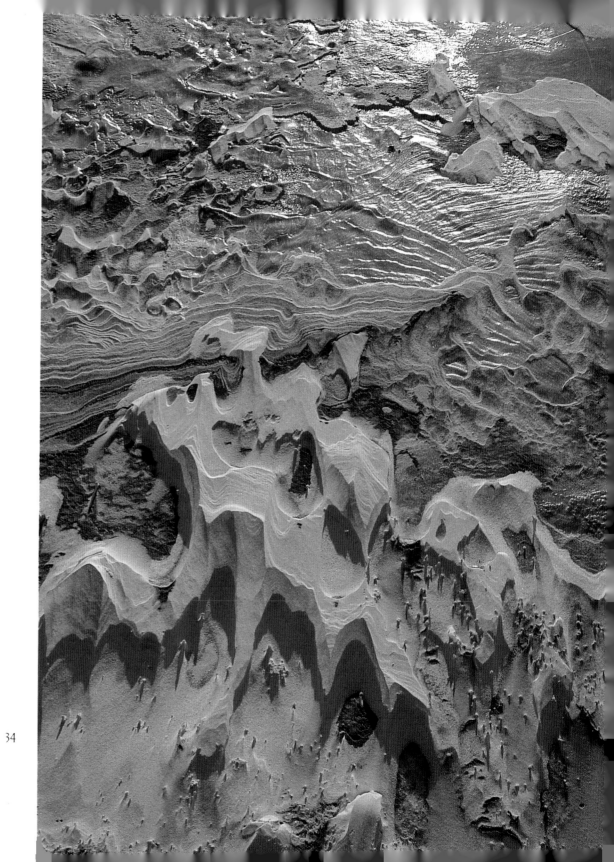

33

34

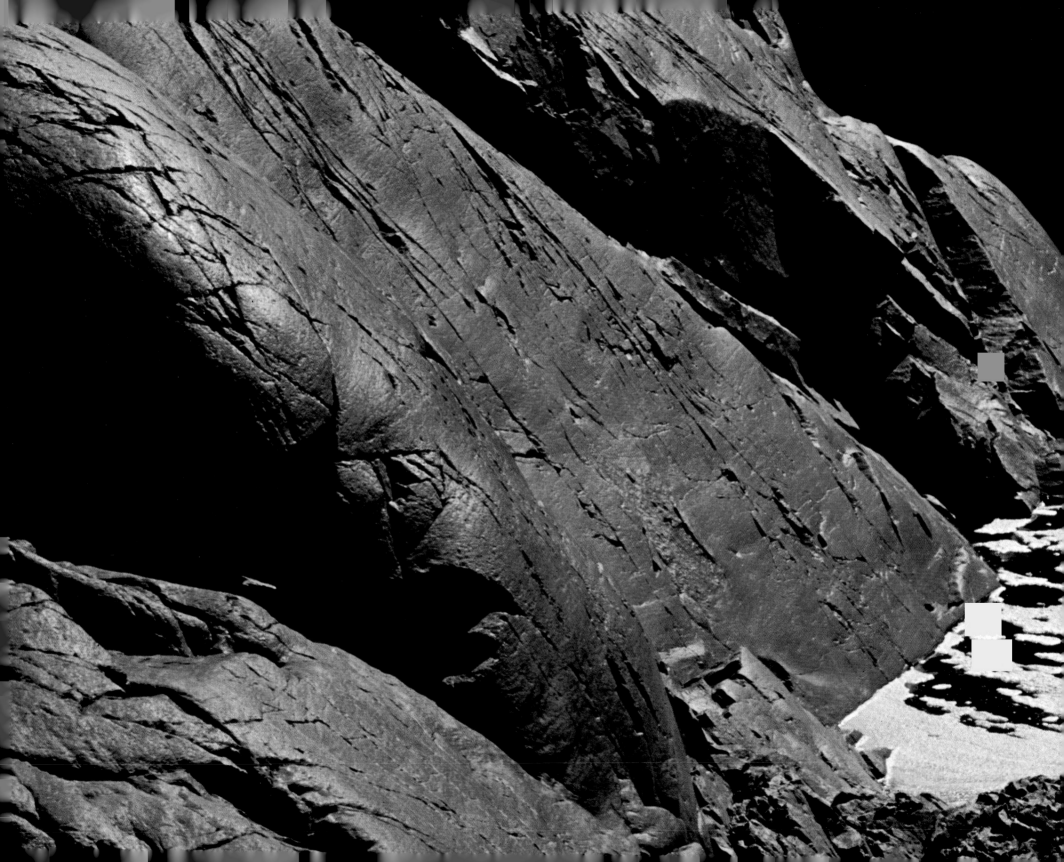

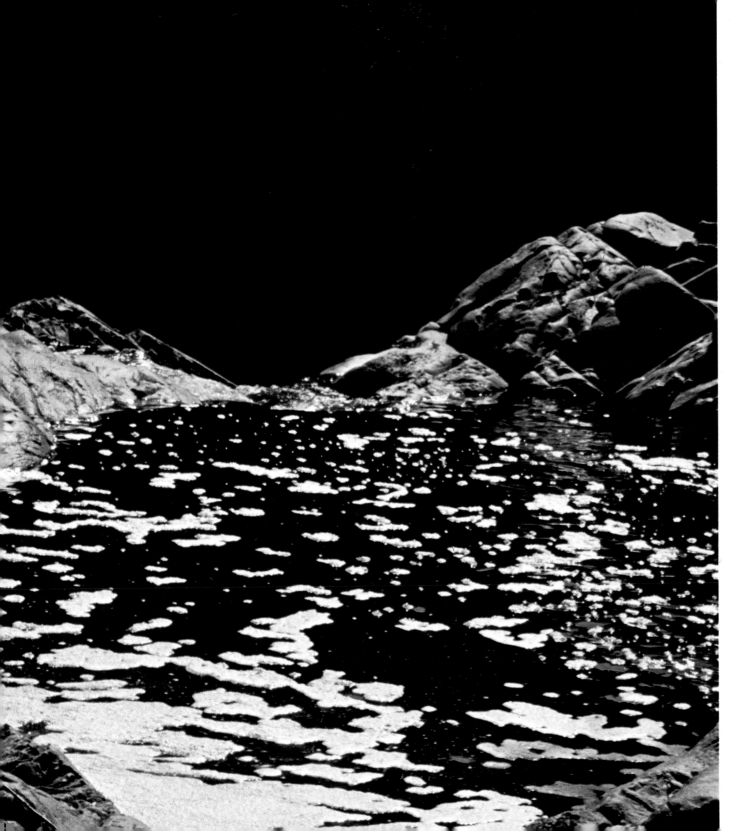

38

39

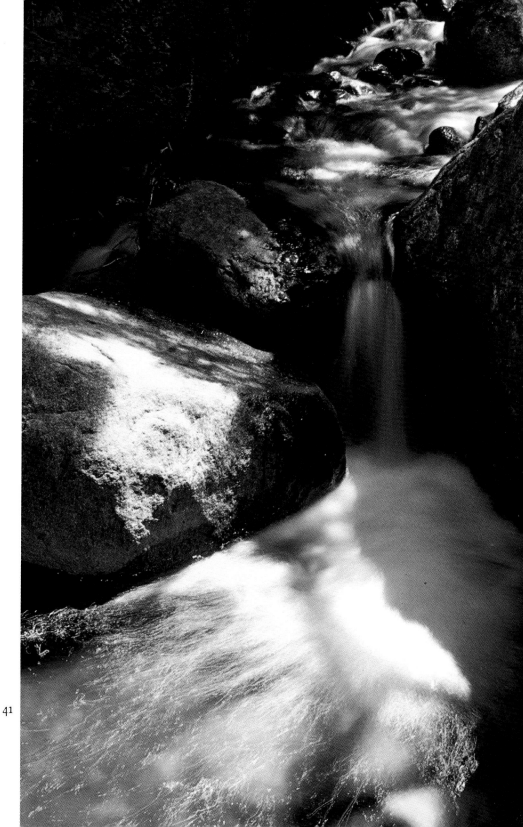

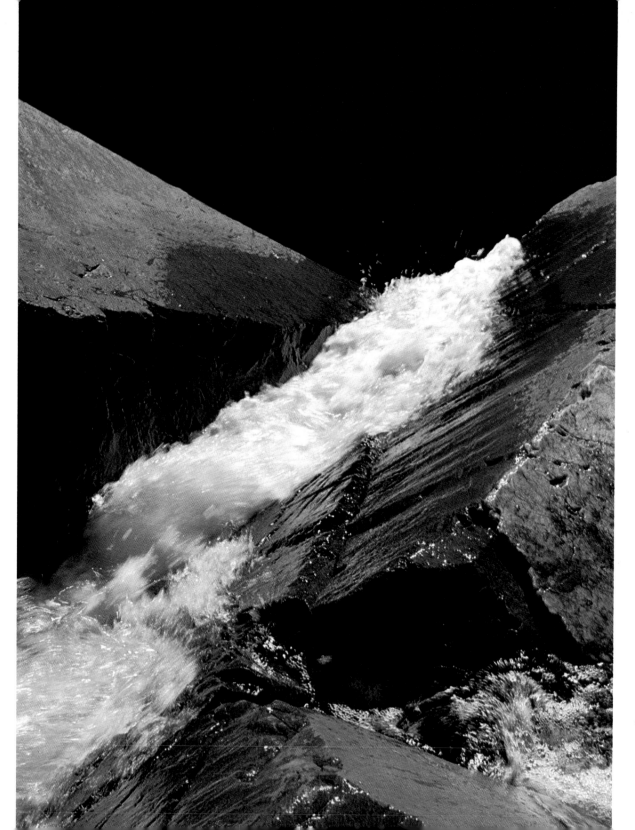

42

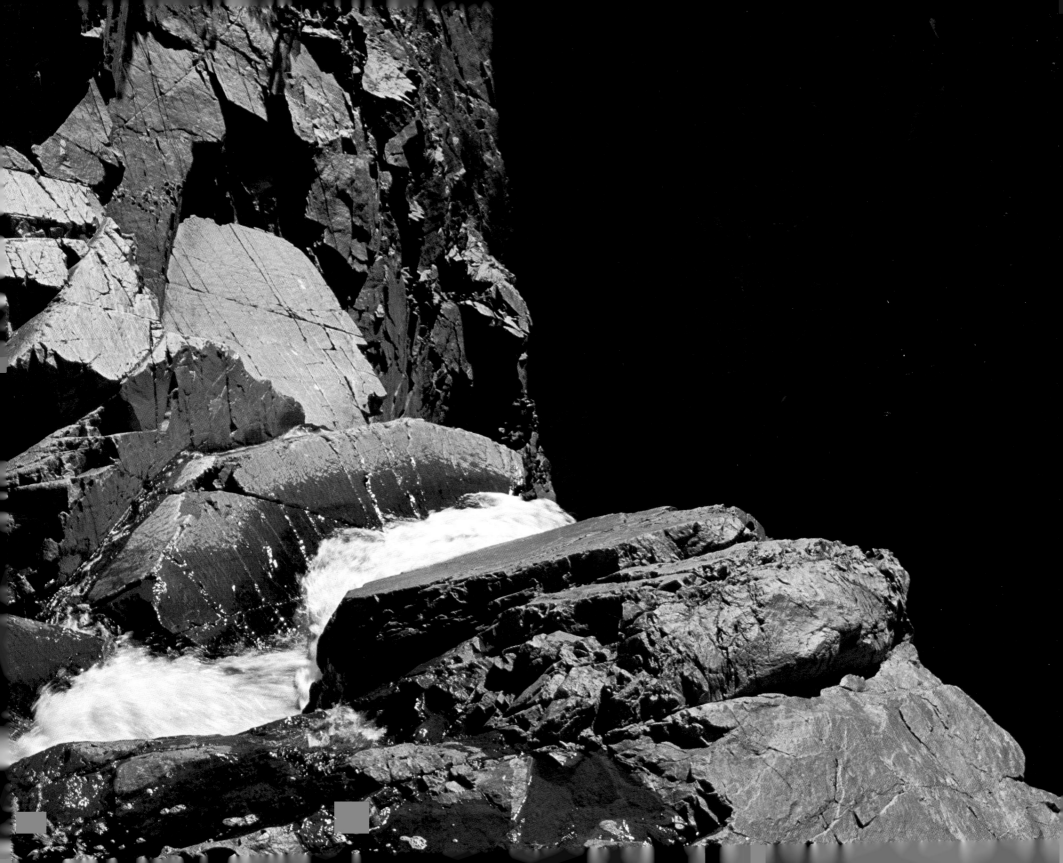

45

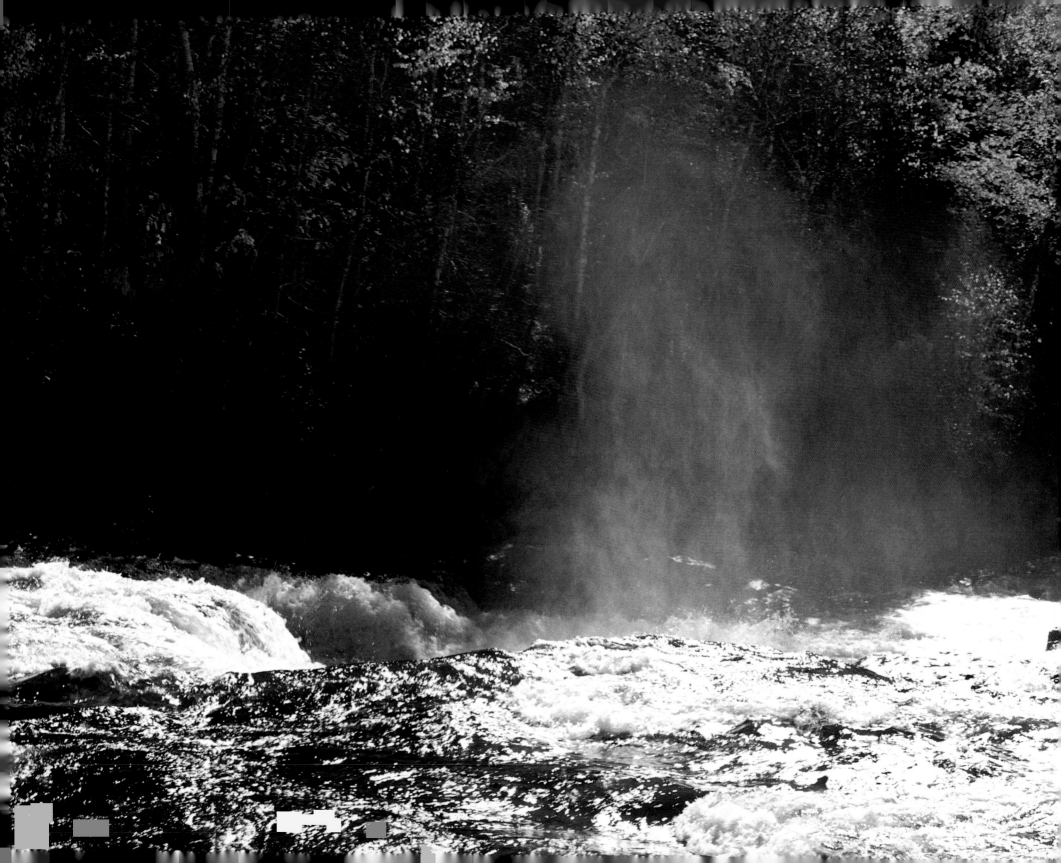

47

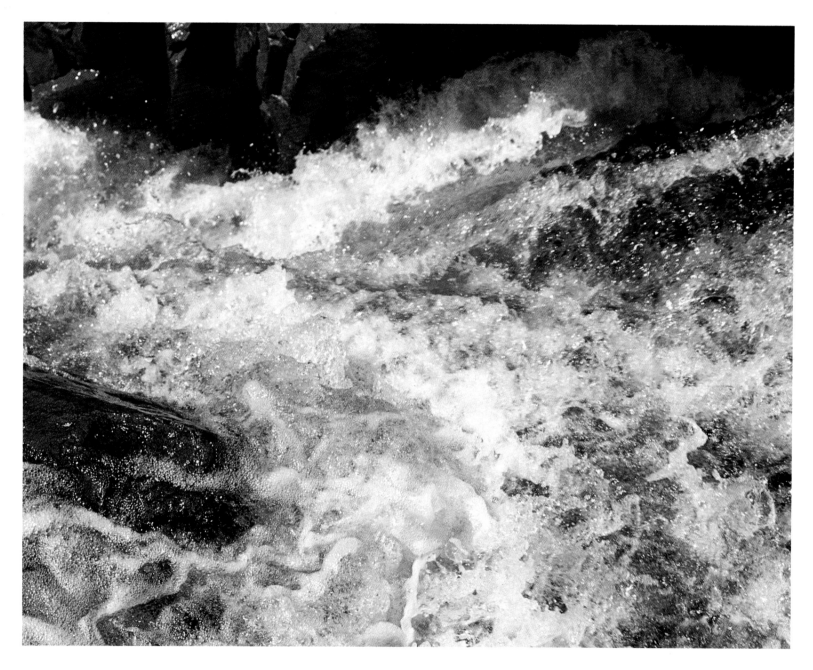

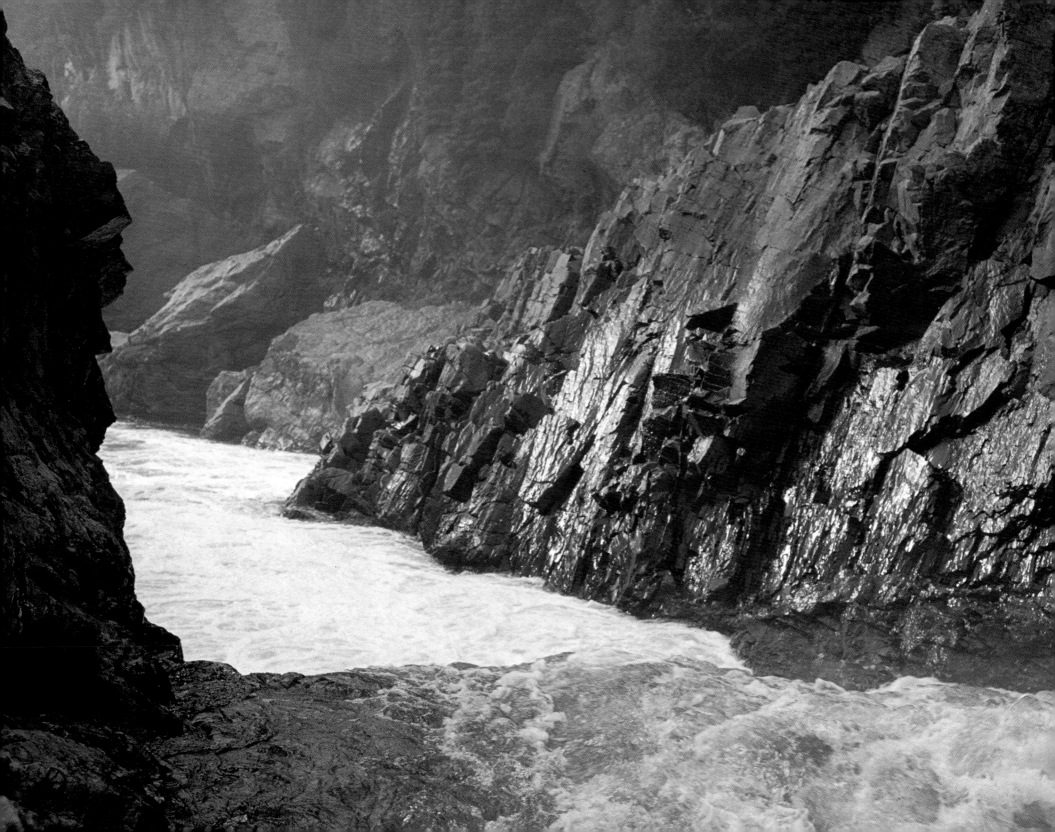

This is a beauty
of dissonance,
this resonance
of stony strand,...

This is the beauty
of strength
broken by strength
and still strong.

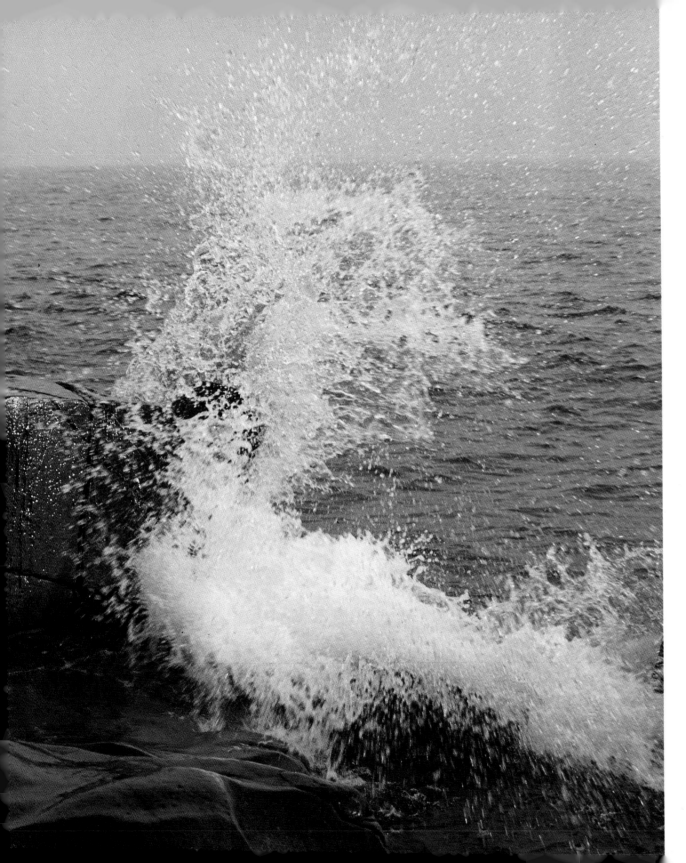

50

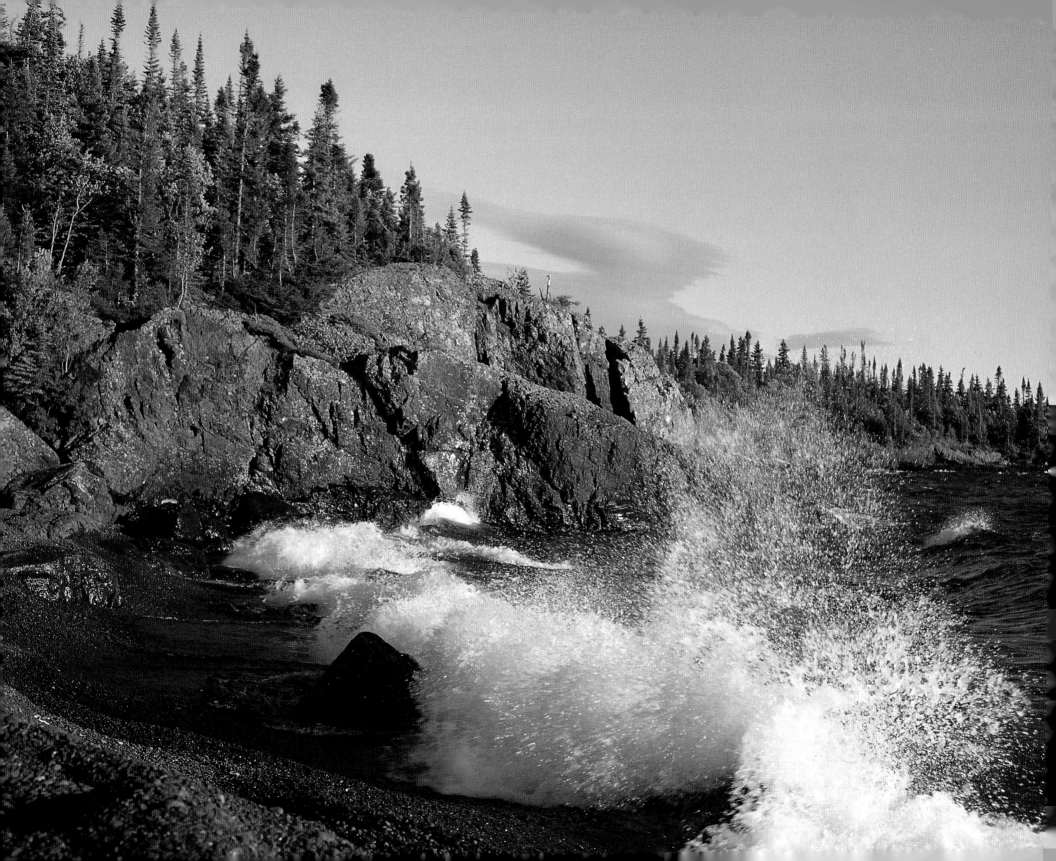

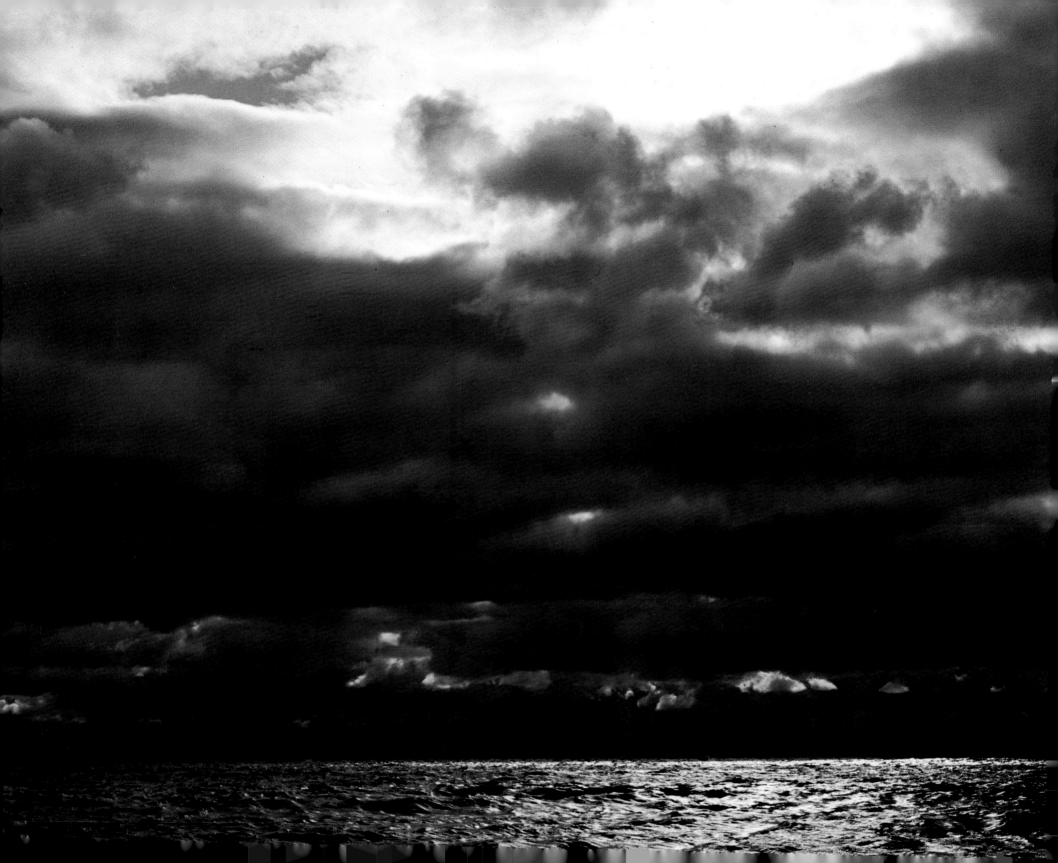

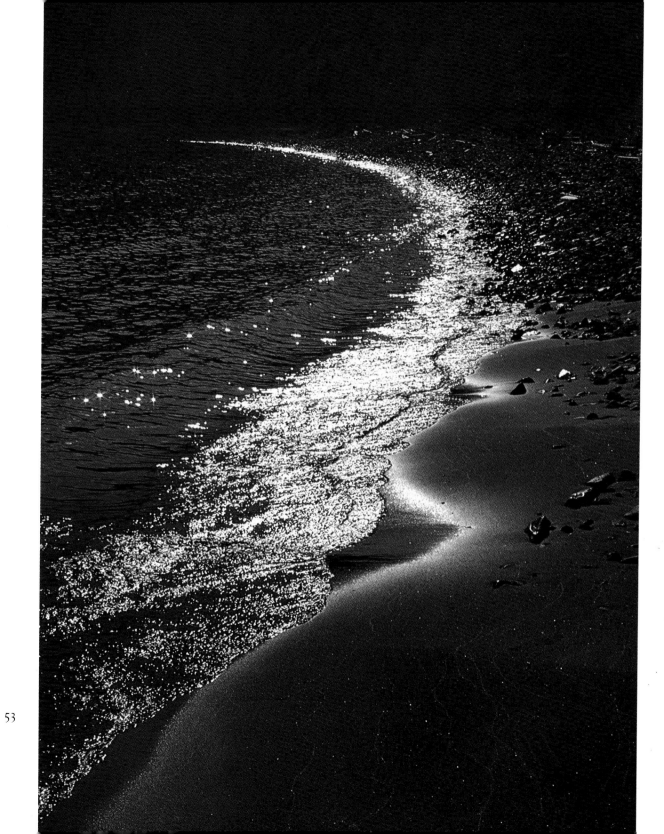

53

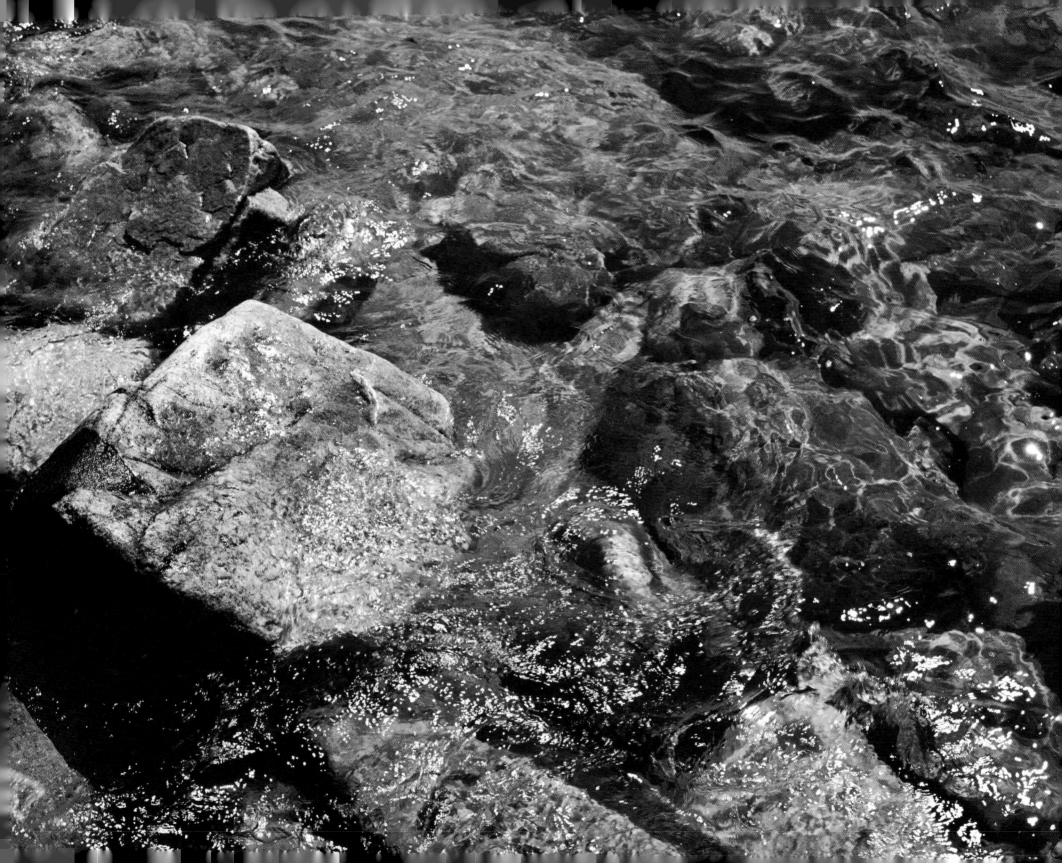

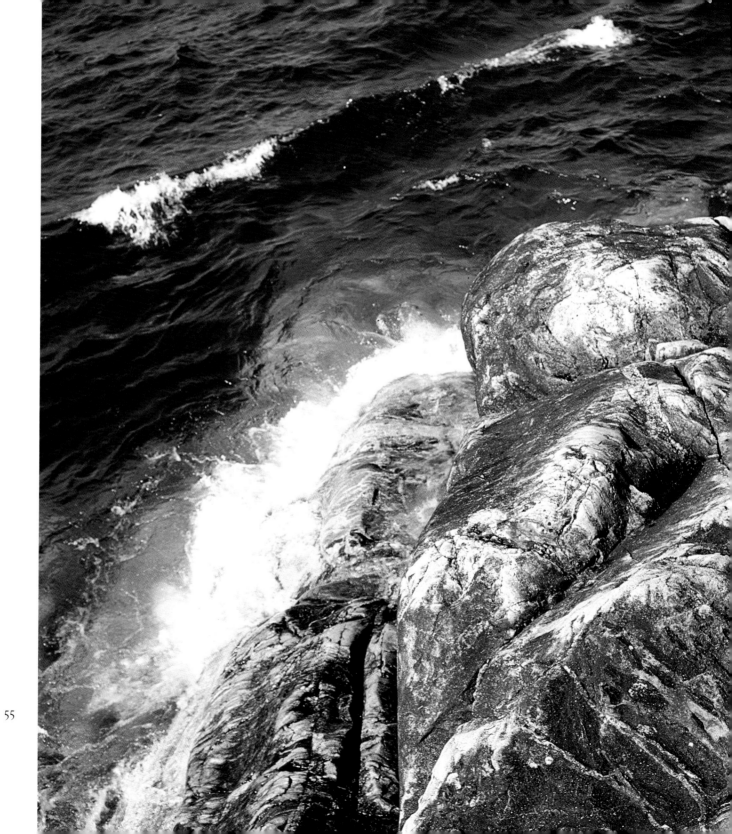

55

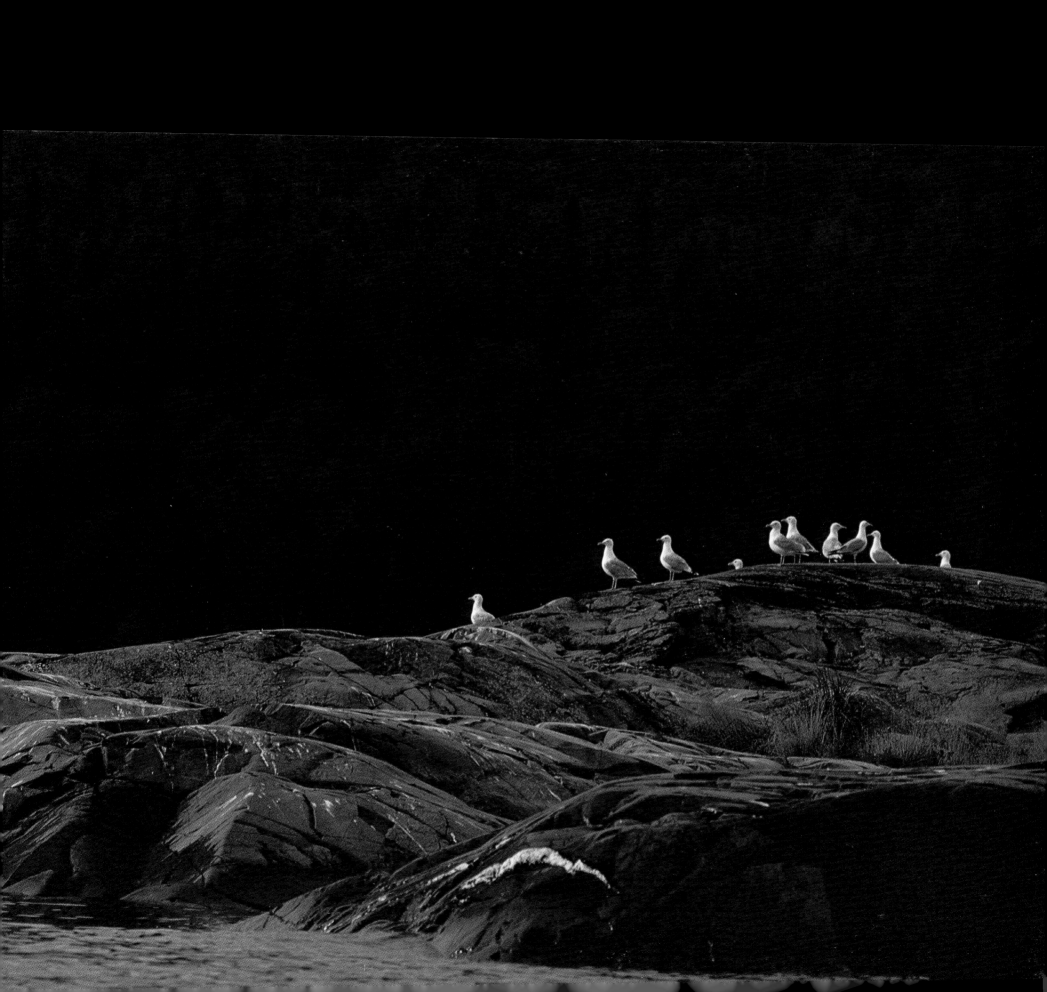

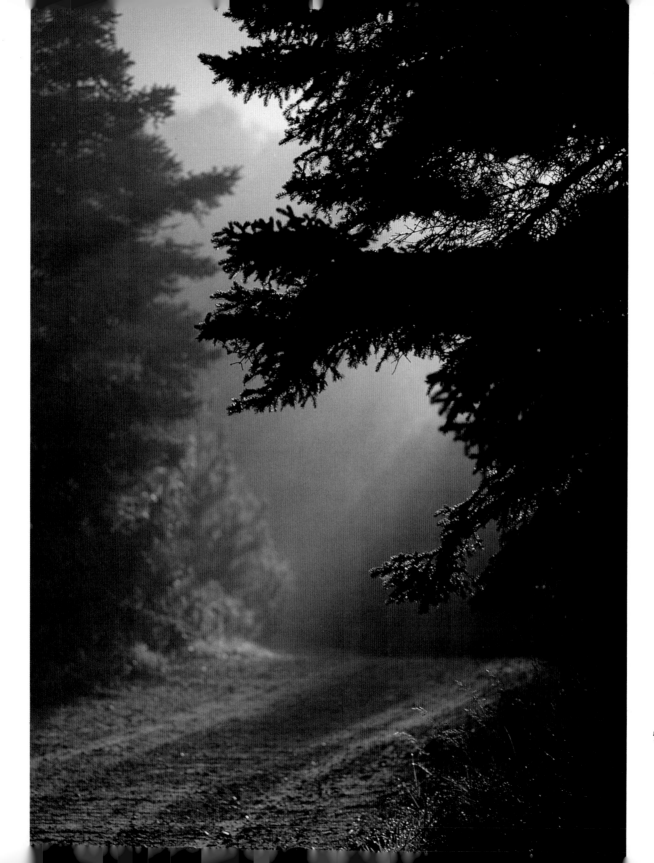

58

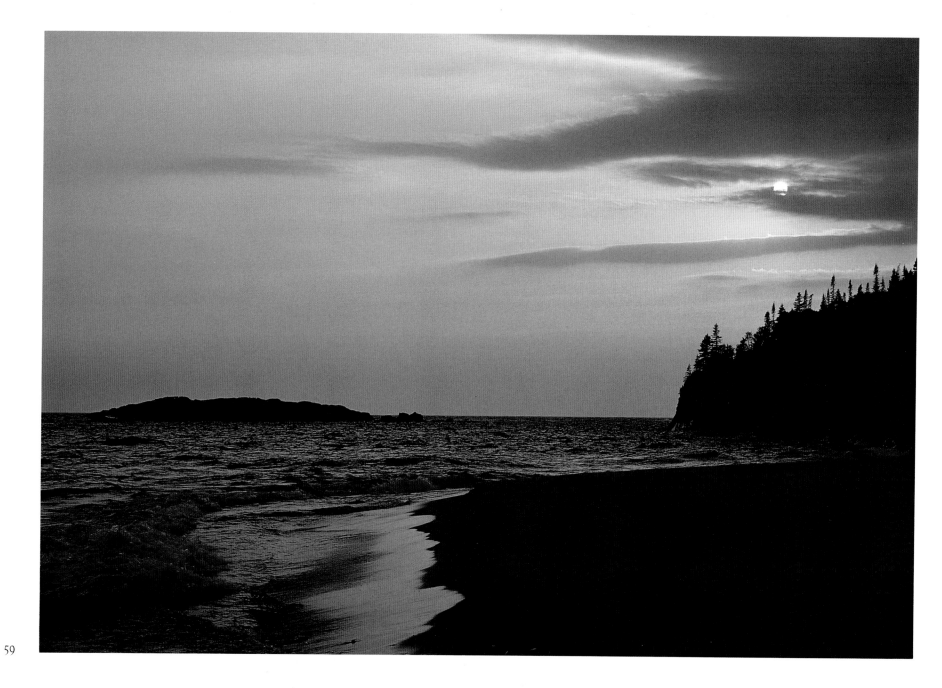

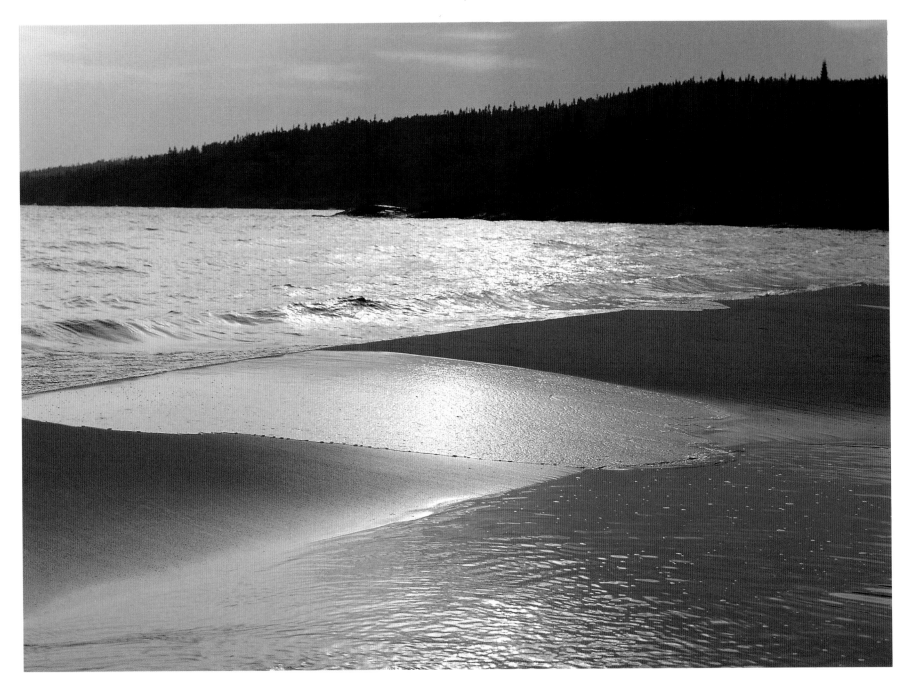

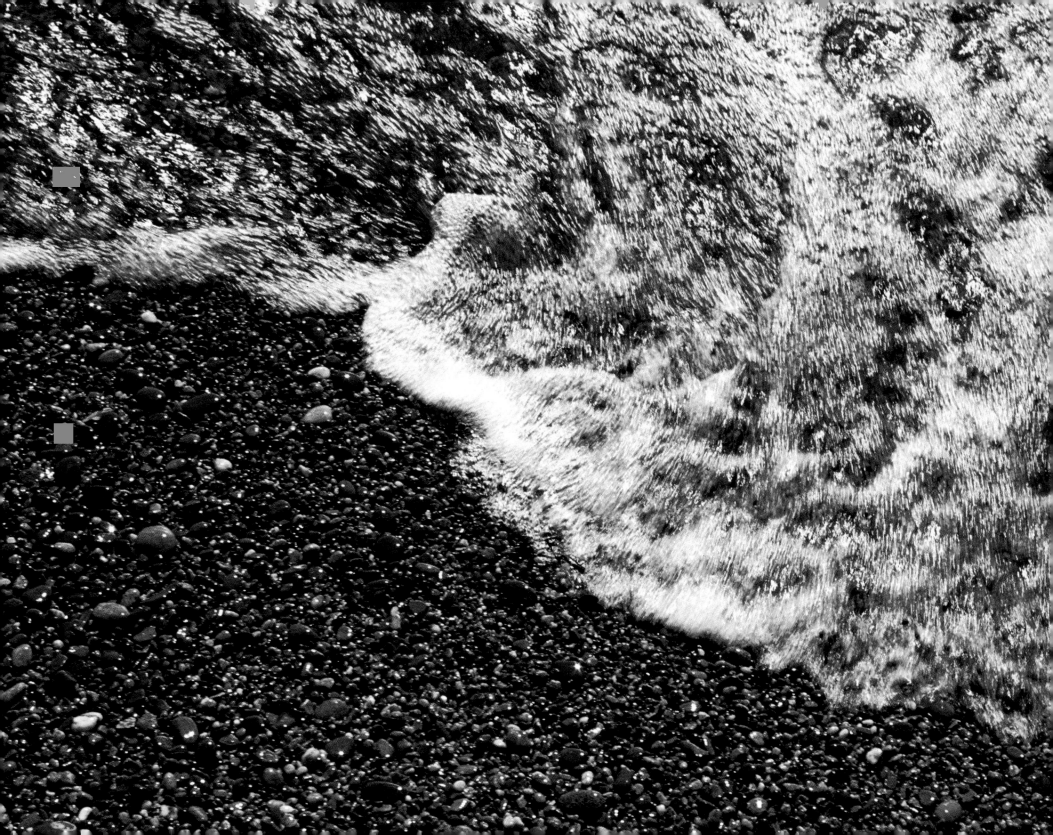

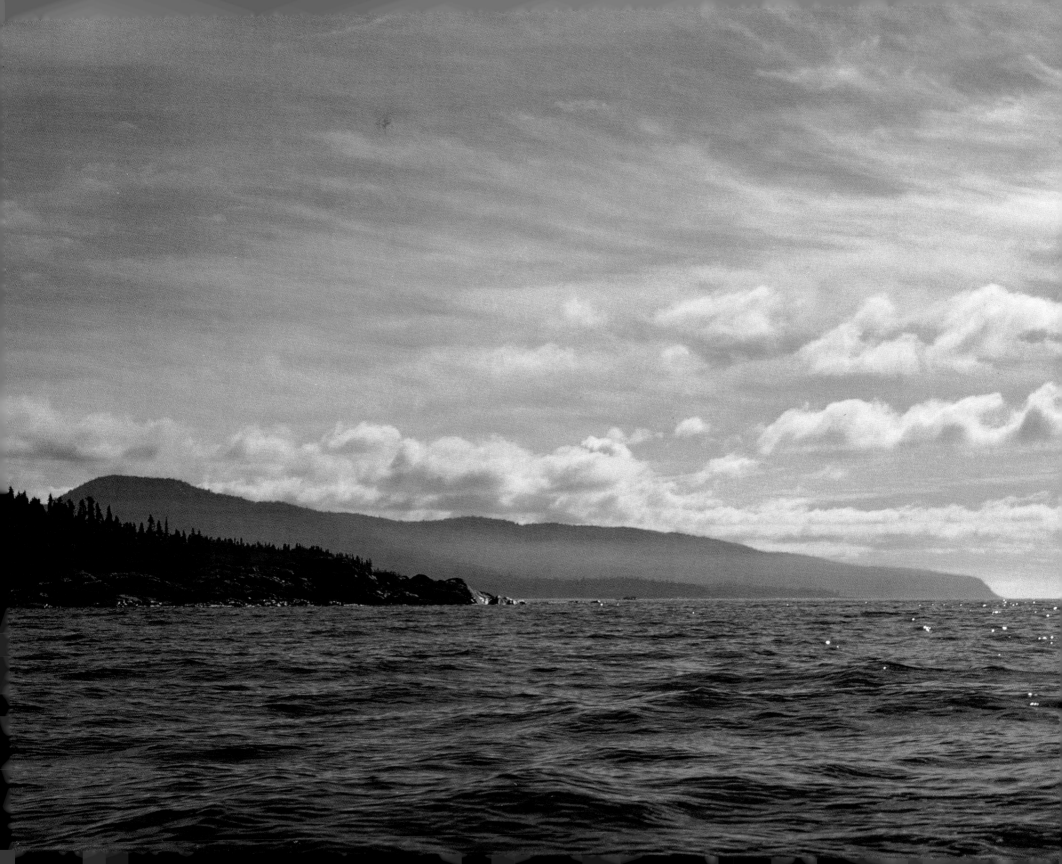

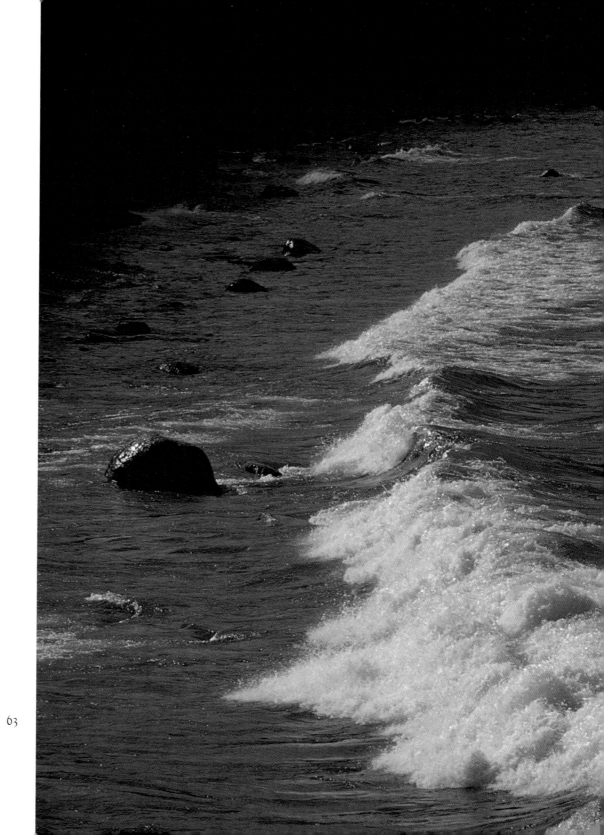

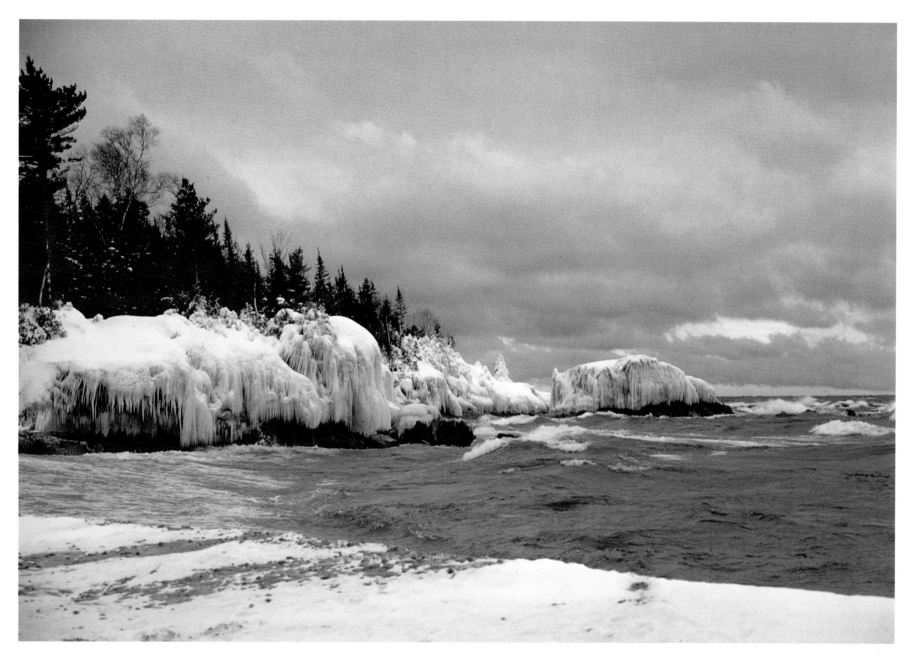

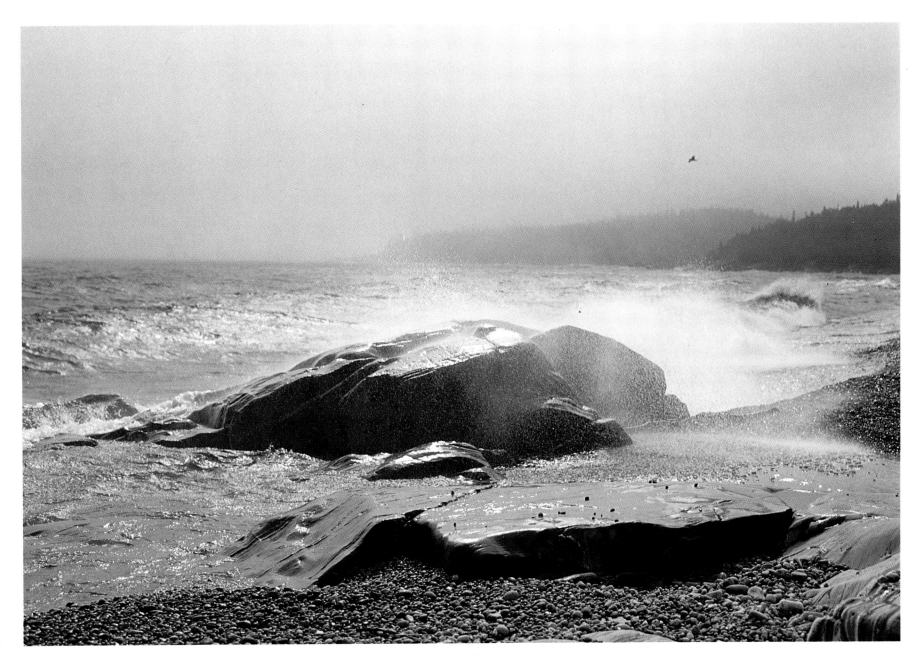

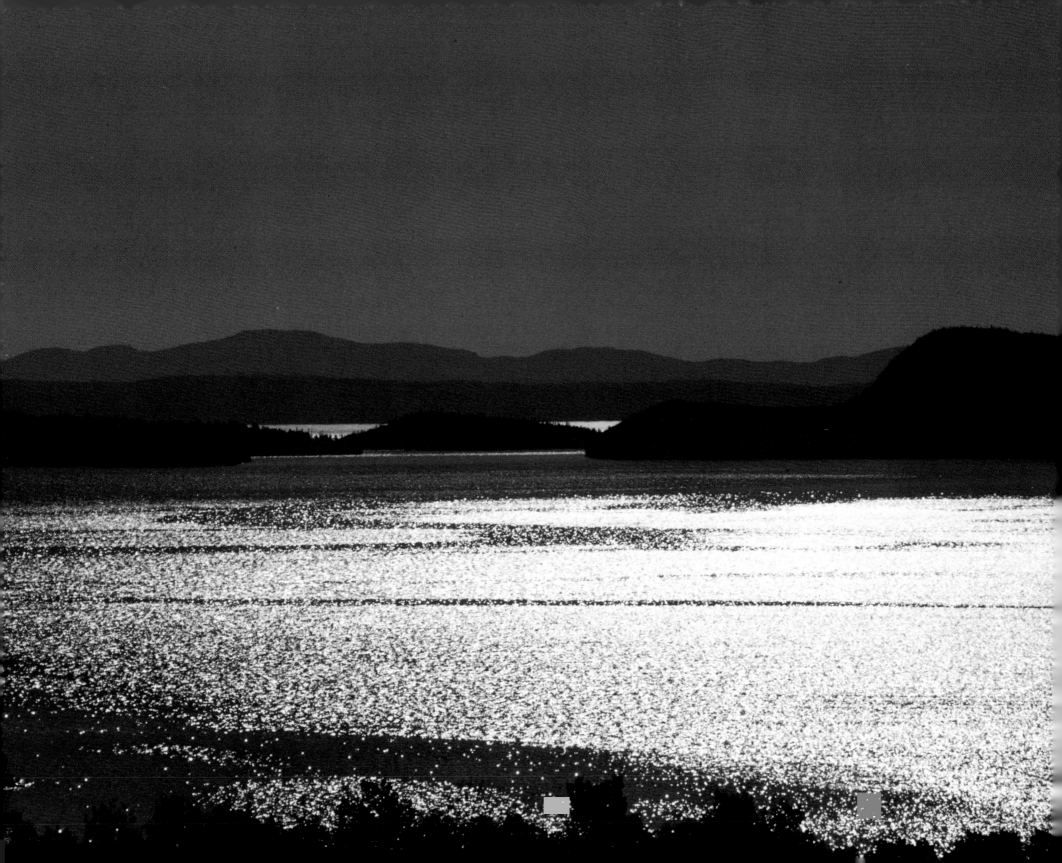

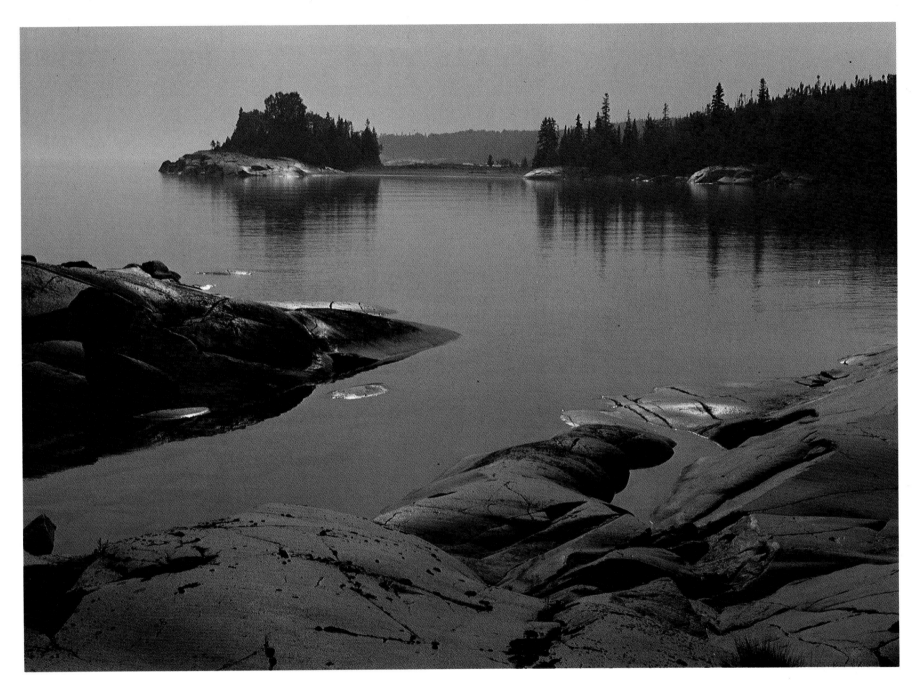

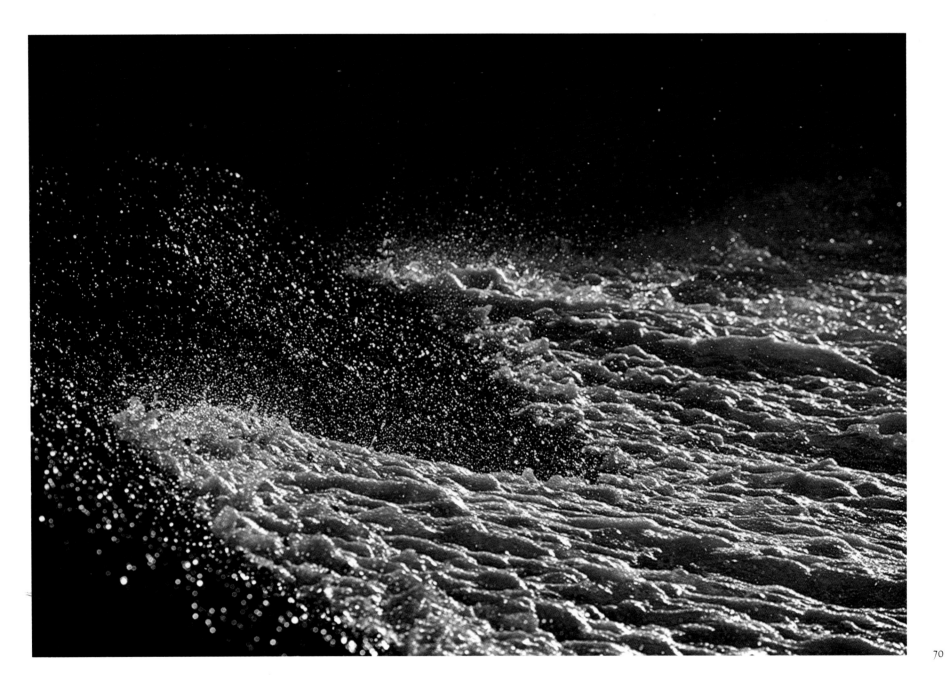

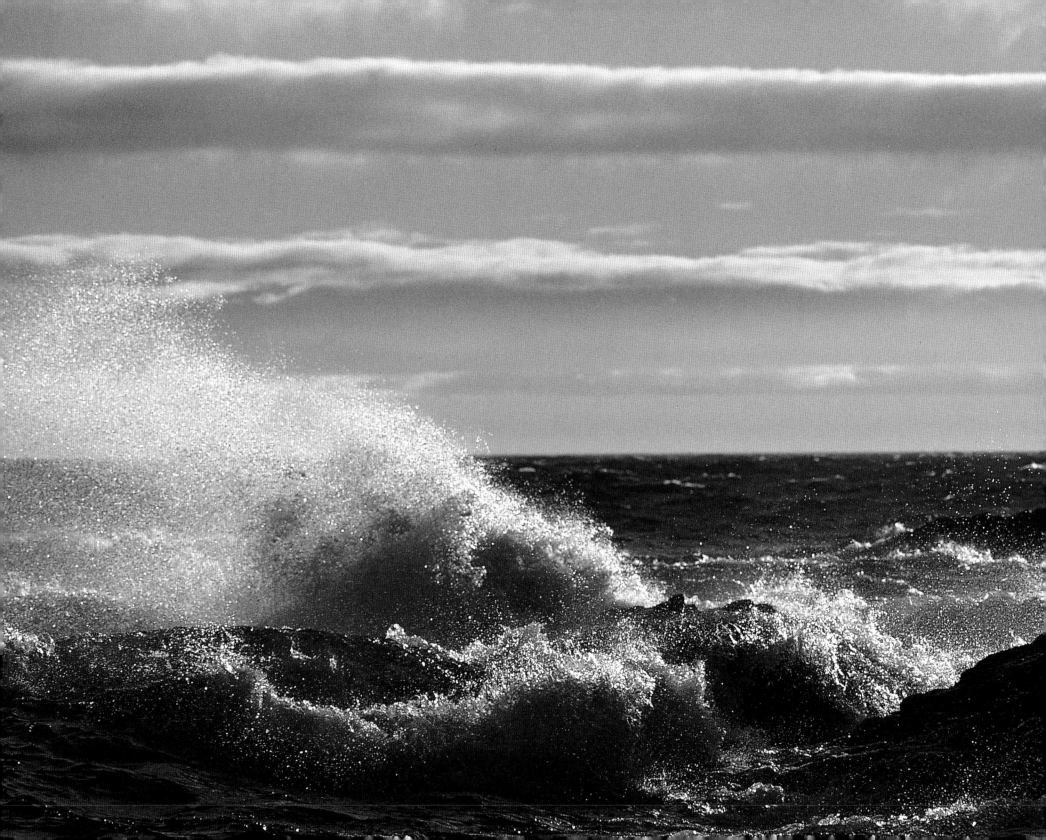

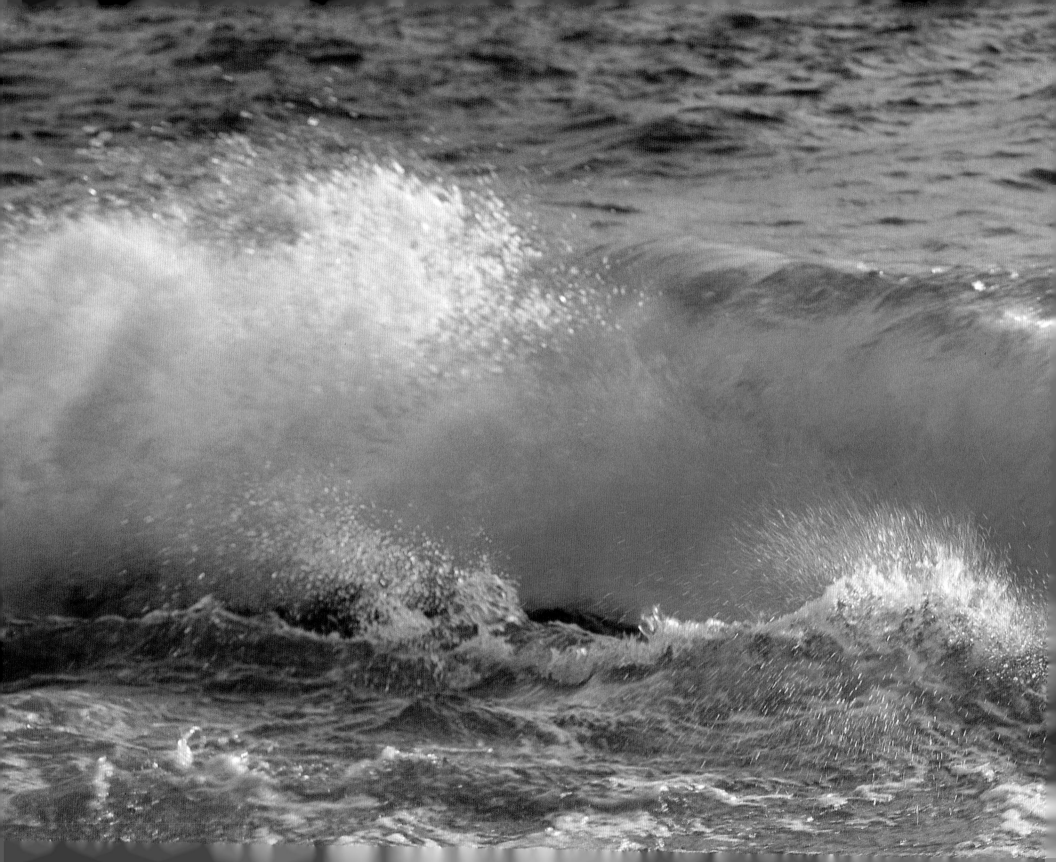

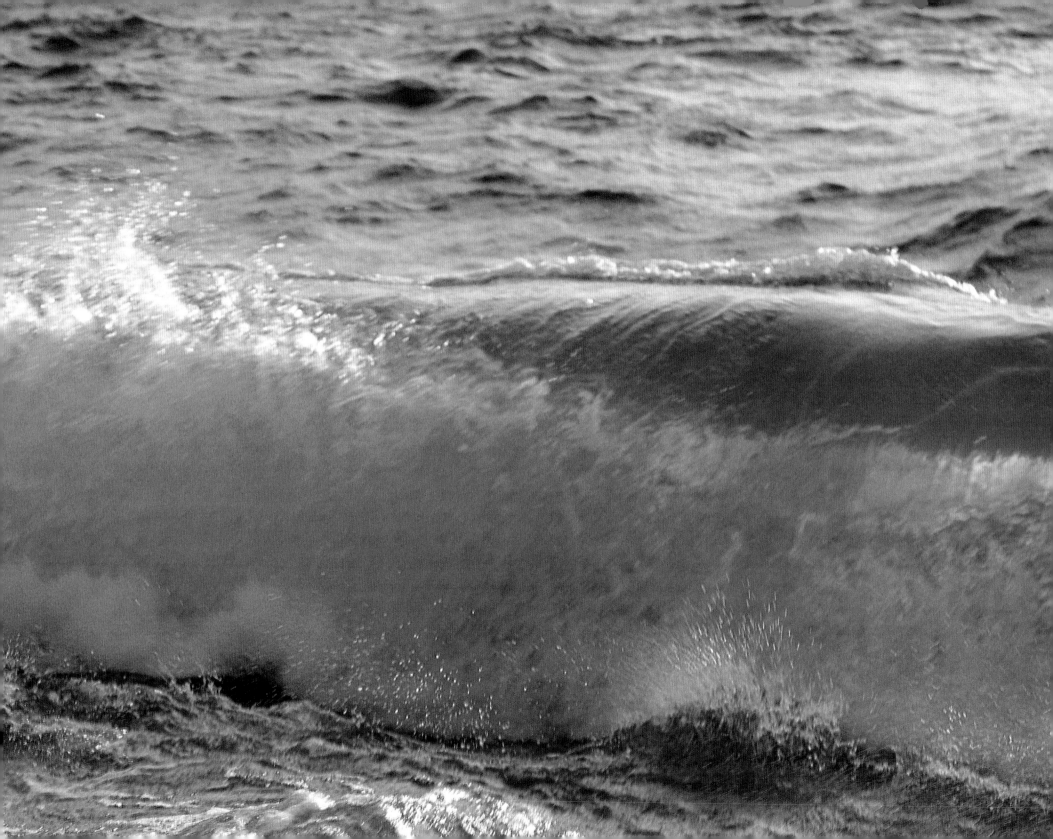

. . . Above the water
the sun smoked golden
and the gulls floated and called.
The figures of the gods
were everywhere, but invisible

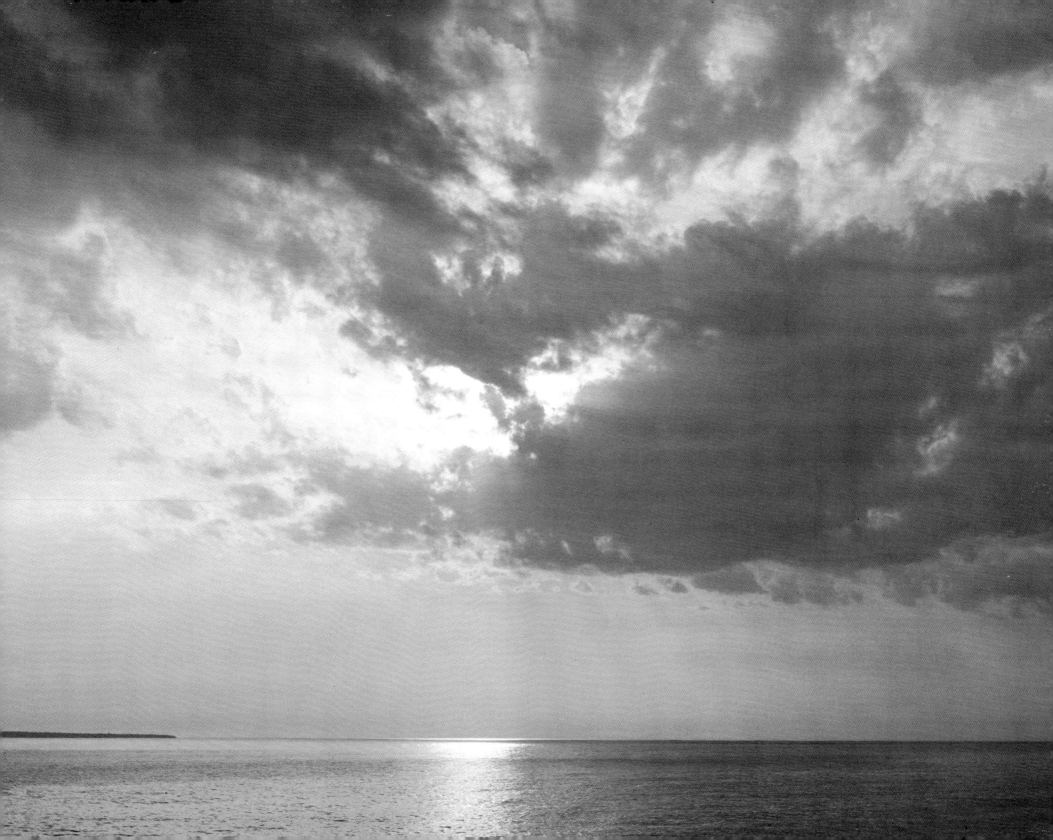

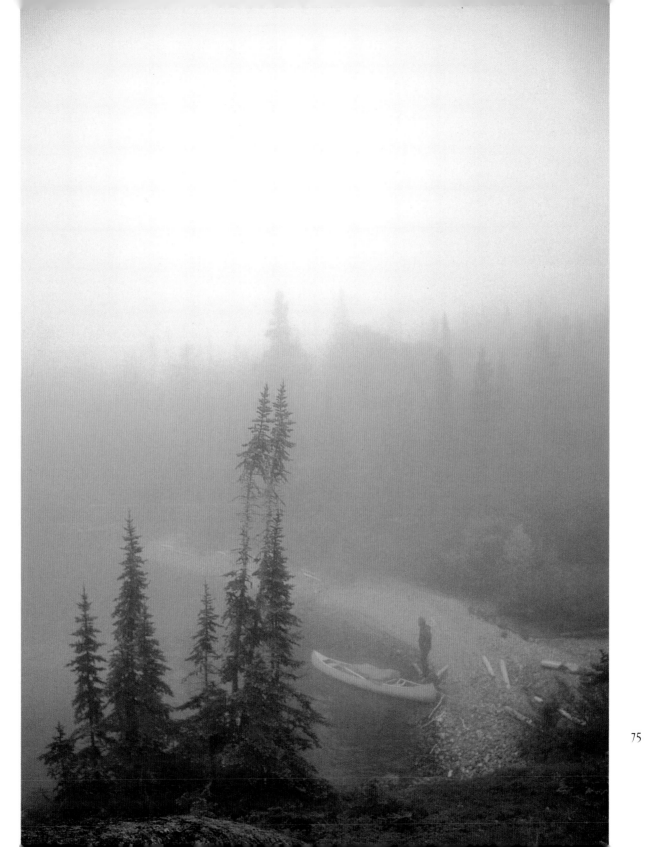

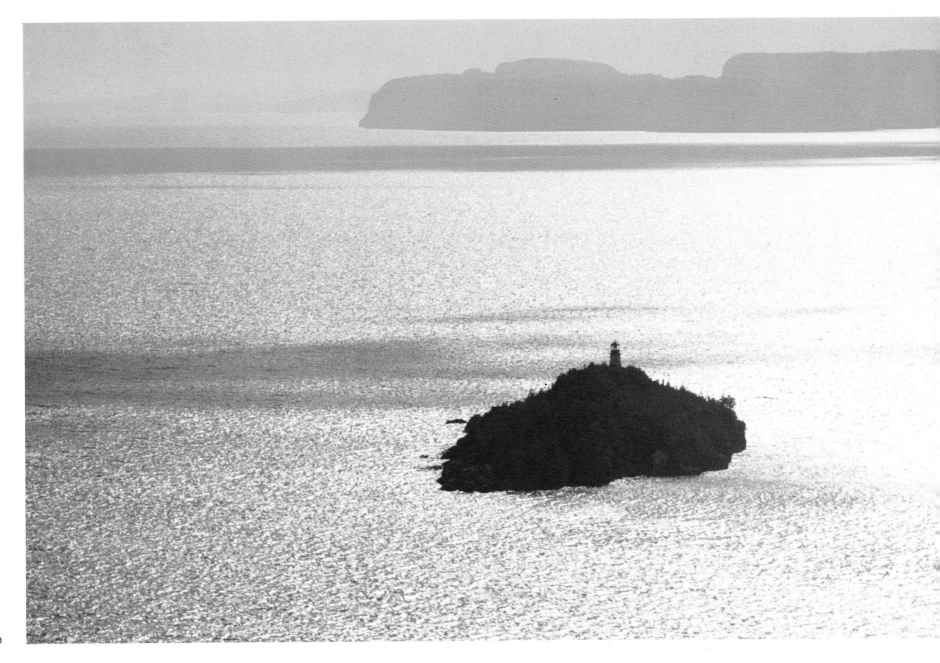

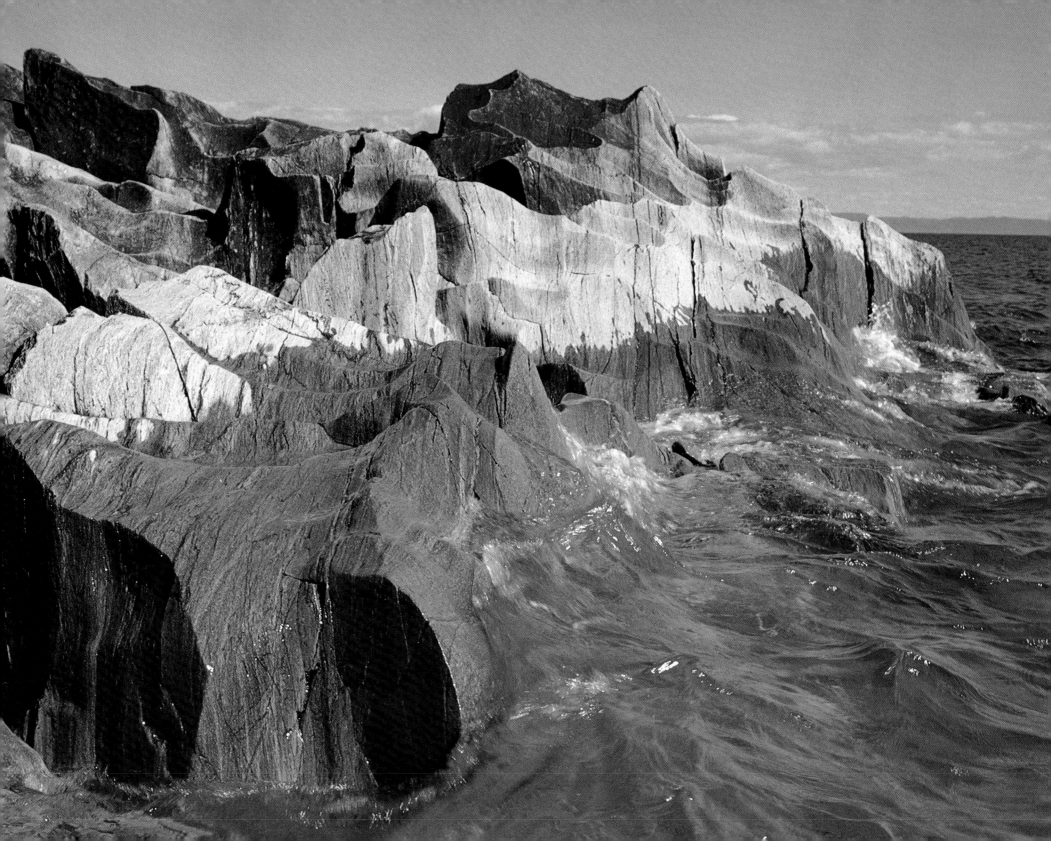

77

78

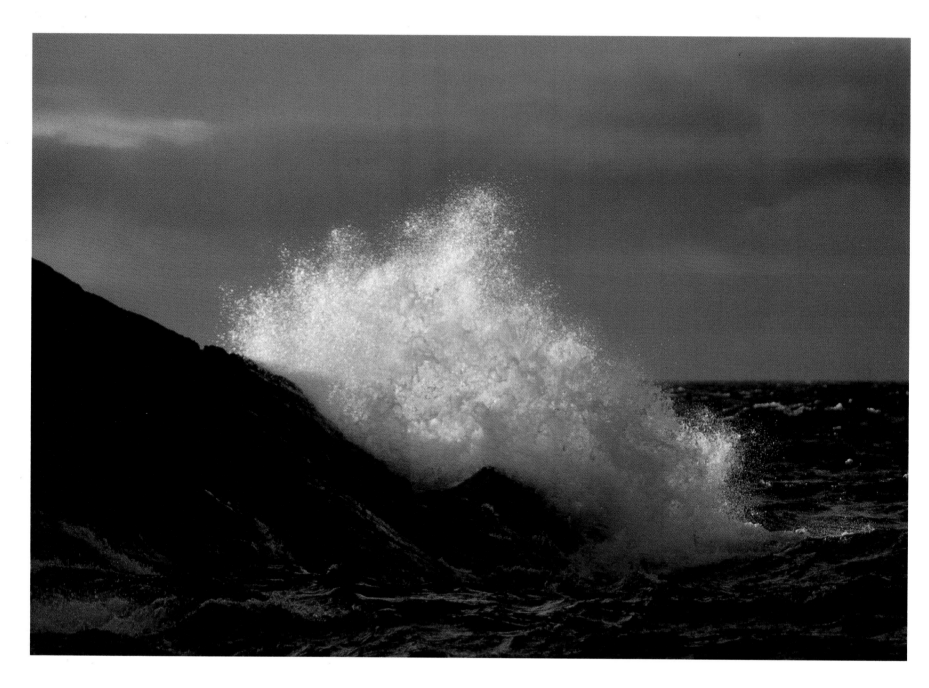

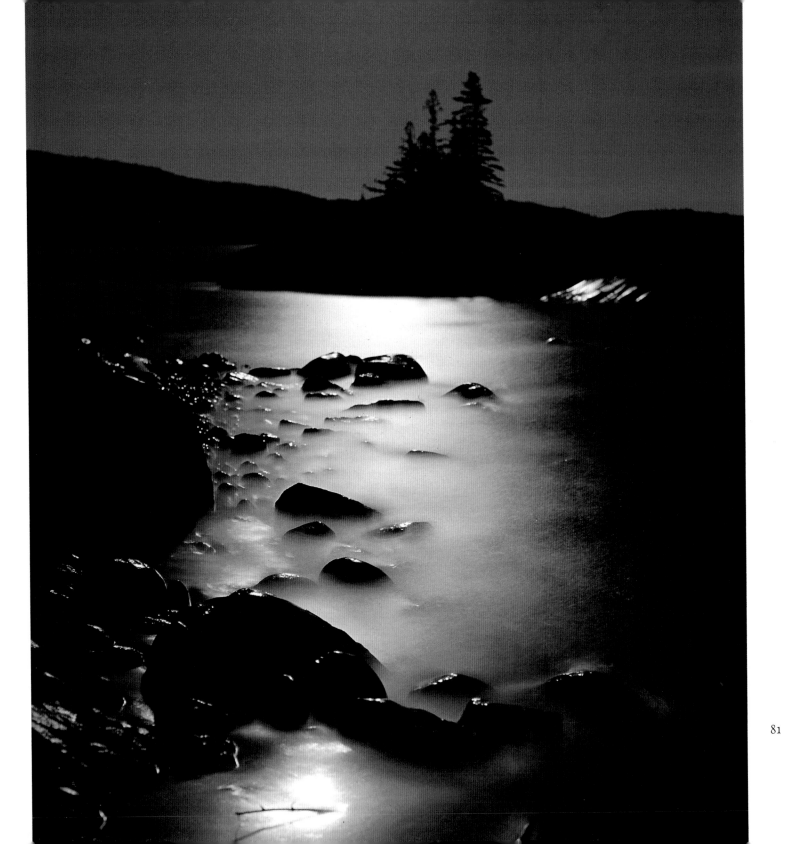

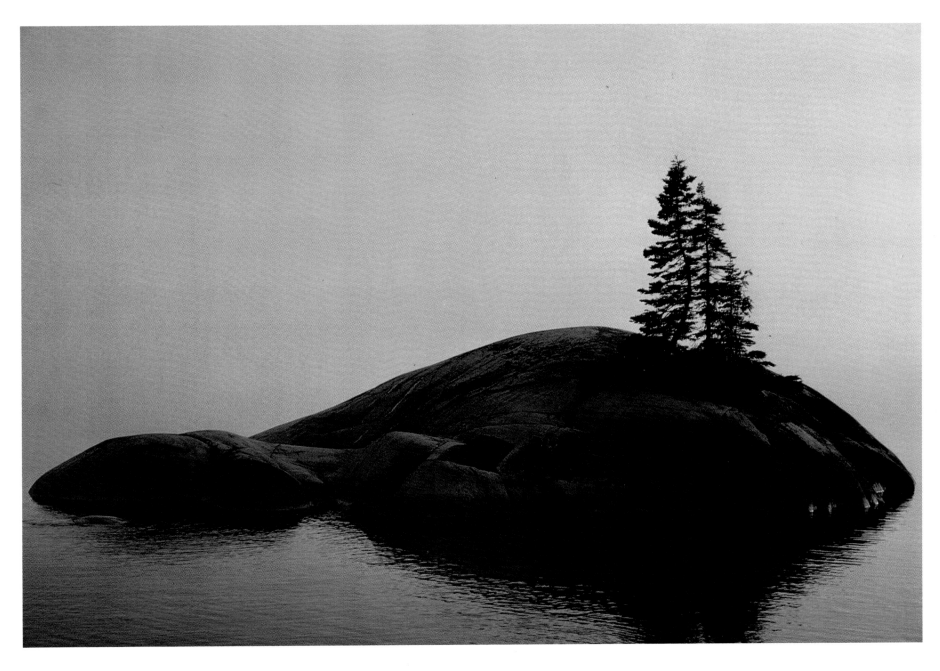

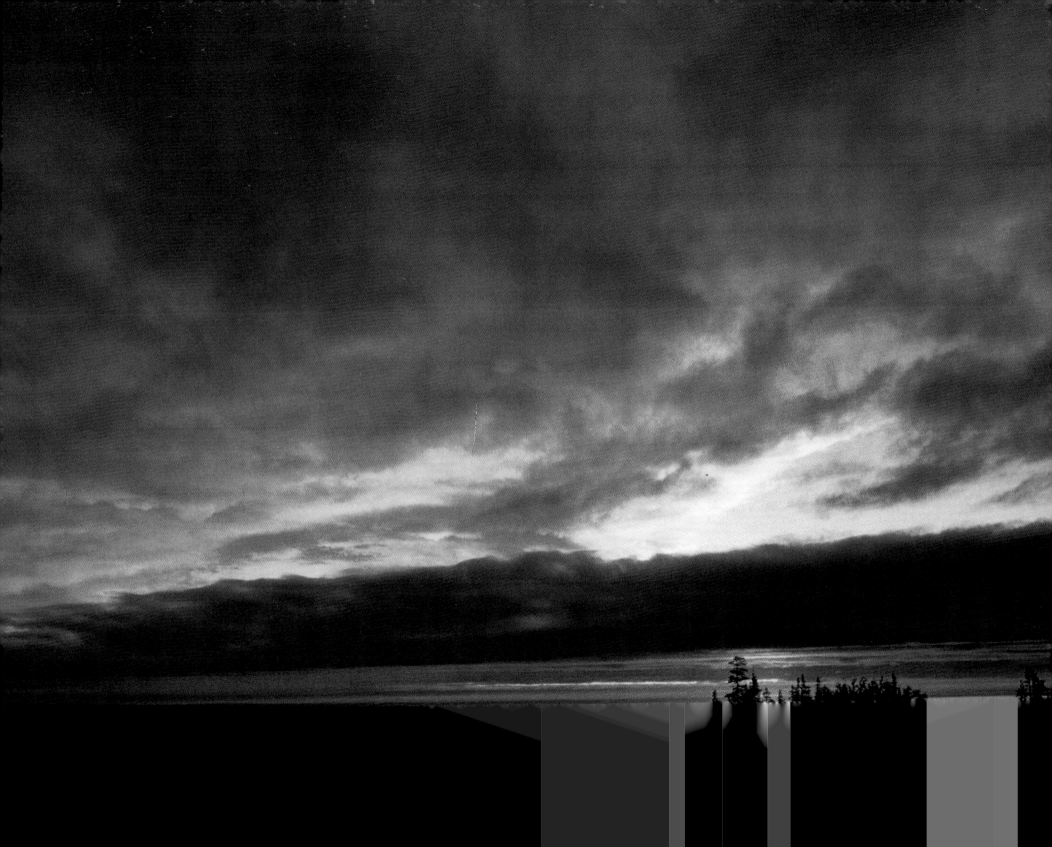

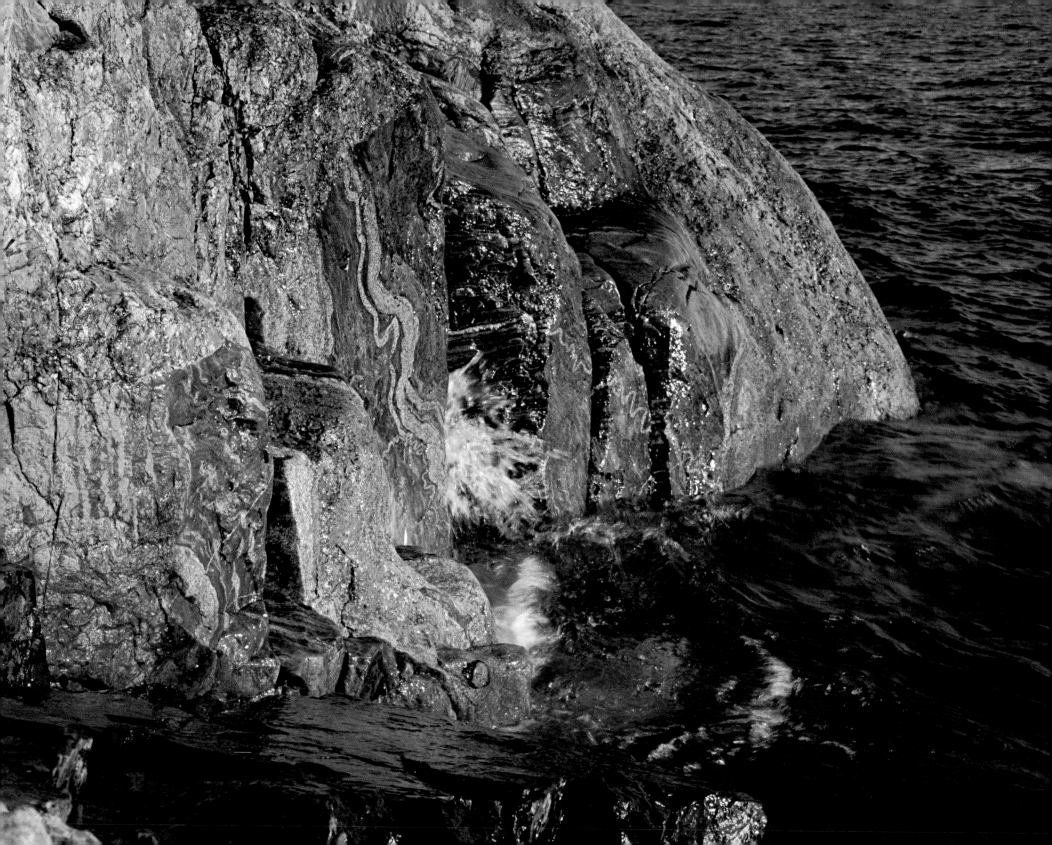

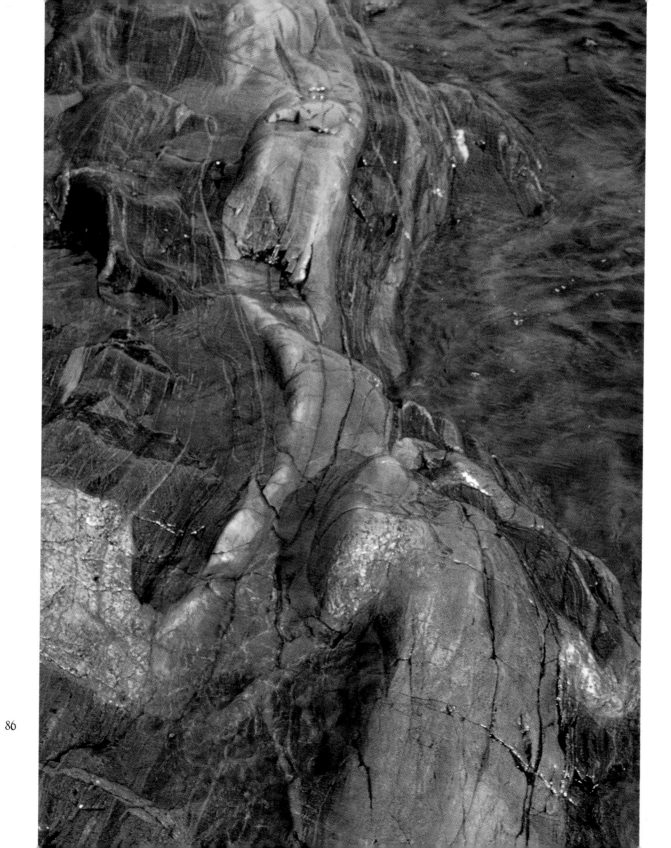

86

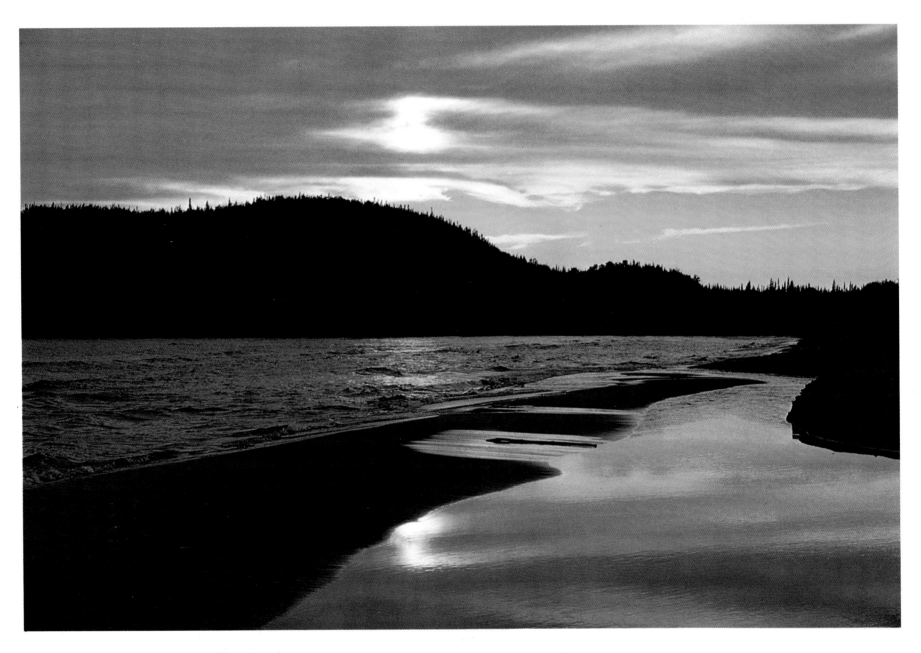

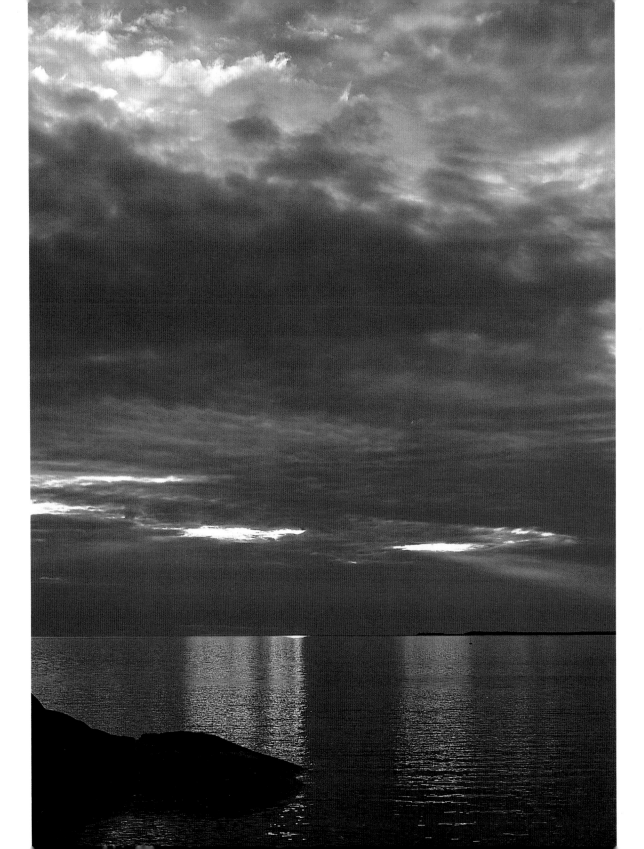

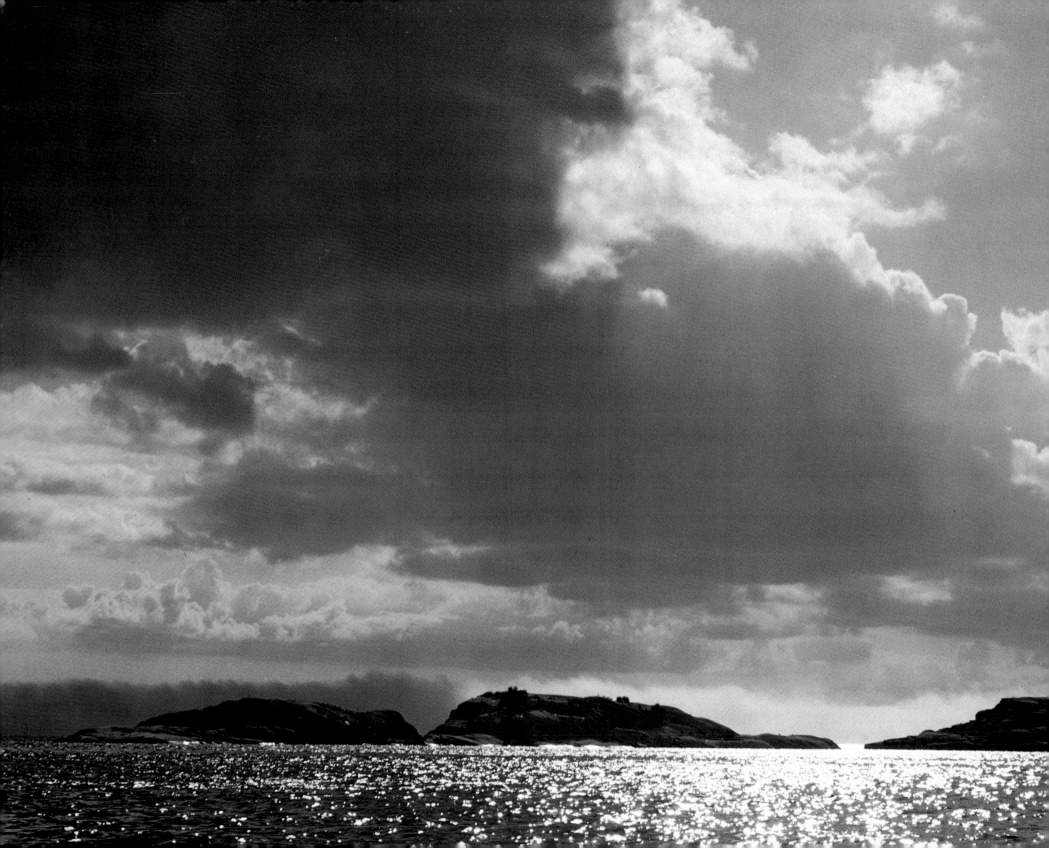

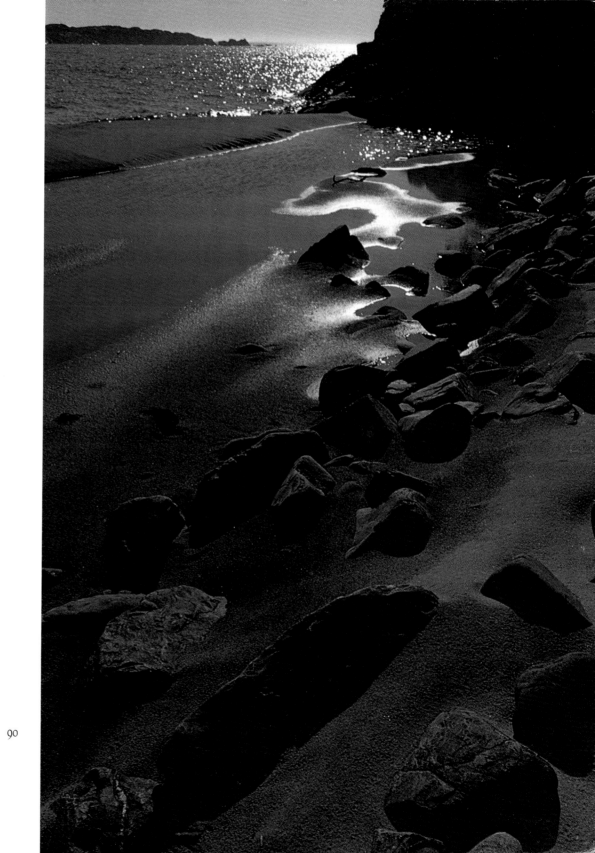

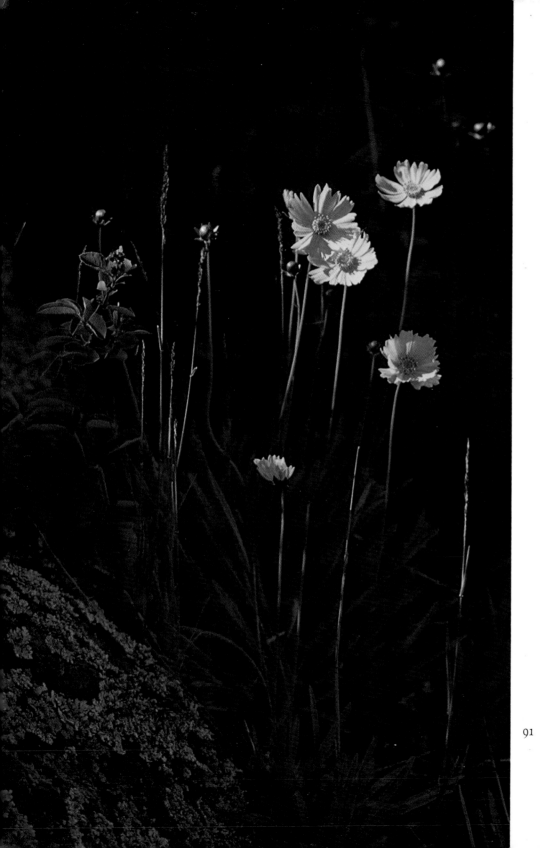

93

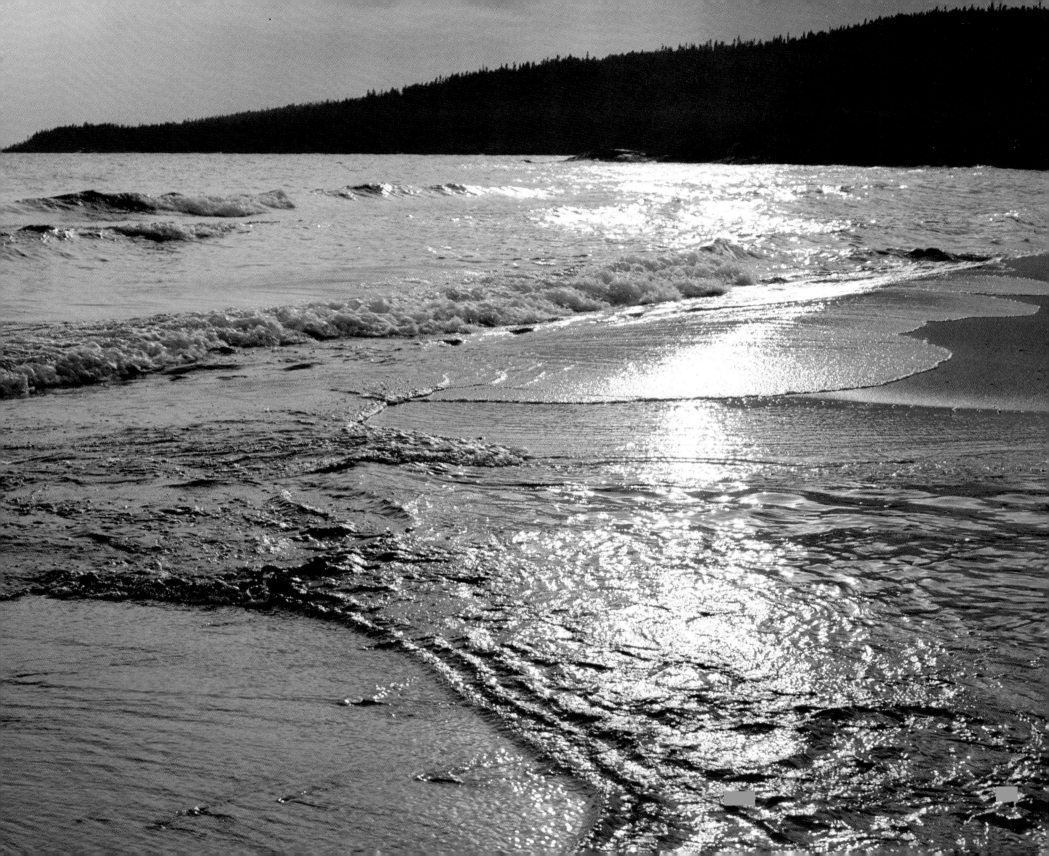

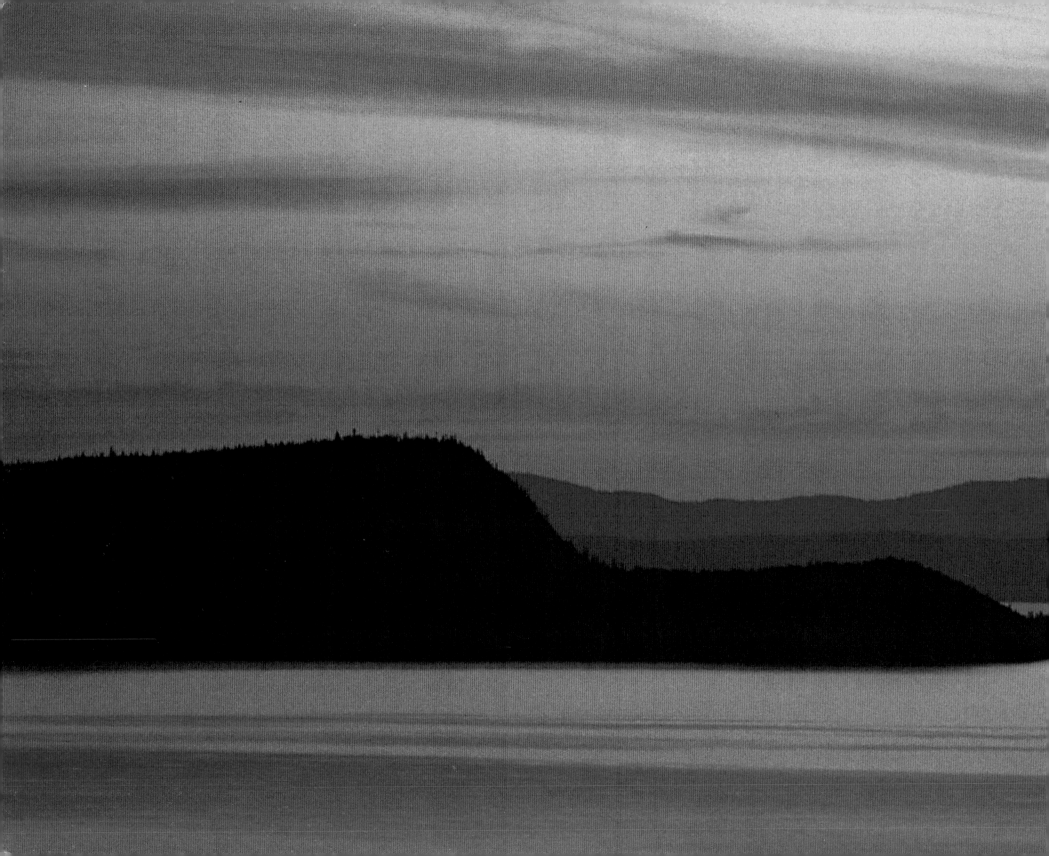

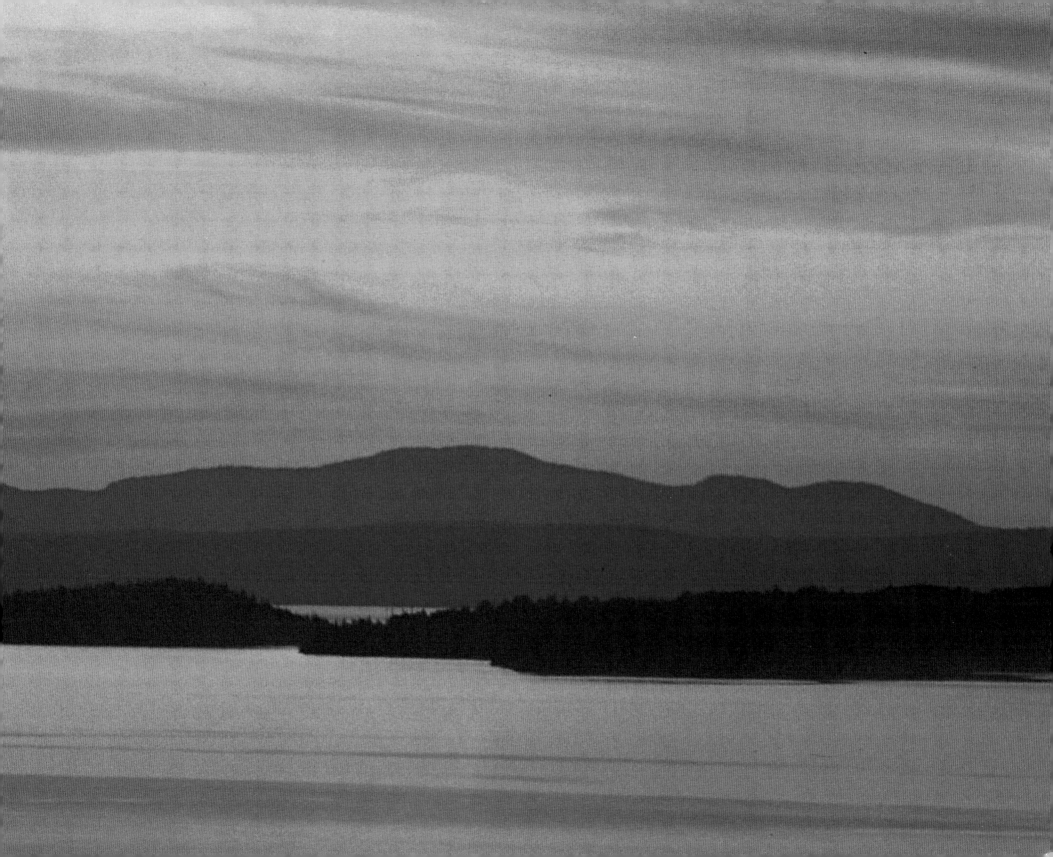

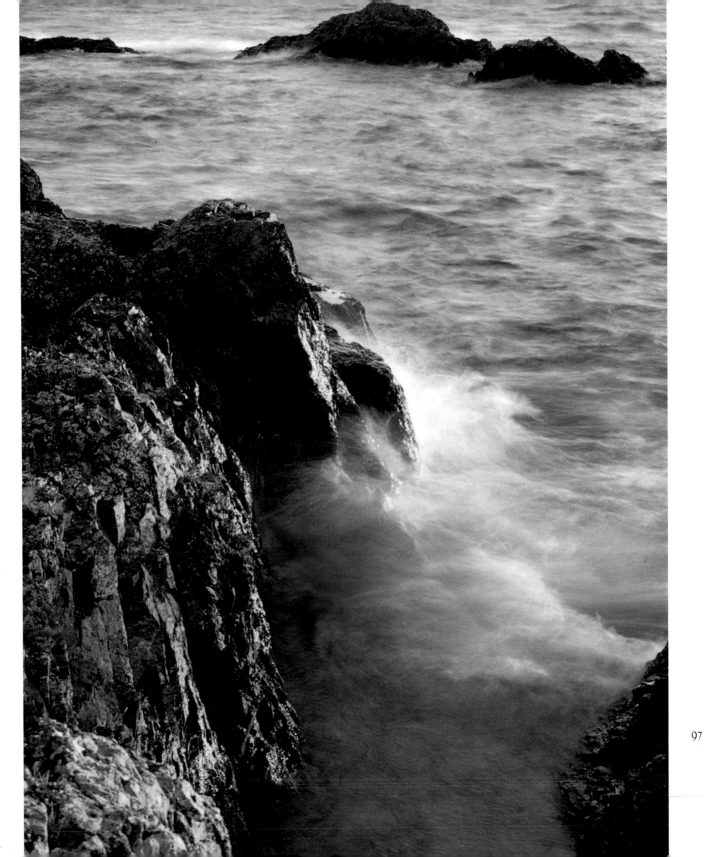

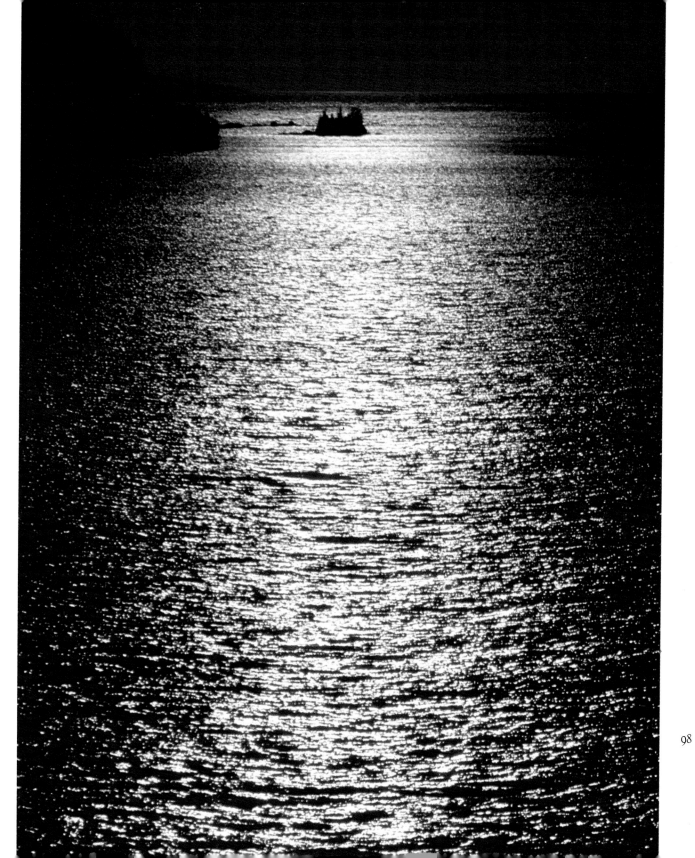

98

Superior: The Haunted Shore The Plates

1 near University (Dog) River

2 Oiseau Bay, Pukaskwa National Park

3 near Schafer Bay, Michipicoten Island

4 Old Woman Bay

5 near the Slate Islands

6 Pukaskwa shoreline

7 Pukaskwa shoreline

8 near Dog Harbour

9 Katherine Cover, L. Superior Prov. Park

10 Michipicoten Bay

11 near Brulé Harbour

12 Old Woman Bay

13 near Pte. la Canadienne

14 Pays Plat Bay

15 Schist Falls, Pukaskwa River

16 Katherine Cove

17 beach, Pukaskwa Depot

18 near Coppermine Point

19 Pie Island, Thunder Bay

20 Ganley Harbour, Pukaskwa shoreline

21 ponds, St Ignace Island

22 boreal forest, near Marathon

23 Brulé Harbour

24 autumn shoreline, near Montreal River

25 near Goulais River

26 interior pond, L. Superior Prov. Park

27 winter stream, L. Superior Prov. Park

28 moose, St. Ignace Island

29 lily pads, interior near Pays Plat

30 Coldwater River

31 valley of Old Woman River

32 near Alona Bay

33 winter detail, Sand River

34 winter detail, Sand River

35 Aguasabon River, near Terrace Bay

36 rock detail, Julia River

37 rock detail, Pukaskwa shoreline

38 rock detail, near Makwa River

39 Bullrushes, L. Superior Prov. Park

40 stream pool, Michipicoten Island

41 stream, Michipicoten Island

42 Aguasabon Canyon

43 Aguasabon Canyon

44 floor of Ouimet Canyon

45 lichen on quartzite

46 Sand River

47 pebbles, west of Makwa River

48 detail, White River

49 Schist Falls, Pukaskwa River

50 near University River

51 Lake Superior shoreline

52 Lake Superior, from Old Woman Bay

53 beach, Pukaskwa Depot

54 near Point Isacor

55 Agawa Bay

56 Great Blue Heron, near Tug Harbour

57 Gulls, near Bare Summit

58 morning light, Point Neys

59 evening, west of Ganley Harbour

60 sandbar, Ghost River

61 pebble beach, near Makwa River

62 Point Isacor

63 surf, Alona Bay

64 near Coppermine Point

65 near Little Dog Harbour

66 paddler, Old Woman Bay

67 sand and surf, Floating Heart Bay

68 near Rosspoint, Lake Superior

69 near Makwa River

70 near Schafer Bay, Michipicoten Is.

71 summer storm, Michipicoten Is.

72 breaking wave, Lake Superior

73 gull, Slate Islands

74 Leach Island from Bald Head

75 Davieux Island spruces

76 lighthouse, near Thunder Cape

77 shoreline, near Doré Point

78 water detail, near Cloud Bay

79 surf, Michipicoten Island

80 surf, Michipicoten Island

81 Oiseau Bay by moonlight

82 island, near Makwa River

83 detail, near Bare Summit

84 near Cotton Cove, Michipicoten Is.

85 Agawa Bay

86 detail, Agawa Bay

87 Imogen River, near Pte. la Canadienne

88 evening, Lake Superior Prov. Park

89 near Otter Island

90 beach, near Ganley Harbour

91 Lance-leaved Coreopsis, Gros Cap

92 Canada Anemone, Sibley Peninsula

93 shoreline falls, Pukaskwa National Park

94 wave sculpted rocks, University (Dog) River

95 mouth of Ghost River

96 evening, near Rossport

97 Michipicoten Island

98 near Devil's Warehouse Island

Pictograph photographs made at Agawa
Picture Rock

Acknowledgements

As a person of great generosity, and in her capacity as Executive Producer, Still Photography Division, National Film Board, Lorraine Monk was an unfailing source of encouragement and expert advice in the making of this book. We gratefully recognize her support and that of the National Film Board of Canada.

The substantial aid of the White Owl Conservation Awards Committee, which did much to further both research and photography, is also acknowledged with thanks.

In the forefront of those who assisted in this project and made it a pleasurable one are our wives, Carolyn and Gwen, and those friends who shared their appreciation and respect for the Lake Superior wilderness: Charlie Cragg, Peter Garstang, Laurie McVicar, Gerald McKeating, David Payne, Gerry O'Reilly, Doug Pimlott, and Doug Woods.

Many residents of the Superior north shore were particularly helpful. Don Casselman, Stuart May, Warren Thureson, Napoleon Michano, Otto Mueller & Jocelyn Watt, and Jim MacDonald and the crew of the *James D.* provided special transportation when it was most appreciated. Don & Jean Crozier of the Agate Isle Motel, Wawa, were unfailingly interested and encouraging during our several stays with them; and Lorrain & Joe Desaulniers, Nick Chopky, Mary Ellen & Henry Stuart, Ian Seddon, Frances & Gordon Dawson, Russ Hurt, Barbara & Bud Saunders, Alwyn Richardson, and Edyth & Keith Denis made many valuable suggestions during discussions in hospitable surroundings.

Several others generously shared their research and experience in local areas: Mary-Ellen MacCallum and Glen Adams at Sault Ste. Marie; Agnes Turcott and Donald Pugh at Michipicoten; Ray Kenney at Rossport; Tom Porett and Ann & Jack Drynan at Silver Islet; Ron Wrigley, Bill Addison, and David Bates at Thunder Bay; and Larry Baarts at Pine Bay. Clem Downey and Adolph King offered a wealth of reminiscence and a widsom to which this book cannot possibly do justice.

Without exception, government officials were co-operative and patient in explaining the complexities of administrative problems. Tom Beechey, Cameron Clarke, Tom Linklater, Cameron McGregor, Wayne MacCallum, Ian Ramsay, Bruce Scott, George Tracey, Lionel Trodd, and Bill Wyett, all shared the concerns of their various offices and directed us to further sources of information. We wish to thank especially Graham MacDonald and the Ontario Ministry of Natural Resources for making available Mr. MacDonald's excellent research report, *East of Superior.*

Expert advice and information came from several sources. Claude Garton's enthusiasm for the flora of the region was contagious, and Henry Halls generously offered his services as a guide through Lake Superior's tortuous geological history. Among the region's archaeologists whose work is justly gaining in importance, Paddy Reid, Don MacLeod, Mike O'Connor, and Thor Conway readily shared their discoveries and their excitement about future prospects. Our work with two outstanding conservation groups, The Algonquin Wildlands League and The Federation of Ontario Naturalists, has done much to heighten our awareness of environmental problems along the Superior shore.

As the work of design progressed, Dorothy & Vernon Mould brought to it a warmth, perception, and energy far in excess of what might reasonably be expected. Jon Pearce made informed suggestions concerning quoted material. Judith Dennison was extremely helpful in the long and sometimes arduous process of photo editing. Ken Rodmell and Prim & John Pemberton have provided valuable insights; both Harvie Brooks and Brian Wheatley have also been very helpful. Judith Parsons has done a good deal to refine our approach to both text and photographs, while Dick Howard and Michael Carver of Upper Canada College have been generous in the provision of physical facilities. We are thankful, too, for the patience and sound advice of Don Ritchie, Bill Hushion, Frank English, and Fortunato Aglialoro of Gage Publishing Limited.

Finally, the efficient assistance of the staffs of the following institutions is most gratefully acknowledged: the McLaughlin Memorial Library, Oshawa; the Archives of Ontario; the Sault Centennial Public Library and the Carnegie Public Library in Sault Ste. Marie, Ontario and Michigan respectively; the Baldwin Room and the Metro Toronto Central Library.

The lines on page 80 from "My Treasured Memories", by Joseph King, are included with the kind permission of the poet.

Other copyright material:

Quotations on pages 73 and 91 from *Contrasts* by Lawren Harris (Toronto: Macmillan, 1922), by permission of Lawren P. Harris.

Quotation on page 121 is from "The Lonely Land" from *Collected Poems* by A. J. M. Smith (Toronto: Oxford University Press, Canadian Branch, 1962), by permission of the author and publisher.

Quotation on page 147 is from "The Gods Avoid Revealing Themselves" from *The Animals in that Country* by Margaret Atwood, by permission of Little, Brown and Co. in association with the Atlantic Monthly Press. Copyright © 1968 by Oxford University Press (Canadian Branch).

Selected Bibliography

Agassiz, Louis, *Lake Superior*, With a narrative of the Tour by J. Elliot Cabot, Gould, Kendall and Lincoln, Boston, 1850.

Arthur, Elizabeth, ed., *Thunder Bay District 1821-1892: A Collection of Documents*, The Champlain Society and University of Toronto Press, Toronto, 1973.

Bigsby, Dr. John J., *The Shoe and Canoe*, London, 1850.

Bryant, William Cullen, *Letters of a Traveller*, N.Y., 1850.

Campbell, Marjorie Wilkins, *The North West Company*, Macmillan, Toronto, 1957.

Carver, Jonathan, *Travels Throughout the Interior Parts of North America*, 3rd edition, London, 1781.

Delafield, Joseph, *The Unfortified Boundary*, ed. McElroy and Riggs, N.Y., 1943.

Dewdney, Selwyn, and Kenneth Kidd, *Indian Rock Paintings of the Great Lakes*, University of Toronto Press, 1962.

Fraser, Simon, *Letters and Journals, 1806-1808*, ed. W. Kaye Lamb, Macmillan, Toronto, 1960.

Grant, George M., *Ocean to Ocean*, Radisson Society, Toronto, 1925.

Harmon, Daniel Williams, *Sixteen Years in the Indian Country*, ed. W. Kaye Lamb, Macmillan, Toronto, 1957.

Henry, Alexander, *Travels and Adventures*, ed. James Bain, Hurtig, Edmonton, 1969.

Hickerson, Harold, *The Chippewa and Their Neighbours: A Study in Ethnohistory*, Holt, Rinehart & Winston, N.Y., 1970.

Huyshe, G. L., *The Red River Expedition*, Macmillan, London, 1871.

Innis, Harold A., *The Fur Trade in Canada*, University of Toronto Press, 1970.

Jameson, Anna B., *Winter Studies and Summer Rambles*, McClelland & Stewart, Toronto, 1965.

Keating, William, *Narrative of an Expedition to the Source of the St. Peter's River, Lake of the Woods, etc.*, Whittaker, London, 1825.

Kinietz, W. Vernon, *The Indians of the Western Great Lakes, 1615-1760*, University of Michigan Press, Ann Arbor, 1940. (Includes Raudot, see below)

Kohl, J. C., *Kitchi-Gami*, Chapman and Hall, London, 1860.

Lefroy, John Henry, *In Search of the Magnetic North*, Macmillan, Toronto, 1955.

McKenney, R., *Sketches of a Tour to the Lakes*, Baltimore, 1827.

Mellon, Peter, *The Group of Seven*, McClelland & Stewart, Toronto, 1970.

Morriseau, Norval, *Legends of My People, the Great Ojibwa*, Ryerson Press, Toronto, 1965.

Morse, Eric, *Fur Trade Canoe Routes of Canada, Then and Now*, Queen's Printer, Ottawa, 1969.

Nute, Grace Lee, *Lake Superior*, Bobbs-Merrill, Indianapolis, 1944.

O'Meara, Walter, *Daughters of the Country*, Harcourt, Brace & World, N.Y., 1968.

Pye, E. G., *Geology and Scenery: North Shore of Lake Superior*, Ontario Dept. of Mines, Toronto, 1969.

Quimby, George Irving, *Indian Life in the Upper Great Lakes*, University of Chicago Press, 1960.

Raudot, Antoine Denis, *Memoir Concerning the Different Indian Nations of North America*, 1710 (Letters 23-41 and 45-72 inclusive in Kinietz, see above)

Spears, Raymond S., *A Trip on the Great Lakes*, A. R. Harding, Columbus, Ohio, 1913.

Tanner, John, *Narrative*, ed. Edwin James, Ross & Haines, Minneapolis, 1956.

Thompson, David, *Travels in Western North America, 1784-1812*, ed. Victor G. Hopwood, Macmillan, Toronto, 1971.

Voorhis, Ernest, *Historic Forts and Trading Posts*, Department of the Interior, Ottawa, 1930.

Warren, William H., *History of the Ojibway Nation*, Ross & Haines, Minneapolis, 1970.

Weiler, John, *Michipicoten: Hudson's Bay Company Post, 1821-1904*, Ontario Ministry of Natural Resources, Historical Sites Branch, 1973.

White, Stewart Edward, *The Forest*, The Outlook Company, N.Y., 1903.